Curated by Thomas Olivri

GEEK-ART
AN ANTHOLOGY

Art, Design, Illustration & Pop Culture

CHRONICLE BOOKS
SAN FRANCISCO

GEEK-ART: An Anthology
Curated by Thomas Olivri

First published in the United States in 2014
by Chronicle Books LLC.
First published in France in 2012 by
Huginn&Muninn.

© Copyright Huginn&Muninn / Médiatoon
Licensing.

Library of Congress Cataloging-in-
Publication Data available.

ISBN: 978-1-4521-4048-3

Cover illustrations:
Front cover: Proton Factories,
Proton 3.1 (2011)
Back cover: Danil Polevoy, Mrs. Parker and
Son (2010)

Chronology chart: Aurélie Moire
Design: Virginia Belcollin

10 9 8 7 6 5 4 3 2 1

Chronicle Books LLC
680 Second Street
San Francisco, California 94107
www.chroniclebooks.com

To Aurélie, my Zelda, my Leia, my Khaleesi.

This book was not easily made, but what
pride and joy to hold it in my hands!

I want to thank all the artists from around the
world who appear in this book, evidence that
the passion for fantasy worlds and geekdom
knows no borders.

I also want to thank my wife, Aurielie, for her
patience, support, and valuable contribution
to the realization of this book. Also thank you
to my parents for letting me live my life as a
geek teen, amateur of RPGs and video games.
Also a small dedication to Loquak, Schwing,
Floz, Dédé, and Birkout, my companions in a
thousand and one adventures, imaginary or
not, that will remain etched in my memory.

And a special thought for Romain, Gui-
tar and Working Class Hero before God.
And finally, a big thank you to all the
Huginn&Muninn team and all those who
directly or indirectly contributed to make
this project a reality.

May the Force be with You, Prosperity and
Long Life, Strength and Honor, So Say We
All, Geronimo!

Thomas Olivri

To every hero who over the years has made
us dream and travel in imaginary worlds.

Their imprint on our lives naturally encour-
ages artists to create these passionate works
in tribute.

The editor wishes to thank Virginia Belcollin,
Sara Sanchez, Marie and Julien Brunel
Boulesteix, Chaïma Abagli, and Charlène
Renault.

CONTENTS

Artists

INTRODUCTION

Geek. The word once used as a derogatory term is now on everyone's lips. Today everyone loves geeks, and everyone wants to be one—or thinks they are one. We have come a long way from the stereotype of the young, pimply, asocial amateur enthusiast of strange worlds that was applied to the first generation of geeks (myself included!). Today, the universe of geeks drives billions of dollars for the entertainment industry, and the lightning advances in communication technology have made geeks a key element in our society. Our perfect revenge! But beyond this, we geeks and our favorite pop cultural fixations are a primary and inexhaustible source of inspiration for thousands of artists around the world, and this has given birth at the dawn of the twenty-first century to a fantastic and exuberant form of folk art: Geek-Art.

THE ART OF BEING A GEEK

What was once a term synonymous with the antisocial, weird, and nerdy has now become a trendy attribute, even a sort of definition of a trendsetter (never mind the hipsters). I'm one of those individuals who embraced the geek universe at an early age: A child of the 1980s, I grew up in the midst of early video game consoles, RPGs, war games, comics, and sci-fi literature, as well as movies that are regarded today as canonical cult films: *Star Wars, The Goonies, Back to the Future, Ghostbusters, Raiders of the Lost Ark*, and many more.

And while I hesitate to rehash the old mantra of "things were better back in the day," it's true that in that golden age before the Internet, the only media we had to entertain us were TV (with a handful of channels), movies, books, and magazines. We therefore drew from our imaginations, perhaps more than we do today. The simplest stolen image, roughly animated cartoon, or fantasy book cover gave our imagination wings.

Once upon a time, a "geek" was a microcomputer enthusiast, back when it was vital to have superior intellectual qualities in order to operate a computer. The term was later extended to include dedicated RPG, arcade, console, and war game players, as well as assiduous readers of science fiction novels and comics. Believe me when I say I have had a lot of experience with these pastimes! For me, after the cinematographic shock of *Star Wars*, came the literary revelation of reading *The Lord of the Rings,* the playful revolution of Game Boy, the endless joy and happiness of *Dungeons & Dragons* and other role-playing games, the fun of collecting *Magic* trading cards and comics, the pleasure of reading science fiction and fantasy novels—actually this is a pretty typical path in the life of many a self-respecting geek.

All these worlds or realms that we call *geekdom* (a combination of *geek* and *kingdom*) never really leave us. The members of my generation, raised as geeks, are now mostly adults in our thirties, maybe in a relationship or married, but in any event with a purchasing power that we did not possess in our childhoods. While back then we might have had to save for months in order to buy a Batman figurine, most of us can now comfortably spend $100 on a new video game or several hundred dollars on an X-Men sculpture. We are now, and have been for the past ten years or so, experiencing a time of glory for geeks. And we have made the entertainment industry a fortune.

Today, it's a fact that to be geek is chic. Since Peter Jackson sold millions of tickets at the box office with dwarves in armor, and Sam Raimi repeated the trick with a hero in tights, the great geek wave has crushed everything in its path. Superhero movies, consoles, video games . . . never has the geek universe grossed more money than in the past decade. Moreover, you can be a geek in any area, now that the term has become synonymous with an all-consuming passion. My wife? A fashion geek. My father? A fishing geek. My sister? A cooking geek. My brother? A rock 'n' roll geek. My mother? A reading geek. And why not? What is also interesting about the rise of geek culture is the impact it has had on contemporary artists. But before talking about Geek-Art itself, let's take a brief look at the big names associated with original geekdom.

ORIGINS: THE GREAT ILLUSTRATORS OF GEEKDOM

The term *Geek-Art* is relatively new, and it is very difficult to agree on the first occurrence of this phenomenon. Is it issue #27 of *Detective Comics* introducing Batman in 1939? Or the cover of the first "pulp," the weekly and monthly collections in the early 1900s of a new fantasy or science fiction publication, which often showed off a blond, muscular hero wielding a laser/sword to save a blonde/brunette young woman from the claws of a robot/dragon? It's hard to say.

Here I would like to call out some of the great geek artists of my generation, those who were successful long before the Internet and the democratization of television, and who brought to life universes that were mostly described on paper. The printed manuals for the game *Dungeons & Dragons*, for example, were filled with illustrations, some of them sublime. Artists such as Jeff Easley, Clyde Caldwell, Larry Elmore, and Gerald Brom—these masters of the fantastic filled my younger years with epic visions that I can still remember. Let's add John Howe and Ted Nasmith, who portrayed Tolkien's Middle Earth as no one else could have. And we must include the late Frank Frazetta, who made Conan the Barbarian real in everyone's collective imagination through epic paintings depicting the hero larger-than-life.

The "geek" illustrators of this era worked in many media. In addition to the covers of novels and role-playing game illustrations, I want to highlight the work featured in choose your own adventure books, the multiple-choice tales where the reader has an active part in the story. From science fiction to fantasy, from post-apocalyptic survival to pure horror, these books covered most of the geekdom universes in book series with evocative names: *Sorcery, Lone Wolf, Fighting Fantasy.* Each volume had a color cover illustration and, inside, black and white drawings, many of which remain etched in my memory. For instance the work of Gary Chalk, an English illustrator and one of the founding fathers of these sort of gamebook illustrations, who is well-known for his characteristically tortured style.

In discussing the great "classics" of the geek world, it's hard to overlook Games Workshop. A British company founded in 1975 by John Peake, Ian Livingstone, and Steve Jackson (the latter two creators of the *Fighting Fantasy* books), Games Workshop offers war games set in fantasy universes heavily inspired by Tolkien. In the game *Warhammer*, players buy and paint lead figurines grouped into armies with different attributes based on their races (elves, humans, dwarves, orcs, the undead, goblins). The rules are based on classic historical war games, where battles are won with a roll of the dice and strategy, but also thanks to magic, dragons, and enchanted artifacts. This hobby quickly impassioned geeks around the world, and new games soon emerged, taking place in different realms.

The futuristic version of *Warhammer*, for example, *Warhammer 40,000*, retains the same protagonists but takes place in the distant future: Dragons are replaced by tanks, swords by laser guns. It is said that the creators of the legendary video game *Starcraft* drew heavily on this dark and futuristic universe. Here, too, illustrations are featured in many of the rulebooks and supplements, as well as on the packaging of the models and figurines. Talented illustrators such as John White, Geoff Taylor, Mark Gibbons, Ian Miller, and Paul Bonner, to name a few, have made a lasting impression and succeeded in giving life to this complex, rich, and exciting universe for thousands of players.

Another revolution in the fun world of geeks came with the appearance of *Magic: The Gathering*, a collectible card game that debuted in 1993 and quickly became a hit with fans of fantasy and strategic universes. In the game, players create their own decks of cards from the hundreds available in order to beat their opponents. With unique artwork featured on each card, hundreds of illustrators are involved. Among those who have left their mark on the game are Quinton Hoover, Aleksi Briclot, Doug Chaffee, Geof Darrow, Melissa Benson, Kaja Foglio, Glenn Fabry (also known for his comic book covers), and many more—after more than twenty years of existence, the list is as huge as the game.

Movie posters have also enjoyed an influential heyday, with artists transforming these simple promotional items into works of art that can be framed. Most notably, I am thinking of Drew Struzan, arguably one of the most prolific and most well-known poster artists, having worked on the legendary Special Edition *Star Wars* posters, *Hook, Blade Runner, Indiana Jones, Back to the Future, The Goonies, Harry Potter,* and *Hellboy.*

The list could be much longer, and I invite you to discover the works of these great artists on their own respective web sites. However, this book is not dedicated to the great founding professional illustrators of geekdom, whose outstanding contributions to our favorite universes each deserve their own book (fortunately, some already have one). The purpose of this book is to celebrate Geek-Art, to highlight the fan artists who have applied their talent and graphic style to the realms about which they have so passionately dreamed.

POP ART AND STREET ART

An artistic movement that emerged in Britain in the 1950s, pop art references popular culture and includes imagery of well-known icons (such as Marilyn Monroe or Mickey Mouse). Pop art and its artists engage with and challenge consumer society, as well as the media's influence on us through advertising, the press, television, and comic strips. Pop artists such as Richard Hamilton, Andy Warhol, Roy Lichtenstein, David Hockney, Jeff Koons, and Takashi Murakami also have helped demystify art, making it accessible and understandable to the masses by addressing them directly via symbols that affect the heart.

Similarly, street art in the past few decades has also managed to bring art out of the museum and to the people. Even if the results are ephemeral, stencils, mosaics, graffiti, posters, collages, and murals have all been put to good use in the streets for artistic expression. And if Banksy is well-known for his stencils, let us also mention Invader, the artist who since 1999 has installed mosaics representing the *Spacer Invaders'* pixilated aliens in major cities around the world. Here, we are dangerously close to Geek-Art.

One of the other greats who should be mentioned is the American artist Ron English, whose surrealist pop work mixes street art and pop art without hesitation, using as inspiration the icons of popular culture such as Mickey Mouse, Ronald McDonald, the Simpsons, and the characters from *South Park.*

THE BIRTH OF GEEK-ART

Being interested in these artistic movements, I realized that these artists draw their inspiration from the pop culture of my generation. Indeed many of today's photographers, illustrators, graphic designers, painters, and sculptors love giving free rein to their art and their childlike souls by working on the universes of geekdom. And thanks to the Internet, they have access to a very wide audience, especially on an international scale. Almost needless to say, the United States is a step ahead when it comes to art galleries featuring such work. Gallery 1988, for instance, based in Los Angeles, regularly organizes exhibitions dedicated solely to these worlds. Of course how could it be otherwise, since Americans have been manufacturing and exporting this sort of pop culture since at least the 1930s? So it's only to be expected that many of these artists are based in the country that gave us Uncle Sam and Obi-Wan Kenobi.

As soon as they were able to use a pencil or computer mouse, this generation of illustrators and graphic designers were inspired to draw their idols, whether it was He-Man, Super Mario, or Darth Vader. Artists have always created works inspired by the popular culture around them. For centuries, the primary source of inspiration for Western artists was religion—the Egyptian, Greek, or Roman pantheons, the Old or New Testament—as well as ancient and contemporary folk tales, legends, myths, and heroes.

Today, these heroes are named Mario, Ripley, Luke Skywalker, Link, and Peter Venkman. Geekdom is an inexhaustible source of inspiration, a bottomless well of references, heroes, mythical objects, memorable scenes, and consuming passions. Pop culture today has its origins in artists who spent their childhoods with joystick in hand, in the arcade or watching VHS cassettes, or poring over the work of their favorite science fiction authors.

The fact that the film and video game industries have exploded in popularity in recent years by focusing on the worlds of geekdom has only reinforced this impression. From Japanese manga to American comic books, we are also witnessing an escalation in novelties: Shops are full of new comics every week, theaters screen new horror/sci-fi/fantasy/superhero films, and astronomical amounts are spent on marketing video games. We live in a time where geek is king, and so it is only natural that artists are inspired by the geek phenomenon. The circle is complete.

FAN-ART, ANCESTOR OF GEEK-ART

This is Geek-Art: When an artist is inspired by a part of his own culture and has it seep out into his art. When she creates a work of art inspired by a video game or a comic using her own codes, her own style. Geek-Art is all this creative energy and the inspiration that revolves exclusively around geekdom at large.

Geekdom is vast with provinces and kingdoms encompassing many media sources and many worlds: comics and manga; video games; cult films; horror, fantasy, cyberpunk,

or sci-fi novels and short stories; games; toys; cartoons; TV series (from cult series of the 1980s and '90s such as *V* and *Quantum Leap* to more recent favorites such as the remake of *Battlestar Galactica*, *Stargate SG-1*, *Lost*, *The Big Bang Theory*, and HBO's *Game of Thrones* inspired by George R. R. Martin's fantasy novels). But it is all geekdom.

Can you draw or use Photoshop? Are you a fan of Gandalf or Zelda? Create your own fantastic illustrations of them to your heart's content! In this sense, fan art is the foundation

of Geek-Art, the place where it all begins. Numerous web sites and platforms have enabled any geek who knows how to draw to share their contributions—some even event host contests to see who can draw the best wizard version of Mario—and many of these amateur works can stand successfully alongside more professional masterpieces of precision.

Fan art is a popular dimension and integral part of geekdom, allowing artists to create without inhibitions. Regardless of language or cultural barriers, and whatever the artistic level, everyone can band together to share their passion.

MINIMALISM AND REIMAGINATION

A few years ago, two new trends appeared almost simultaneously in the realm of Geek-Art, often complementing one another: reimagining movie posters and minimalism. Film fans have long held studio-created movie posters in low regard, the products usually overly reliant on Photoshop and the cropped, floating heads of the protagonists. As it usually happens in fan or geek communities, if they are not satisfied with something, they do it themselves. Thus thousands of illustrators and graphic designers have been having great fun reimagining and redesigning movie posters of recent films, as well as their favorites from childhood.

In this area, the work of Saul Bass—the great graphic artist who applied his boldly symbolic style to incredible posters for films by Alfred Hitchcock and Otto Preminger—seems to have made a deep impression on the work of geek artists. Here we have the rise of the minimalist poster trend, a style whose goal is to evoke a film or a hero of geekdom using the minimum number of elements possible. Such elements are often direct references from the film, and ones that only true fans will know. For example, the artist Jamie Bolton's reimagination of the poster for *Jurassic Park* features an image of a cup of rippling water against a black background. Not much to do with dinosaurs, one might say? Well, not unless you know the movie and remember the scene (maybe the best in the movie) when the Tyrannosaurus' arrival is foreshadowed by its heavy footsteps, shaking a glass of water in a car's cupholder. Likewise, Bolton's beautiful poster for Kubrick's *The Shining* suggests the film by merely reproducing the Overlook Hotel's distinctive carpet pattern, a clever and graphic reference that the film's fans would immediately recognize. In this way, paradoxically, the minimalist poster is often addressing only those fans who are intimately familiar with the movie! Interestingly, and characteristic of Geek-Art, geek artists are often creating work addressed to other geeks. Another example of this is the work of one of the founders of the minimalist movement, Albert Exergian, whose illustrations celebrate TV series such as *Dexter*, *The X-Files*, and *Twin Peaks* with graphics that only true fans will understand—a sort of visual nod to finding "Easter eggs," the secret elements playfully hidden by programmers in video games or DVDs and found only by the fiercest of geeks. Artists such as Olly Moss take the game element a step further and combine minimalist style with trompe-l'oeil effects to create breathtaking, ultra-graphic posters.

While these movements stand out, Geek-Art, broadly defined, includes all works related to geek culture and geekdom in a wide range of styles, from artists of all kinds (photographers, illustrators, painters, sculptors . . .). Ultimately, Geek-Art is an immense declaration of love for these fantastic worlds that cradle us and allow us to dream. The artists who create Geek-Art are driven to express their talent and creativity, but also, above all, by passion.

ENJOY!

An incredible feature of geekdom is that it makes a mockery of imposed geographical, social, cultural, religious, or even generational barriers. A fan of *Pokémon* remains a fan of *Pokémon*, whether Japanese, American, Moroccan, or Scandinavian. The same goes for *Star Wars* fans, or fans of video games, or Tolkien. The Internet has only highlighted this fact, especially via fan forums, where you can talk for hours about any particular scene of a cult film, a favorite game, or a revered comic. A visit to conventions such as the Japan Expo in Paris or the San Diego Comic-Con—where you can come across a teenager dressed as Goku or a lawyer in a Stormtrooper costume—helps make clear the magnitude of this phenomenon. For any criticisms that might apply to geekdom, its strength is its universality.

The same can be said of Geek-Art. Here universal values, a common passion, dedication to the geek universe, even nostalgia all come together under the banner of fun and entertainment. In fact, my favorite definition of Geek-Art, simple but not simplistic, is this: fun art. Cool art. Geek-Art is an expression of the will to never forget the child we once were and that, ultimately, we have remained. It is the impulse, when seeing a movie trailer featuring Viking warriors, pirates, superheroes, or spacecraft, to smile and say *cooool*. Yes, I am

thirty years old. I work and pay taxes. I can discuss politics with my family. But nothing, absolutely nothing can make me forget that, somewhere inside me, Frodo is still traveling through Middle Earth, Luke Skywalker continues his Jedi training on Dagobah, Spider-Man is still trying to balance his private life and his fight against crime, and Sloth still loves Chunk.

Geek-Art is an essential way to reconcile imagination, creativity, and nostalgia. This is why, for the past several years, I have been compiling and sharing on my website Geek-Art. net these incredible works of craft, talent, and originality, dedicated to our common passions. The collection of this work here and online are signs that the geek community is stronger than ever. I hope that, whether you are a geek or not, you will discover in these pages many great artists, who have never forgotten the inner child in pajamas secretly watching *The Goonies*. May this book also prompt similar great memories for you!

—Thomas Olivri, creator of geek-art.net

SELECTIVE CHRONOLOGY OF GEEKDOM

PRESS START

Fusajiro Yamauchi creates Nintendo, a company at that time specializing in card games.

1889

Edgar Rice Burroughs publishes *Under the Moons of Mars*, the debut of his John Carter of Mars series, as well as the first short story introducing Tarzan.

1912

H. P. Lovecraft writes "The Call of the Cthulhu."

1926

J. R. R. Tolkien publishes *The Lord of the Rings*.

1954

Launch of the satirical magazine *MAD*.

1952

Creation of the International Graphic Alliance in Paris.

1950

Flag, created by the American artist Jasper Johns, is considered to be one of the precursors of pop art.

1954

The term *pop art* is coined by the U.S. artist John McHale, member of the British Independent Group. He will be dubbed the "Father of Pop" by the critic Reyner Banham.

1954

Topps issues the trading card series *Mars Attacks* illustrated by Wally Wood and Norman Saunders.

1962

Dr. No brings James Bond (as portrayed by Sean Connery) to the big screen.

1962

Roy Lichtenstein makes news with his work *Look Mickey*, depicting Mickey Mouse and Donald Duck.

1961

Astro Boy, Osamu Tezuka's little robot, is the first Japanese animated TV series.

1963

Doctor Who debuts on British TV screens. Created by Sydney Newman and Donald Wilson, it will become the longest-running sci-fi series in history.

1963

Lichtenstein paints *Whaam!*, a work inspired by a comic book from DC Comics.

1963

AND INFLUENCES OF GEEK-ART

Mickey Mouse, created by Walt Disney, makes his first appearance in the animated cartoon *Steamboat Willie*.

1928

Frankenstein, directed by James Whale and starring Boris Karloff, opens in theaters. Today, its original six-sheet poster is considered the rarest cinematographic poster in the world.

1931

Robert E. Howard creates Conan the Barbarian.

1932

Batman appears in *Detective Comics* #27.

1939

Eduardo Paolozzi, who will later become cofounder of the British Independent Group, creates a collage titled *I Was a Rich Man's Plaything*, considered the first pop art work.

1947

Osamu Tezuka publishes *New Treasure Island*.

1947

Joe Simon and Jack Kirby send Captain America to war against the Nazis.

1940

The artist Reynold Brown paints the poster for *Creature from the Black Lagoon*. He later illustrates the sublime posters for *Tarantula* (1955), *I Was a Teenage Werewolf* (1957), *Attack of the 50 Foot Woman* (1958), and *Ben-Hur* (1959).

1954

Saul Bass creates the influential graphic poster and title sequence for Otto Preminger's *The Man with the Golden Arm*.

1955

Saul Bass designs the ultra-graphic poster and title sequence for Hitchcock's *Vertigo*.

1958

Stan Lee's Marvel revolution arrives with the first superhero team in *The Fantastic Four* #1.

1961

Etch A Sketch first produced.

1960

Hasbro inaugurates the G.I. Joe toy collection.

1964

"The Cage," the pilot episode of the series *Star Trek*, created by Gene Roddenberry, is rejected by NBC.

1964

Andy Warhol makes the movie *Batman Dracula*, without DC Comics' approval. The film is only projected during his exhibitions.

1964

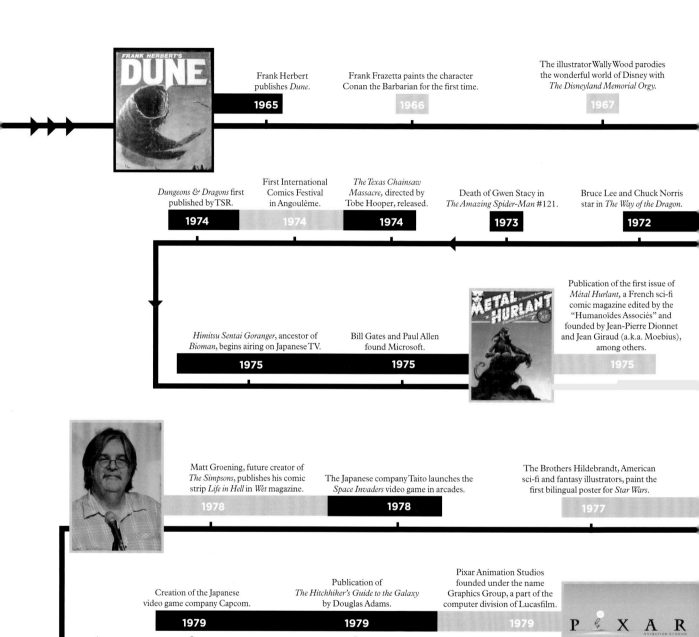

Frank Herbert publishes *Dune*.

1965

Frank Frazetta paints the character Conan the Barbarian for the first time.

1966

The illustrator Wally Wood parodies the wonderful world of Disney with *The Disneyland Memorial Orgy.*

1967

Dungeons & Dragons first published by TSR.

1974

First International Comics Festival in Angoulême.

1974

The Texas Chainsaw Massacre, directed by Tobe Hooper, released.

1974

Death of Gwen Stacy in *The Amazing Spider-Man* #121.

1973

Bruce Lee and Chuck Norris star in *The Way of the Dragon.*

1972

Himitsu Sentai Goranger, ancestor of *Bioman,* begins airing on Japanese TV.

1975

Bill Gates and Paul Allen found Microsoft.

1975

Publication of the first issue of *Métal Hurlant,* a French sci-fi comic magazine edited by the "Humanoïdes Associés" and founded by Jean-Pierre Dionnet and Jean Giraud (a.k.a. Moebius), among others.

1975

Matt Groening, future creator of *The Simpsons,* publishes his comic strip *Life in Hell* in *Wet* magazine.

1978

The Japanese company Taito launches the *Space Invaders* video game in arcades.

1978

The Brothers Hildebrandt, American sci-fi and fantasy illustrators, paint the first bilingual poster for *Star Wars.*

1977

Creation of the Japanese video game company Capcom.

1979

Publication of *The Hitchhiker's Guide to the Galaxy* by Douglas Adams.

1979

Pixar Animation Studios founded under the name Graphics Group, a part of the computer division of Lucasfilm.

1979

PIXAR

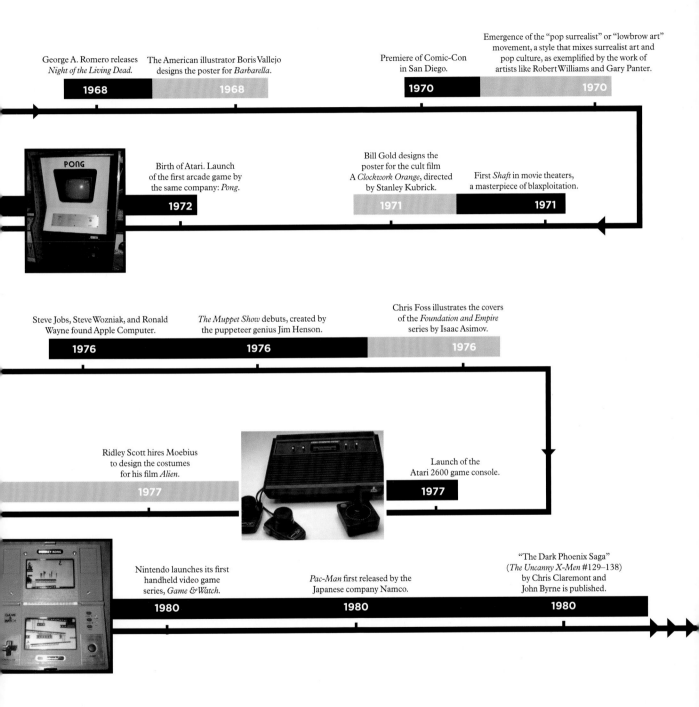

George A. Romero releases *Night of the Living Dead.*

1968

The American illustrator Boris Vallejo designs the poster for *Barbarella.*

1968

Premiere of Comic-Con in San Diego.

1970

Emergence of the "pop surrealist" or "lowbrow art" movement, a style that mixes surrealist art and pop culture, as exemplified by the work of artists like Robert Williams and Gary Panter.

1970

Birth of Atari. Launch of the first arcade game by the same company: *Pong.*

1972

Bill Gold designs the poster for the cult film *A Clockwork Orange,* directed by Stanley Kubrick.

1971

First *Shaft* in movie theaters, a masterpiece of blaxploitation.

1971

Steve Jobs, Steve Wozniak, and Ronald Wayne found Apple Computer.

1976

The Muppet Show debuts, created by the puppeteer genius Jim Henson.

1976

Chris Foss illustrates the covers of the *Foundation and Empire* series by Isaac Asimov.

1976

Ridley Scott hires Moebius to design the costumes for his film *Alien.*

1977

Launch of the Atari 2600 game console.

1977

Nintendo launches its first handheld video game series, *Game & Watch.*

1980

Pac-Man first released by the Japanese company Namco.

1980

"The Dark Phoenix Saga" (*The Uncanny X-Men* #129–138) by Chris Claremont and John Byrne is published.

1980

The Shining, directed by Stanley Kubrick, premiers with posters designed by Saul Bass.

1980

The first Indiana Jones film, *Raiders of the Lost Ark*, directed by Steven Spielberg, is released.

1981

Nintendo releases *Donkey Kong*, one of the first platform games.

1981

First launch of animated TV series *Ulysses 31*.

1981

The Dark Crystal, by Jim Henson and Frank Oz, revolutionizes special effects and animatronics for movies.

1982

The first *Back to the Future* movie, directed by Robert Zemeckis, is released.

1982

British artist Gary Chalk illustrates the first *Lone Wolf* choose your own adventure gamebook.

1984

Russian computer engineer Alexey Pajitnov creates the game *Tetris*.

1984

Hasbro first launches the Transformers toy franchise.

1984

American illustrator Earl Norem, famous for his work on *He-Man and the Masters of the Universe*, paints the cover of the book *Transformers: Battle for Cybertron*.

1984

Thundercats, created by Tobin Wolf, first airs.

1985

The Goonies, directed by Richard Donner, is released.

1985

Launch of *Super Mario Bros.*

1985

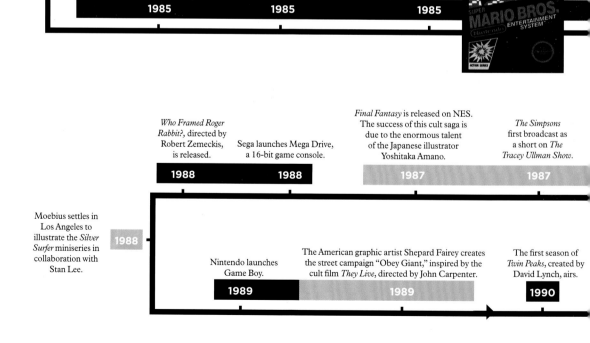

Who Framed Roger Rabbit?, directed by Robert Zemeckis, is released.

1988

Sega launches Mega Drive, a 16-bit game console.

1988

Final Fantasy is released on NES. The success of this cult saga is due to the enormous talent of the Japanese illustrator Yoshitaka Amano.

1987

The Simpsons first broadcast as a short on *The Tracey Ullman Show*.

1987

Moebius settles in Los Angeles to illustrate the *Silver Surfer* miniseries in collaboration with Stan Lee.

1988

Nintendo launches Game Boy.

1989

The American graphic artist Shepard Fairey creates the street campaign "Obey Giant," inspired by the cult film *They Live*, directed by John Carpenter.

1989

The first season of *Twin Peaks*, created by David Lynch, airs.

1990

Disney releases *Tron*,
directed by
Steven Lisberger.

1982

Blade Runner, directed
by Ridley Scott, is released.

1982

Drew Struzan creates the
poster for *Blade Runner*.

1982

V for Vendetta by
Alan Moore and
David Lloyd is first
published in
Quality Comics.

1982

First Blood, the first of the
Rambo series, directed by
Ted Kotcheff, is released.

1982

British author Terry Pratchett
releases his first book in the
Discworld series: *The Colour
of Magic.*

1983

Release in Japan of Famicom,
which is better known under the
name Nintendo Entertainment
System (NES).

1983

*He-Man and
the Masters of the
Universe* first airs.

1983

Artist Jeff Easley is hired by
TSR as an illustrator for
Dungeons & Dragons.

1982

The animated TV series
G.I. Joe first airs.

1985

The companies Harmony Gold USA
and Tatsunoko Production release
Robotech on American TV.

1985

Topps releases *Garbage Pail Kids* trading cards in
the United States, created by Art Spiegelman and
cartoonist Mark Newgarden. John Pound is
the official designer of the first series.

1985

Creation of Studio Ghibli in Japan, by
Hayao Miyazaki, after the success of
Nausicaä of the Valley of the Wind, which
he wrote and directed.

1985

The pilot episode of the *Teenage Mutant
Ninja Turtles* animated series, inspired
by the comic books created by
Kevin Eastman and Peter Laird, first airs.

1987

John Blanche becomes the art
director of Games Workshop.

1986

Steve Jobs buys
Pixar Animation Studios.

1986

Debut of the anime TV series
Knights of the Zodiac, produced
by Toei Animation.

1986

Debut of Frank Miller's
Sin City comic.

1991

Street Fighter II released.
It's one of the biggest video
game successes to date.

1991

Sonic the Hedgehog is released
for Sega Genesis.

1991

Mark Ryden, one of the leading
artists in the pop surrealist move-
ment, creates the album cover for
Michael Jackson's *Dangerous.*

1991

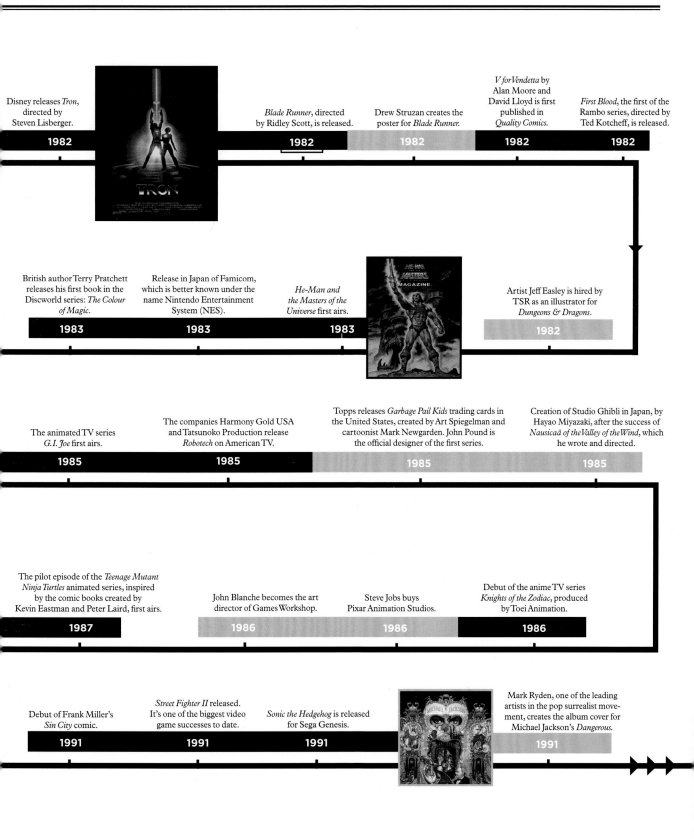

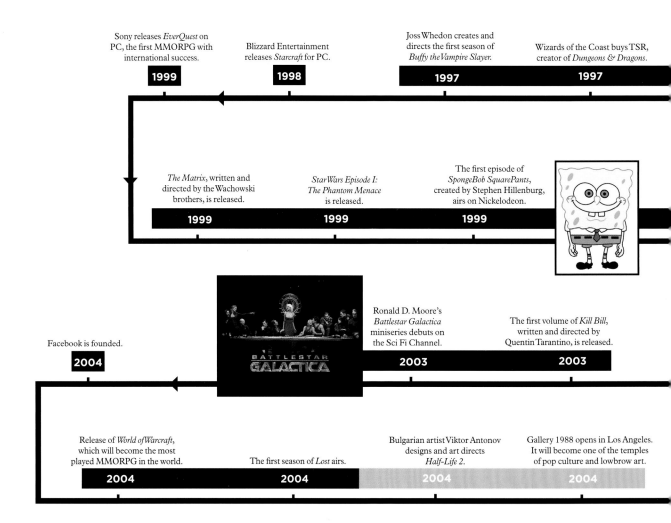

Batman: The Animated Series, developed by Bruce Timm, first airs.

1992

Marvel defectors (Jim Lee, Todd McFarlane, etc.) found the comic book publisher Image Comics.

1992

Wizards of the Coast releases the collector card game *Magic: The Gathering*, created by Richard Garfield.

1993

Launch of PlayStation.

1994

Sony releases *EverQuest* on PC, the first MMORPG with international success.

1999

Blizzard Entertainment releases *Starcraft* for PC.

1998

Joss Whedon creates and directs the first season of *Buffy the Vampire Slayer*.

1997

Wizards of the Coast buys TSR, creator of *Dungeons & Dragons*.

1997

The Matrix, written and directed by the Wachowski brothers, is released.

1999

Star Wars Episode I: The Phantom Menace is released.

1999

The first episode of *SpongeBob SquarePants*, created by Stephen Hillenburg, airs on Nickelodeon.

1999

Facebook is founded.

2004

Ronald D. Moore's *Battlestar Galactica* miniseries debuts on the Sci Fi Channel.

2003

The first volume of *Kill Bill*, written and directed by Quentin Tarantino, is released.

2003

Release of *World of Warcraft*, which will become the most played MMORPG in the world.

2004

The first season of *Lost* airs.

2004

Bulgarian artist Viktor Antonov designs and art directs *Half-Life 2*.

2004

Gallery 1988 opens in Los Angeles. It will become one of the temples of pop culture and lowbrow art.

2004

Creator Mike Mignola's *Hellboy* comic debuts.

1994

The American artist Brom, known for his work at TSR, illustrates the cover of the game *Doom II*.

1994

Raymond Choy founds Toy2R in Hong Kong. The company develops the Qee, one of the first designer toys.

1995

Harry Potter and the Philosopher's Stone by J. K. Rowling is published in England.

1997

The artist John Howe, a specialist of the Tolkien universe, begins illustrating maps of Middle Earth.

1996

Satoshi Tajiri creates the Pokémon franchise for Nintendo.

1996

The French artist Invader installs one of his pixels mosaics on the letter *D* of the famous giant Hollywood sign "to mark the Y2K bug."

1999

Sony launches the PlayStation 2.

2000

Blizard Entertainment releases *Diablo II* for PC.

2000

"Obey Propaganda" exhibit in Los Angeles by Shepard Fairey and Ron English.

2000

The street artist Banksy's first Los Angeles exhibition opens.

2002

The Lord of the Rings: The Fellowship of the Ring, directed by Peter Jackson, is released.

2001

Microsoft releases its first home video game console: the Xbox.

2001

Microsoft launches its Xbox 360.

2005

A poster from the film *Metropolis*, directed by Fritz Lang, is sold at auction for $690,000.

2005

Nintendo revolutionizes video games with the Wii.

2006

Sony launches PS3.

2006

Okami, an adventure game that includes Japanese woodblock-inspired graphics and cel-shading, is launched for PlayStation 2.

2006

Michel Ancel creates *Rayman Raving Rabbids* for Ubisoft.

2006

Portal is released for PC, Xbox, and PlayStation, and creates a revolution in games of skill.

2007

The Dark Knight Rises is released in movies theaters, concluding Christopher Nolan's Batman trilogy.

2012

The Game Story exhibition opens at the Grand Palais in Paris.

2011

Marvel hires Olly Moss, a British artist specializing in the redesign of movie posters, to design the poster for the film *Thor*.

2011

Marvel Studios' *The Avengers*, directed by Joss Whedon, has phenomenal success at the box office.

2012

An exhibition of Tim Burton's artwork and film production materials, which originated at New York's Museum of Modern Art in 2009, opens in Paris and Seoul.

2012

Transformers, directed by Michael Bay, is released.

2007

The first season of *The Big Bang Theory* premieres.

2007

Indie platform game *Braid* debuts. Its pictorial graphics inspired by Impressionism help drive its success.

2008

Markus Persson develops *Minecraft*, a video game that rapidly attained cult status, and was a tribute to pixel and LEGO culture.

2009

The first season of *Game of Thrones*, based on George R. R. Martin's *A Song of Ice and Fire* book series, airs on HBO.

2011

Graphic artist Albert Exergian furthers the minimalist poster trend with his work dedicated to cult TV series.

2010

The exhibition at the Palace of Versailles of Takashi Murakami's work, inspired by manga culture, sparks controversy.

2010

American poster artist Tyler Stout creates the cover of the video game *Sleeping Dogs*.

2012

TO BE CONTINUED . . .

INTERVIEW WITH STEVE SANSWEET

After a successful career in journalism with the *Wall Street Journal* for more than twenty-five years, Steve Sansweet's consuming passion for *Star Wars* eventually caught up to him, and in 1996 he embarked on a radical career change, becoming Lucasfilm Ltd.'s director of specialty marketing, and later its director of content management and head of fan relations. To put it more simply, Steve Sansweet became the ambassador of Lucasfilm for fans worldwide, traveling from conventions to events while remaining very active on the web. While he left the position in 2011, he has nevertheless kept a very active role in the *Star Wars* community. He is the author of more than sixteen books on the *Star Wars* universe, and the owner of the largest private collection of memorabilia associated with the saga, the Rancho Obi-Wan museum in Northern California.

> **"** Geek-Art is a visual
> expression of fandom;
> it is art from the people. **"**

For years, you were the ambassador for the aficionados of the *Star Wars* saga. What did you learn from this long relationship with the fans?

I learned to listen. Very carefully. The terms "fandom" and "geekdom" certainly have a very community-based approach, but the sensitivities and opinions differ from one person to another. Each fan remains a unique personality, and must be treated as such. I also learned that fans often have a very big heart, and sometimes a surprising capacity to help one another.

Does the passion around *Star Wars* differ from one country to another?

Passion is very strong for all fans, regardless of their country. The differences lie in the manner in which they express their passion. In some countries, such as Mexico, the fans especially love creating objects themselves, the drive to "do it yourself" is very pronounced. In Japan, it is mostly in the form of cosplay and buying goods. However, the collector impulse is common to all fans regardless of their country, the only difference being the percentage of collectors relative to the population. In that area, the United States fans are the champions.

Star Wars has now become a modern mythology, but the path to this planetary recognition was not always smooth.

The major difficulty was to give life to this space fantasy straight out of the imagination of George Lucas. The film was rejected by two major studios, and 20th Century Fox only accepted the project because of the trust they had in George as a person. There were subsequently complicated issues such as the budget, difficulties in developing special effects techniques never seen before, and the capacity of Fox to market and communicate around this "UFO project" at that time. But in the end we did it!

Design writer and author Steven Heller has said that he thinks that the illustrations used in the merchandising for *Star Wars* (book covers, toy packaging, etc. . . .) greatly contributed to the popularity of the saga. What do you think?

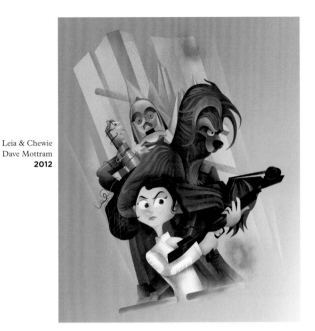

Leia & Chewie
Dave Mottram
2012

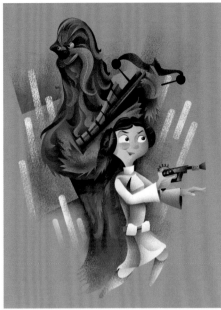

Leia & Chewie
Part 2
Dave Mottram
2012

I firmly believe that if *Star Wars* was implanted so strongly in the global popular culture, it is precisely thanks to its merchandising, artwork included. The original trilogy was released just before the massive influx of VHS tapes, video games, and all these new distractions that have invaded our daily lives. Kids—and adults—who wanted to bring a piece of the film home to recreate the excitement they experienced in the movie theater did so with, among other things, toys and posters.

Initially the art that gravitated around *Star Wars* was an official affair, restricted to professionals. Later, notably thanks to the Internet, this universe was assimilated, recycled, to eventually inspire thousands of artists. What do these tributes and parodies inspire in you?

I believe that Lucasfilm, contrary to many other major media groups, was very clever in the way they managed the fandom over the years (fan art, fan films, parodies . . .). This is one reason why the phenomenon has lasted so long and has remained as powerful as it was thirty years ago. If you have a flaming passion, if you have talent, you too can come play in George Lucas' big sandbox. That said, there is a difference between fan art and imitations.

Do you feel that the fan art has become Geek-Art? What would be your definition of it?

I personally think that being a fan (in the sense that I understand it) is implicitly linked to being a geek. We have merely reclaimed the term that was once derogatory, and we have made a label out of it that we currently are proud to wear. For me, Geek-Art is the intellectual reinterpretation of a commercial world (from a book, a film, a TV series . . .) representing it publicly in a different form, influenced by its own personality, its talent, its aspirations.

ASPÖCK, INGRID

Ingrid Aspöck is a graduate of the University of Applied Arts Vienna and currently lives in Austria, where she works as a freelance illustrator and graphic designer. She draws inspiration from the aesthetics of the 1980s and hours spent in front of her computer. She pays tribute to this era in the Christmas cards she created for her clients in 2010.

WEBSITE: ingrid-aspoeck.at

BLOG: i-doodles.blogspot.com

CONTACT: mail@ingrid-aspoeck.at

Christmas Peace
2010

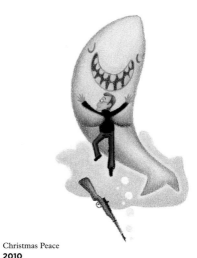

Christmas Peace
2010

> " I guess what intrigues you as a kid stays with you or finds its way back into your life. "

Christmas Peace
2010

Christmas Peace
2010

Christmas Peace
2010

AVANAUT

A freelance illustrator for many years who is also passionate about photography and movies, Helsinki-based Avanaut is renowned in the Geek-Art community for his LEGO *Star Wars* work. His secret to depicting Hoth's snowy atmosphere? He takes his photos in an aquarium.

WEBSITE: flickr.com/photos/avanaut

> " I guess I was a geek to begin with. I recently found an old stash of photos I shot about thirty years ago, including one of a LEGO Y-wing fighter I had built myself. "

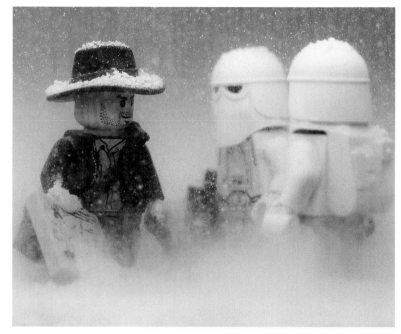

Briefing on Hoth
2009

Damn It, Marcus!
This Ain't the Map of Nepal
2009

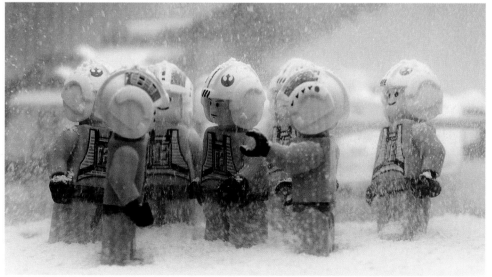

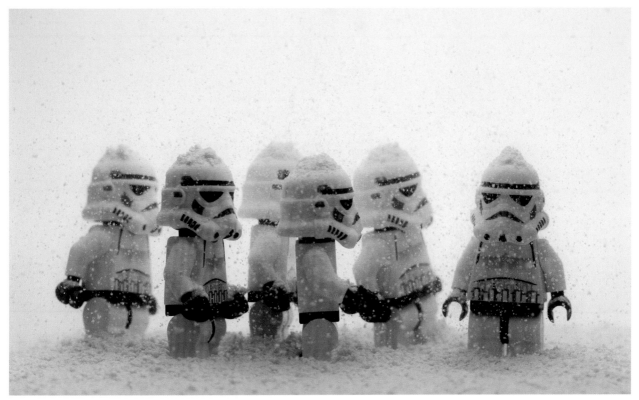

Guys, I Think We Took
a Wrong Turn Somewhere
2009

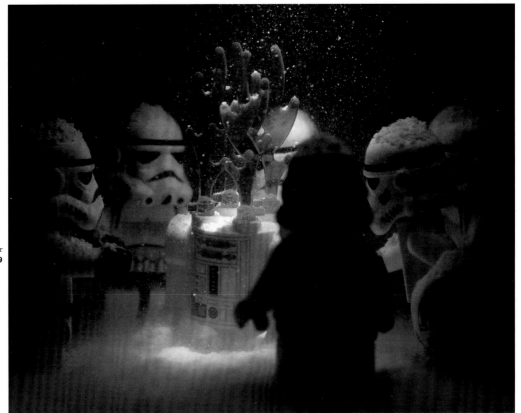

Stormtroopers' Perpetual Winter
2009

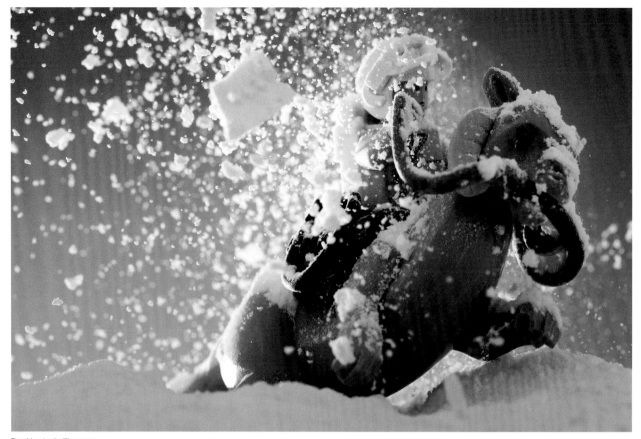

Breaking in the Tauntaun
2010

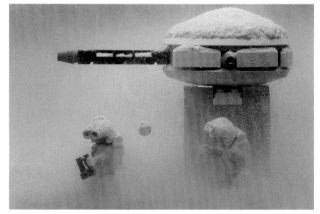

The Inconvenient Flaw
of the Y-wing
2009

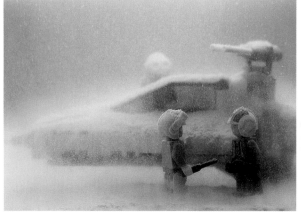

The Long and Winding Days
on Echo Station 3-T-8
2009

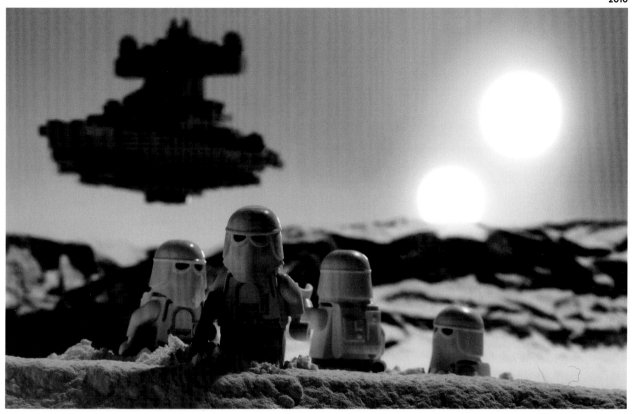

The Derelict
2011

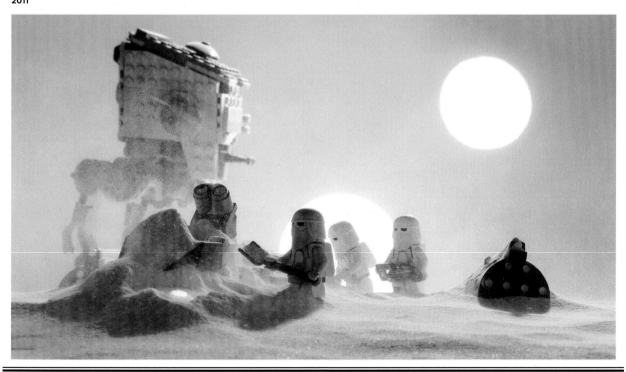

AWESOME, ANDY

Andy Awesome, also known as Jan Schlösser, lives in Munich, Germany. As a kid in the 1990s, he grew up with the TMNT, Super Mario, and other characters of the era. When he was young, his mother took him on a painting excursion in France and Italy. Now he enjoys rendering his childhood heroes in circles.

WEBSITE: andyawesome.com

BLOG: 3x9.org

CONTACT: hello@andyawesome.com

忍者豆 Series 01-ID01
2009

英雄 Series 01-ID05
2009

Series 01-ID13
2009

パックマン

スポンジ

脂肪怠惰なろくでなし (partial)

脂肪怠惰なろくでなし 😎
Series 01-ID18
2009

ネアンデルタール人 😎
Series 02-ID02
2010

> **" I hope my work
> helps others
> remember
> their wonderful
> childhoods. "**

ロボット 😎
Series 02-ID04
2010

ウォリアーズ [1] 😎

Series 02-ID19
2010

ゴーストハンター 😎

Series 02-ID01
2010

チーム 😎

Series 02-ID10
2010

セサミストリート

おもちゃ

Series 02-ID21
2010

将来の家族

Series 01-ID19
2009

BALL, ROBERT

Illustrator by day and supergeek by night, Robert Ball lives and works in London. Fascinated by *Star Wars*, Marvel comics, and *2000 AD* since his childhood, he uses his geometric graphic style to serve his favorite heroes.

WEBSITE: robertmball.com

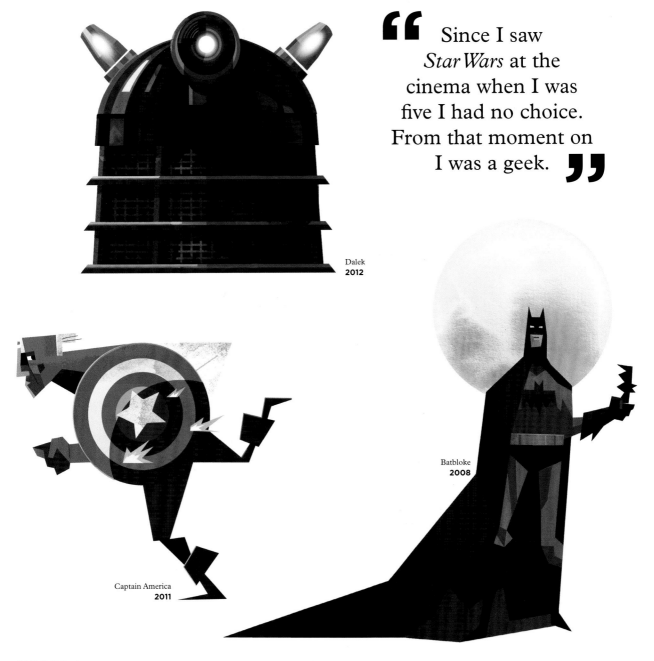

> **"** Since I saw *Star Wars* at the cinema when I was five I had no choice. From that moment on I was a geek. **"**

Dalek
2012

Captain America
2011

Batbloke
2008

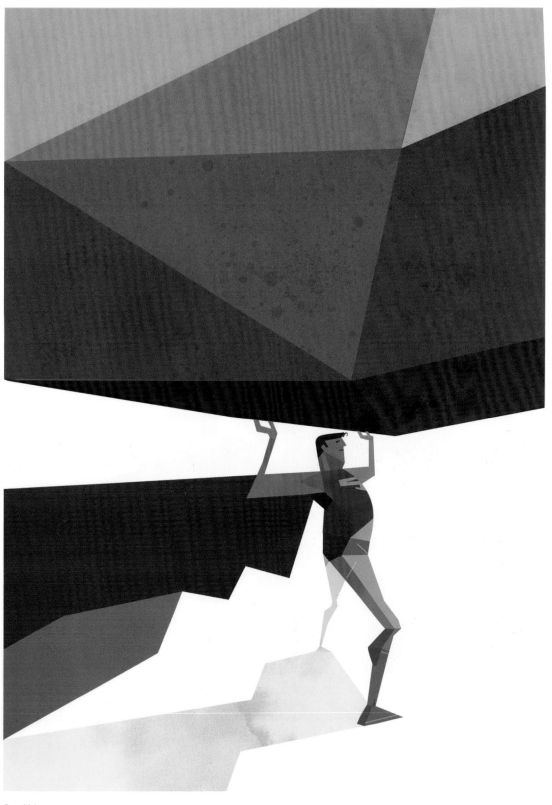

Superbloke
2011

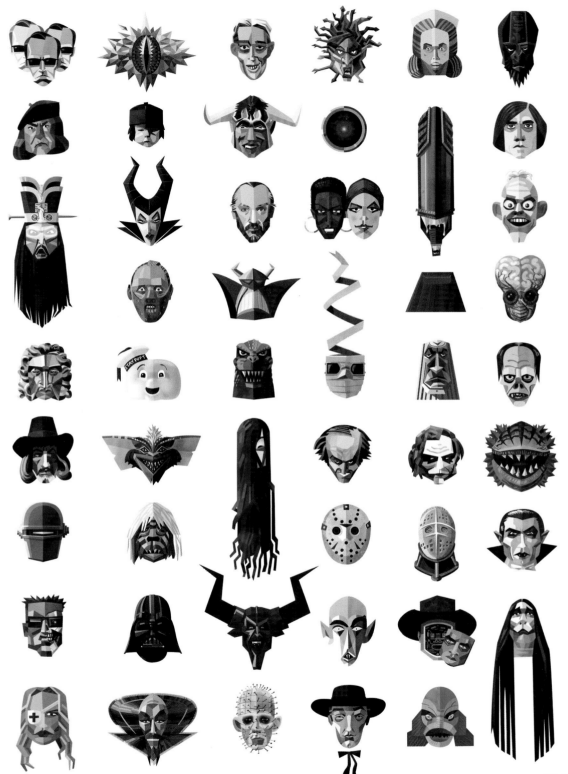

Fifty Baddies
2011

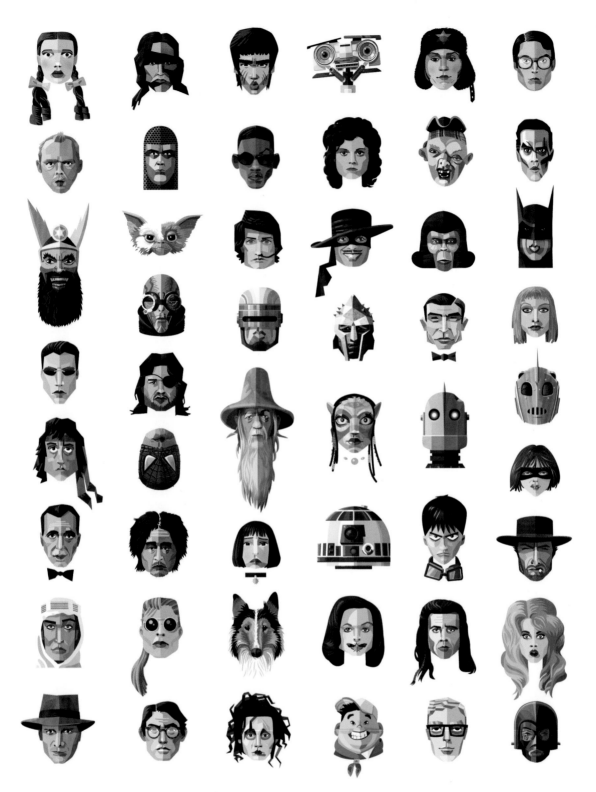

Fifty Goodies
2011

BARKLA, NICKY

Melbourne-based artist Nicky Barkla has essentially banned black and white from her work, and she appreciates the evil and weird characters of geekdom for the opportunity to make them less dark. For her, "Using iconic characters is not about stealing someone else's idea. It's about appreciating the characters that have been around for a long time, and will live on forever."

WEBSITE: nickybarkla.com

CONTACT: nickybarkla@live.com

Darth Maul
2012

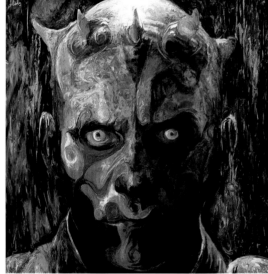

> " It's like putting a party hat on Darth Vader and telling him to cheer up. "

The Joker
2012

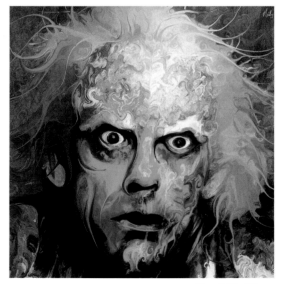

Emmett "Doc" Brown
2011

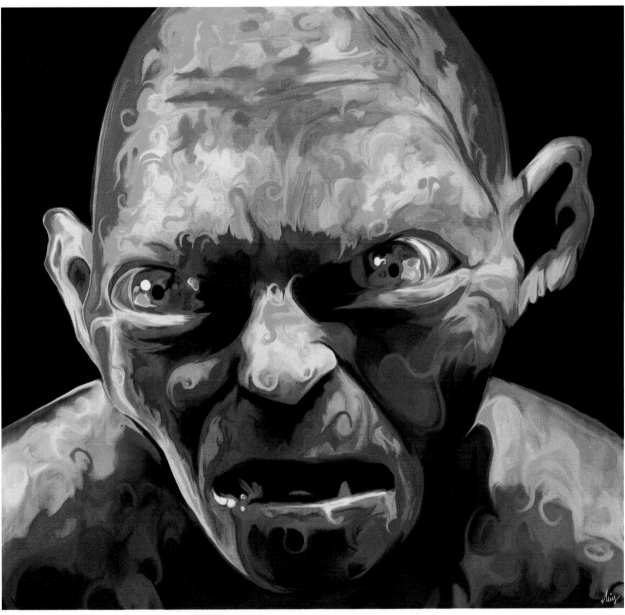

Gollum
2011

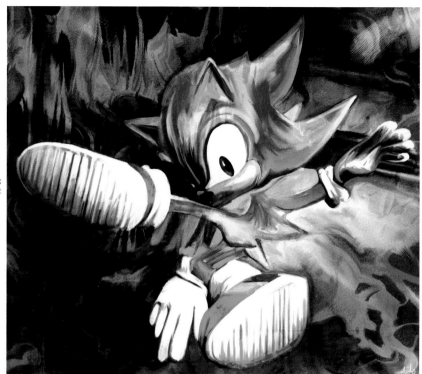

Sonic the Hedgehog
2012

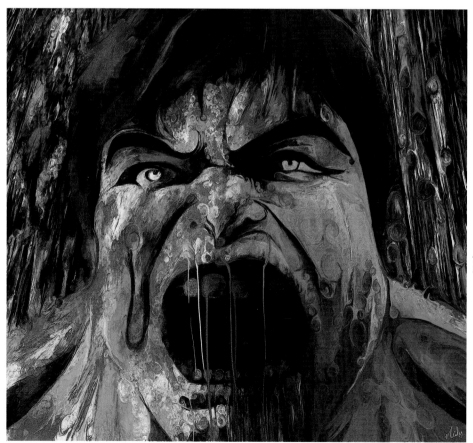

The Incredible Hulk
2012

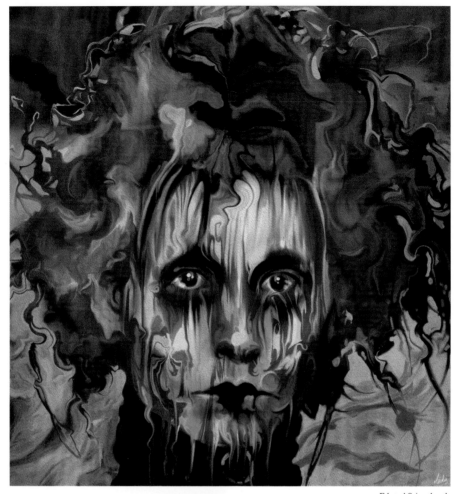

Edward Scissorhands
2011

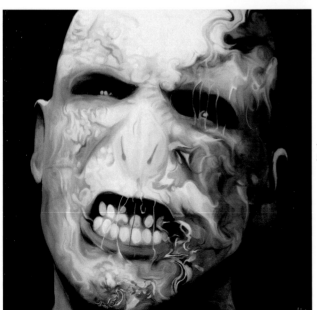

Voldemort
2012

BEYX

Beyx grew up in Connecticut, where her love for video games, movies, and television forged her geek identity. She now lives in New York City.

WEBSITE: beyx.tumblr.com

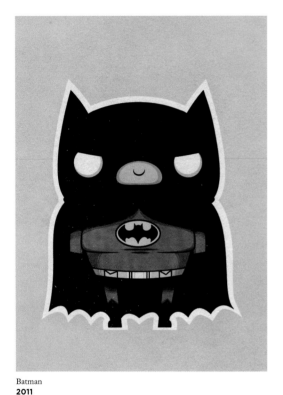

Batman
2011

TMNT
2011

Wallmaster
2011

" As I grew up I found that well-written stories, deep universes, and complex characters reign supreme! "

Boo!
2011

Mario Suits
2011

Bubble Bobble
2011

 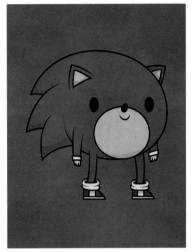

Sonic Dudes
2011

Clown Car
2011

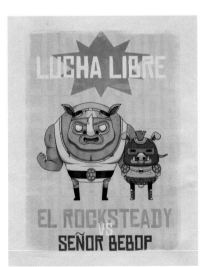

Luchadores
2011

BIALIK, STEVE

Steve Bialik lives in New York and has two passions: *Star Wars* and Asian art. In light of the influence George Lucas has identified in his own work drawn from samurai movies of the 1950s and 1960s, Bialik's work makes perfect sense.

WEBSITE: stevapalooza.blogspot.com

CONTACT: sdbialik@gmail.com

The Gangster
2010

Invasion of the Death Palace
2010

The Admiral
2010

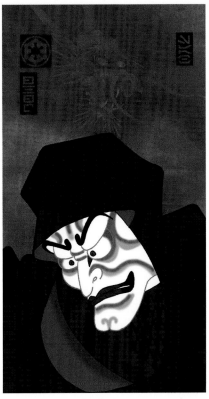

The Emperor
2010

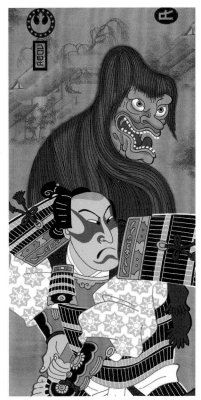

The Smuggler
2010

Robots
2010

" Comic books, video games, fantasy, and science fiction . . . Now that there's no longer the stigma of these things being childish, people are free to enjoy them as much as they like. **"**

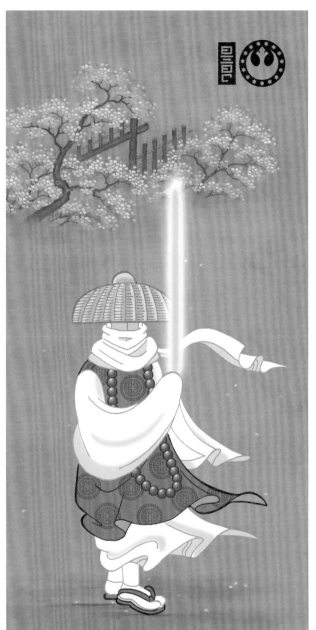

The Master
2010

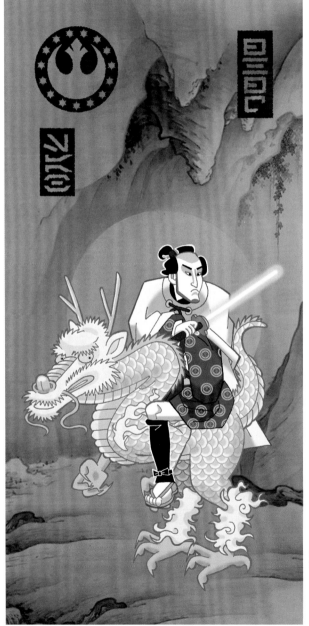

Spacewalker
2011

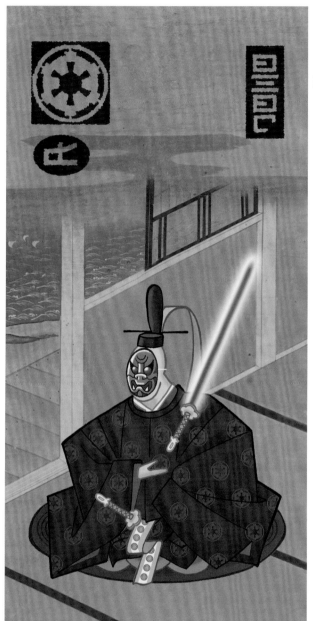

Akuma
2010

The Hermit
2010

BIGGERS, BARRETT

Barrett Biggers is a self-taught artist with a degree in biology. His main sources of inspiration are H. R. Giger, Yoshitaka Amano, and Hayao Miyazaki. He lives and works in Florida.

WEBSITE: barrettbiggers.com

CONTACT: contact@studiomuku.com

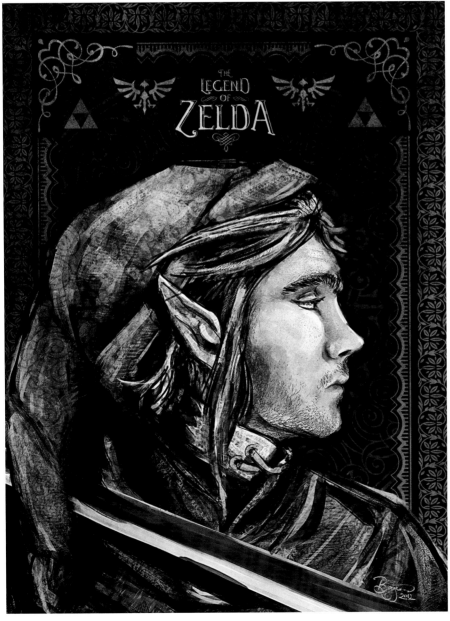

Proud Link Geek
2012

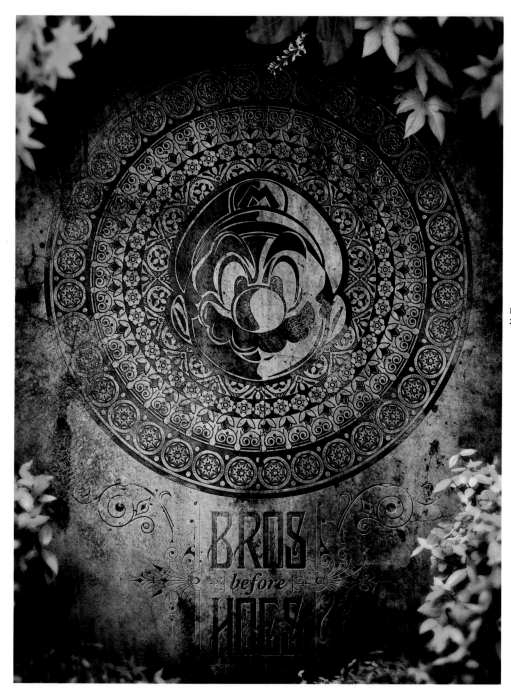

Here Lies Mario
2012

 We are all geeks
deep down.

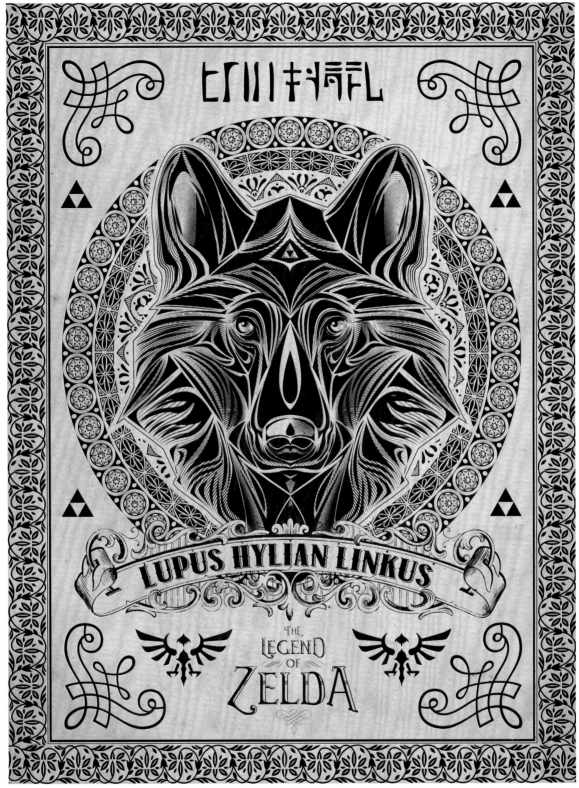

Lupus Hylian
2012

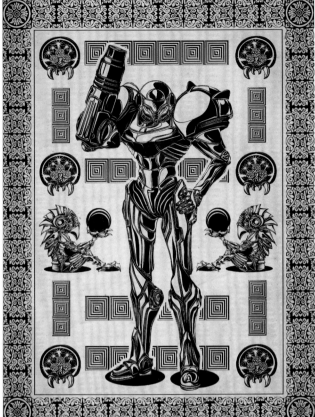

Samus Aran and
the Metroid
2012

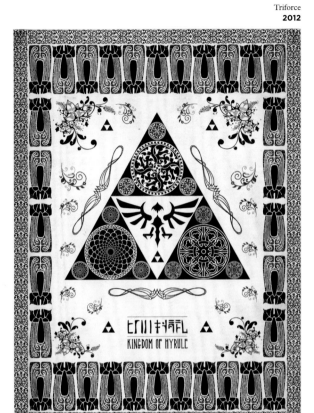

Triforce
2012

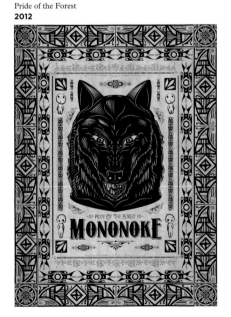

Pride of the Forest
2012

Hylian Shield
2012

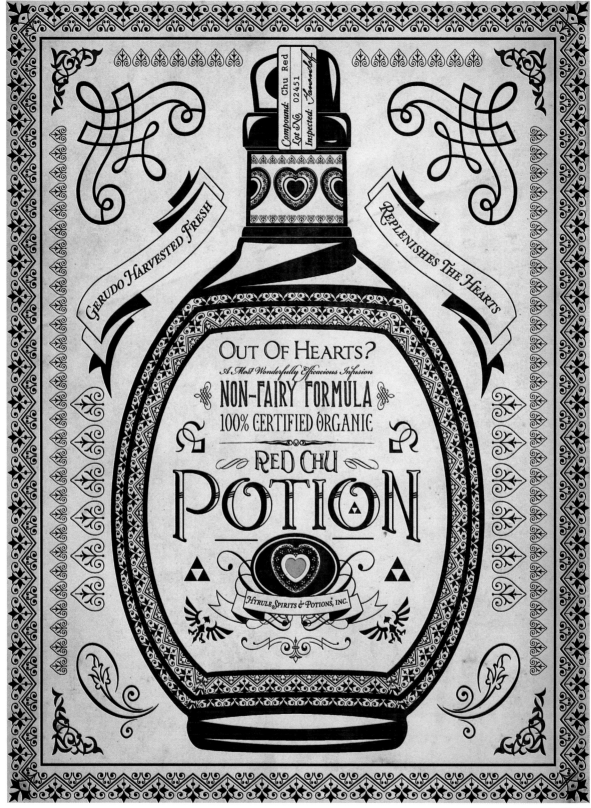

Red Potion
2012

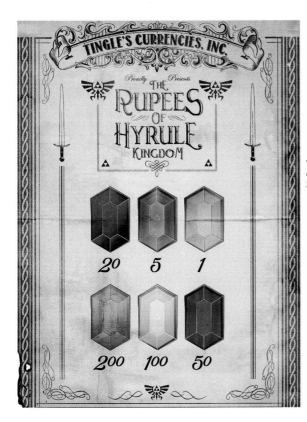

Tingle's The Rupees
of Hyrule Kingdom
2012

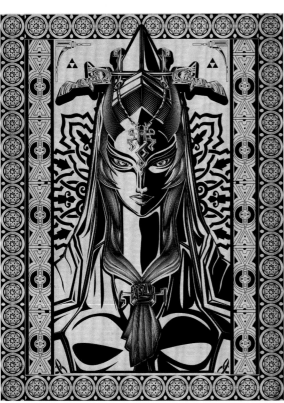

Midna
2012

BONEFACE

Boneface likes to say he comes from another dimension. His secret lair is now located somewhere in the wastelands of Liverpool, England. His work has been shown in cities around the world, including San Francisco and Sydney, and is inspired by Marvel comics and 1950s pulp art.

WEBSITE: boneface.co.uk

BLOG: bone-face.blogspot.com

CONTACT: contact@boneface.co.uk

" Just don't ask what's underneath their masks. **"**

"Crack!"
2011

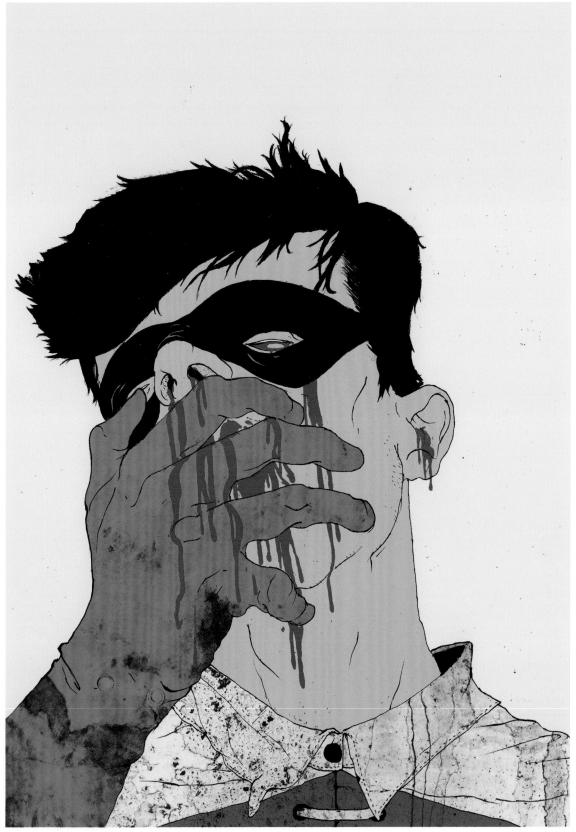

"Zing!"
2011

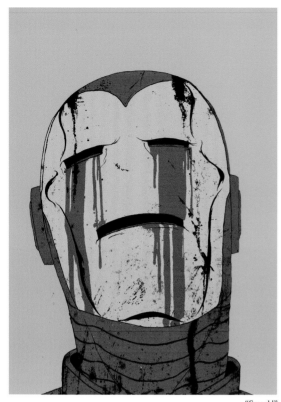

"Smack!"
2011

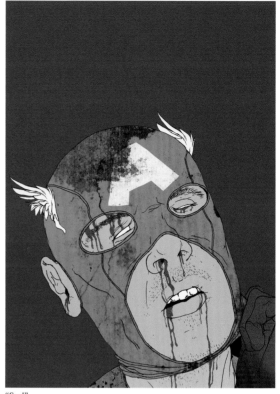

"Soc!"
2011

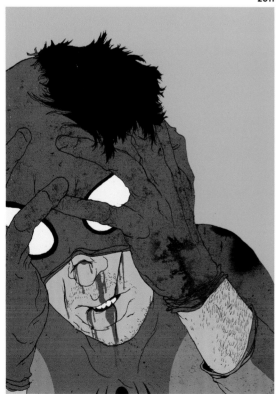

"Thudd!"
2011

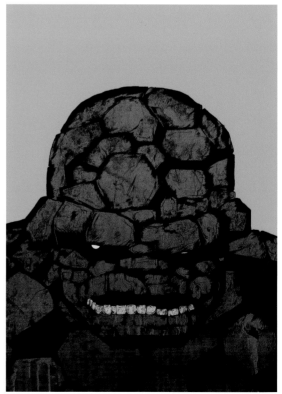

"Whump!"
2011

Over My Dead Body
2011

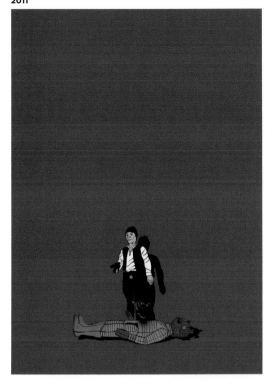

I Have the Power
2011

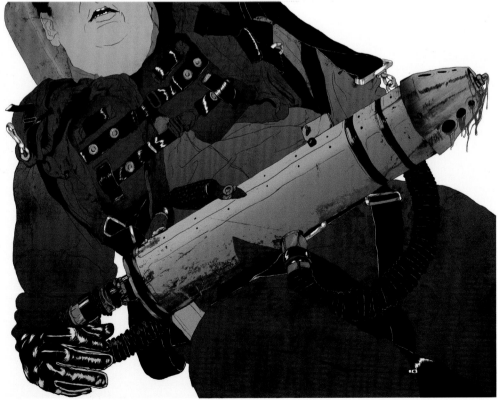

Ghostbusters 2
2011

BRAMBILLA, FRANCO

Franco Brambilla is a prolific Italian illustrator living in Milan. He has created dozens of illustrations centered on science fiction, the most popular of which are in his "Invading the Vintage" series, wherein sci-fi heroes and icons inhabit antique postcards.

WEBSITE: francobrambilla.com

CONTACT: brambilla.franco@gmail.com

" I grow up in the '70s and '80s . . . sci-fi was everywhere. **"**

Our Lord of Darkness
2008

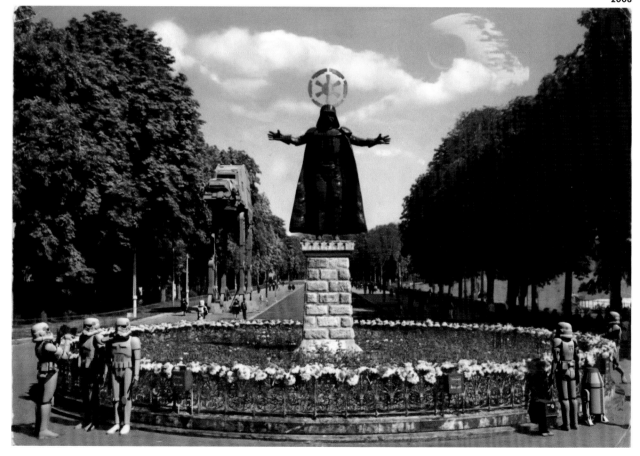

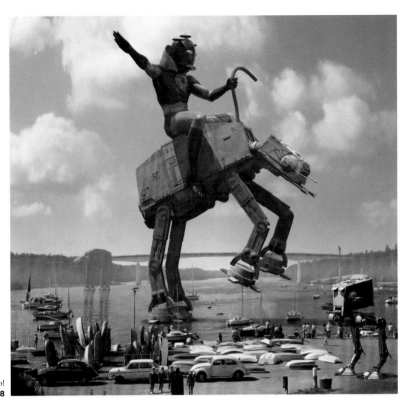

Imperial Rodeo!
2008

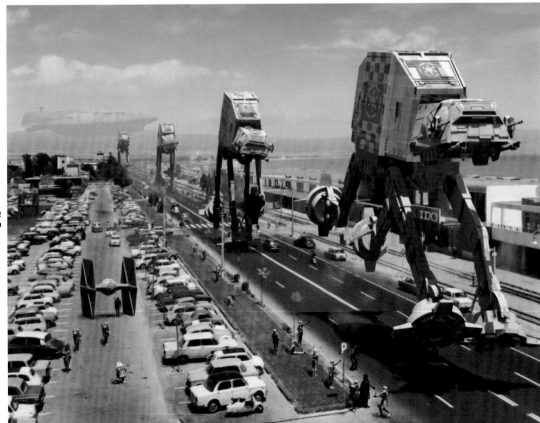

AT-AT Lido Cup!
2009

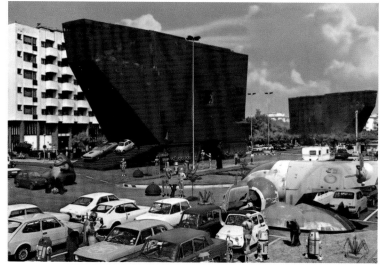

We Sell Used Cars and Droids ...
2008

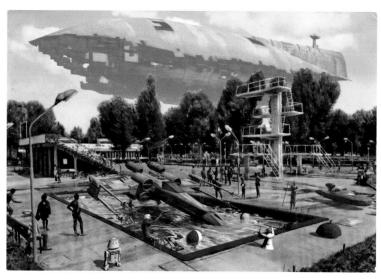

Dagobaths au Printemps!
2009

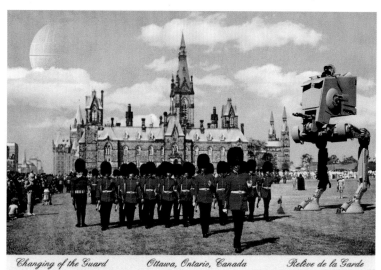

Changing of the Guard
2011

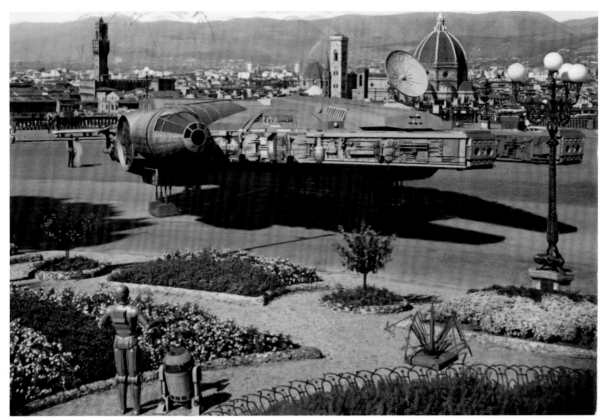

Millennium Honeymoon Florence!
2010

Millennium Honeymoon Benevento
2010

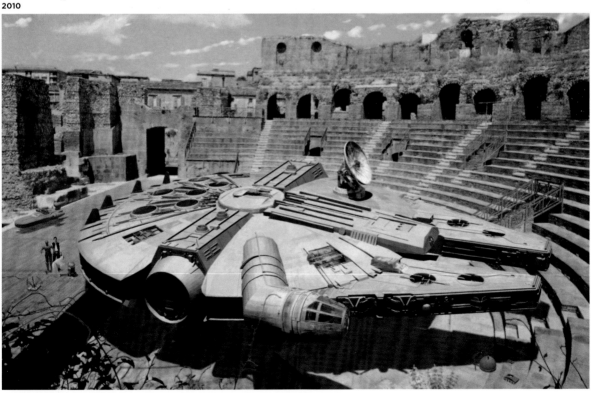

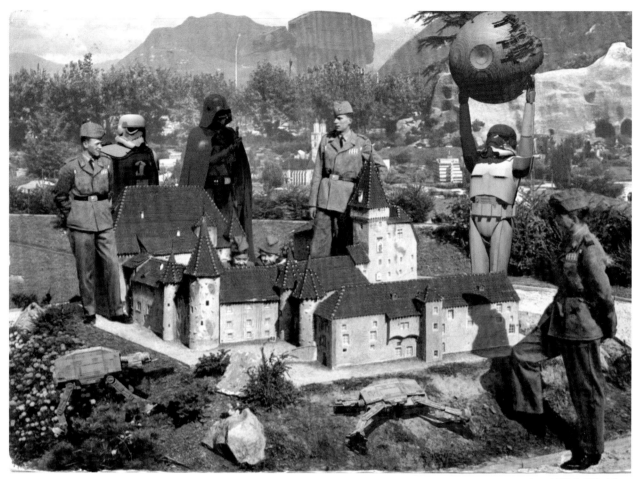

Imperial Minigolf Final Exam
2010

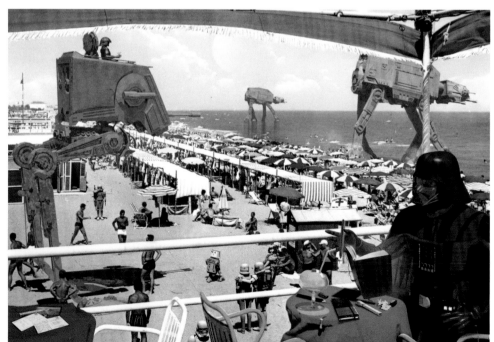

I Hate Summer
2011

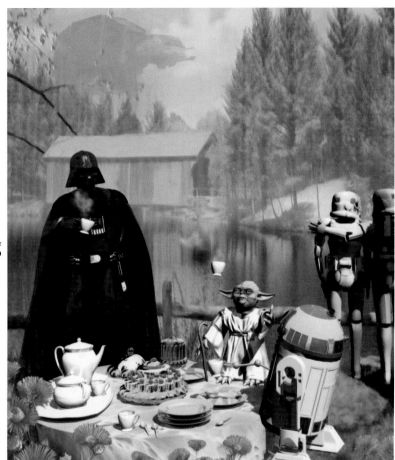

The Galactic Tea of Love
2010

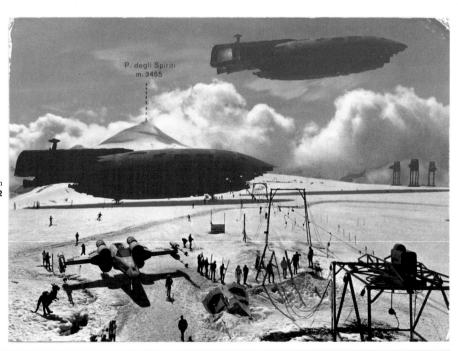

Hoth Pleasures ... Last Ski Run
2012

BRAZIER, LIAM

Liam Brazier began to draw when he was a child, and he's grateful that continuing on with these early scribbles has allowed him to make a living from his art. Inspired by his memories and pop culture, he lives in London.

WEBSITE: liambrazier.com

CONTACT: contact@liambrazier.com

Guard
2011

Cave Man
2011

Dark Lord
2011

Man Up
2011

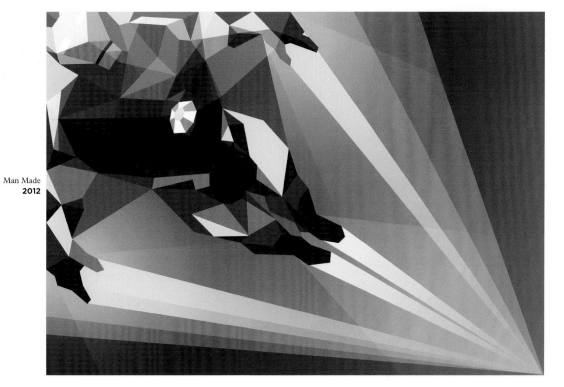

Man Made
2012

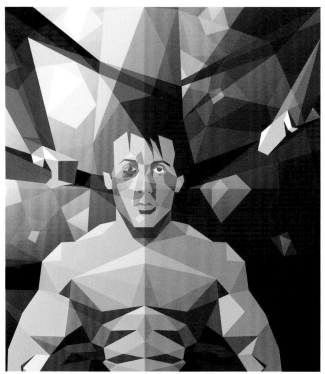

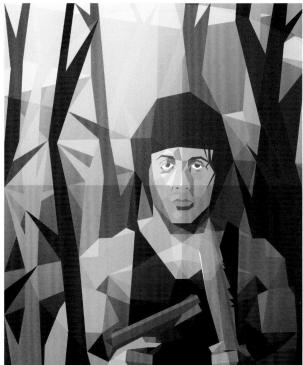

R & R
2012

Bounty Hunter
2011

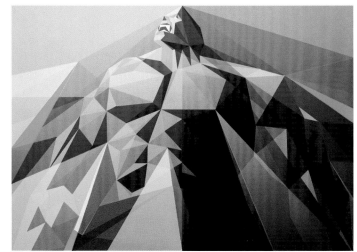

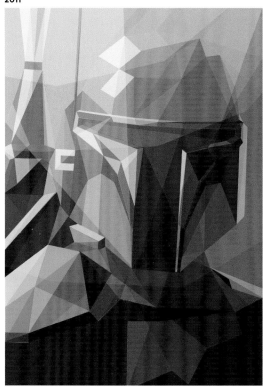

Mad Man
2011

> ❝ I draw what I love because it comes easiest, is the most fun, and is built on thirty-plus years of memories and enjoyment. ❞

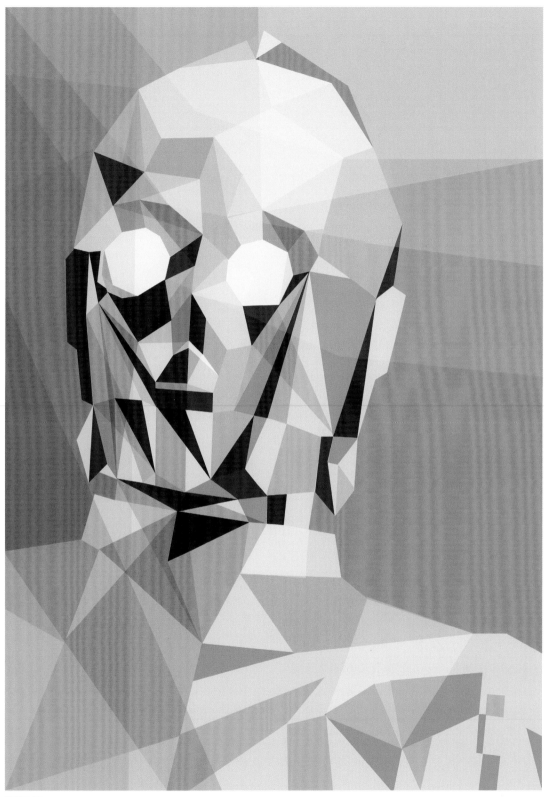

Golden One
2011

Brazier, Liam **69**

BROGAN, GLEN

Glen Brogan is an American illustrator based in Huntington, West Virginia. His body of work draws on pop culture, and he enjoys working in his own cartoon-inspired style. His drawings and apparel designs have been featured in galleries worldwide.

WEBSITE: albinoraven.com

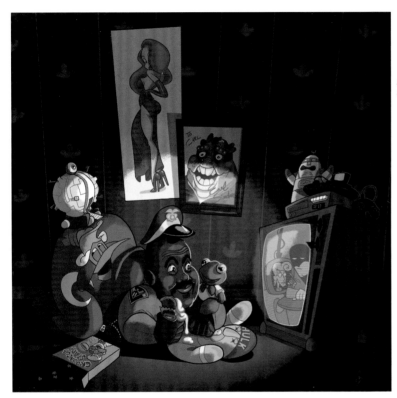

As Days Go By
2010

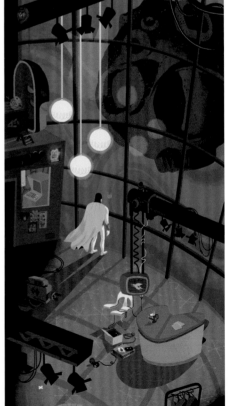

Are You Getting Enough Oxygen?
2011

> **“** Most people reach a point when they decide they're too old for cartoons, but for whatever reason I have yet to reach that point. **”**

Bottled Fairy
2011

Daylight Come
2011

The Great Shelled Dragon
2011

Super Hellboy Bros
2010

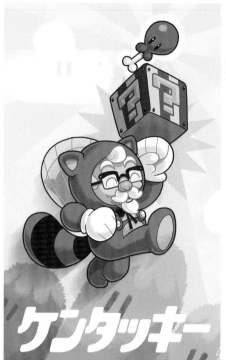

KFC Mario
2010

ケンタッキー

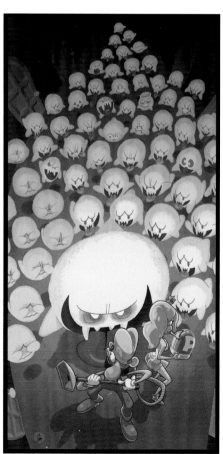

The Blue Door
2010

Big Apple, 3 am
2011

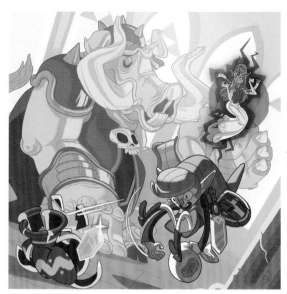

The Legend of Zelda
2011

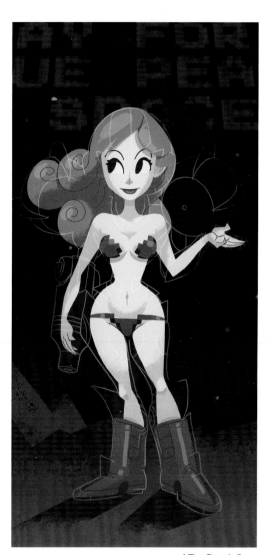

A True Peace in Space
2010

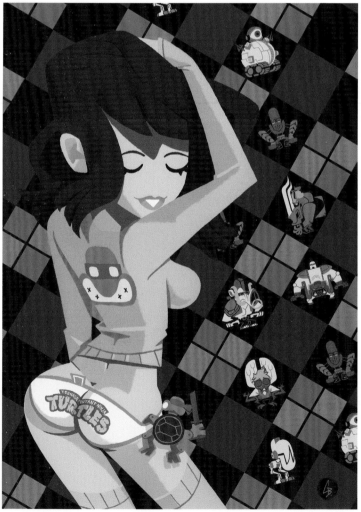

April Fools
2011

BRUNET, JÉRÉMIE

Jérémie Brunet is a French art director who lives in Paris. Nordic design, 1960s vintage design, and the minimalist movement are his main influences. When not working on ad campaigns, he spends his free time combining his passions for design and Geek-Art.

WEBSITE: behance.net/imerj

CONTACT: imerj@me.com

FLAT HEROES—Dardevil
2011

FLAT HEROES—Iron Man
2011

> **"** To me, Geek-Art is a way to have fun with the iconic characters of my childhood. **"**

FLAT HEROES—Superman
2011

FLAT HEROES—Batman
2011

FLAT HEROES—Cyclops
2011

FLAT HEROES—Venom
2011

FLAT HEROES—Human Torch
2011

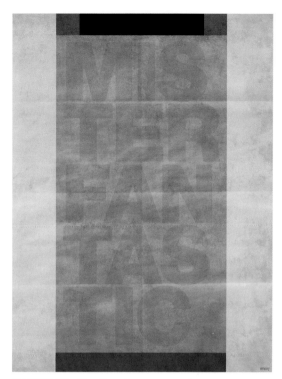

FLAT HEROES—Mister Fantastic
2011

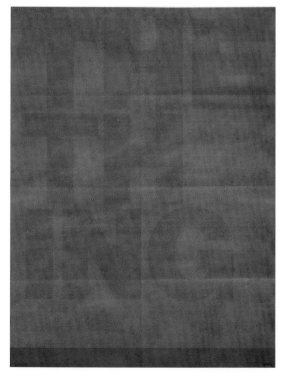

FLAT HEROES—The Thing
2011

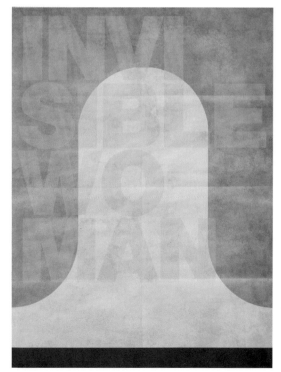

FLAT HEROES—Invisible Woman
2011

BURLINSON, JAMES

James Burlinson is a British illustrator and designer living in Brighton, England. He remembers drawing his favorite heroes from an early age, copying the characters from cereal boxes. Now his unique style allows him to fulfill his fanboy urges while making a living from his art.

WEBSITE: burlisaurus.co.uk

BLOG: burlisaurus.tumblr.com

> ❝ To me the word *geek* signifies a person that's just really interested in something, usually a thing that's not for everyone. ❞

Pug Fuel (Men in Black)
2011

Mogwai (Gremlins)
2011

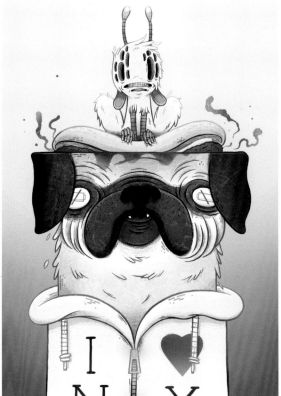

Mario Machine
(Super Mario)
2011

Z (Legend of Zelda)
2012

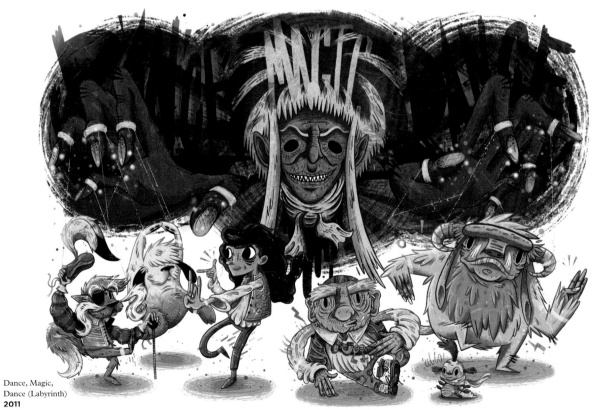

Dance, Magic,
Dance (Labyrinth)
2011

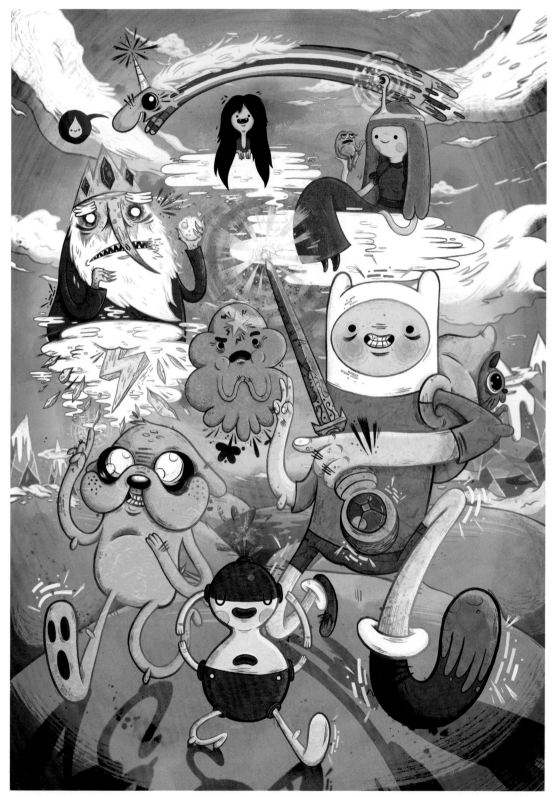

Time for Adventure (Adventure Time)
2011

BUTLER, EMMA

Born in New Zealand, graphic designer Emma Butler now lives and works in Canada. She's inspired by typography, and her current influences include the work of Jessica Hische, Jay Roeder, and Saul Bass. Seeing minimalist poster designs online prompted her to create poster designs of her own.

WEBSITE: emma-butler.com

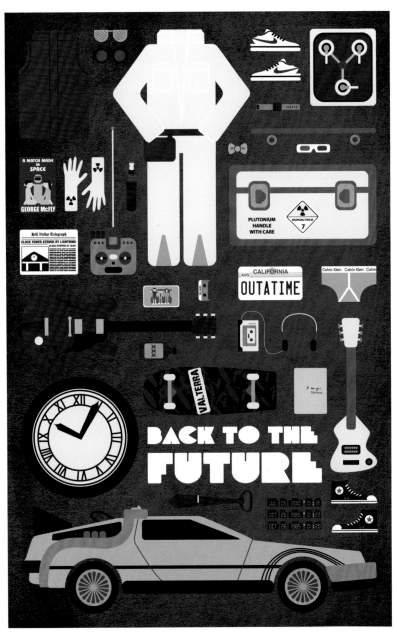

" Once I had the style down, the challenge was to think of all the "parts" to include, a challenge that ended up being half the fun of the whole design process. **"**

Back to the Future Movie Parts Poster
2011

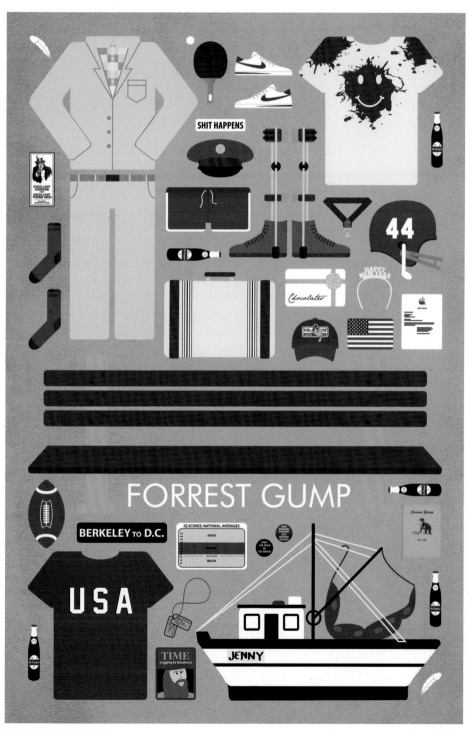

Forrest Gump Movie Parts Poster
2011

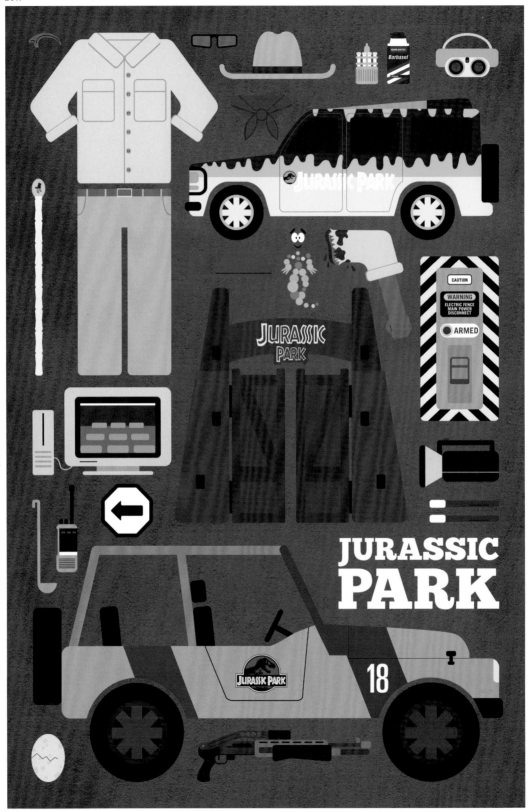

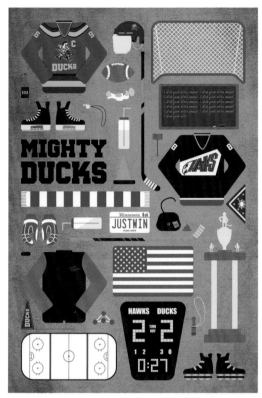

Mighty Ducks Movie Parts Poster
2011

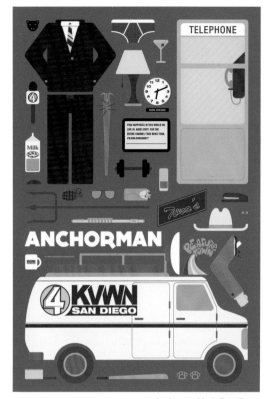

Anchorman Movie Parts Poster
2011

Juno Movie Parts Poster
2011

Top Gun Movie Parts Poster
2011

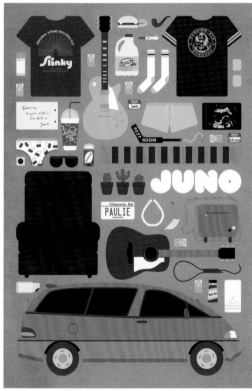

CASSINELLI, HORACIO

Horacio Cassinelli was born in Montevideo, Uruguay, but moved to France twenty years ago. After earning a degree in fine arts, he has created intimate works that have been exhibited worldwide. A workaholic and a chameleon, he applies his talents to such various practices as illustrating children's books, designing graphics for Air France, and crafting layouts for art books.

WEBSITE: horaciocassinelli.com

CONTACT: hcassh@hotmail.com

Manga Eyes
2011

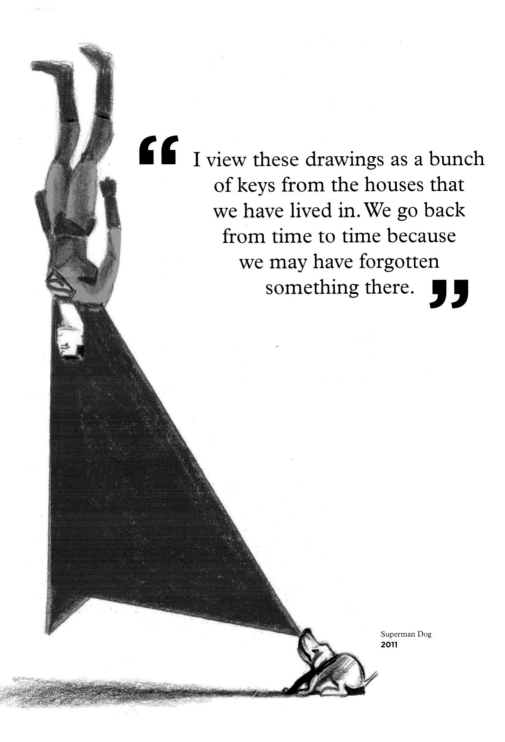

> " I view these drawings as a bunch of keys from the houses that we have lived in. We go back from time to time because we may have forgotten something there. "

Superman Dog
2011

Carré
2010

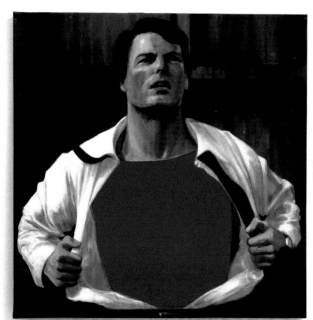

Bleu Clark
2010

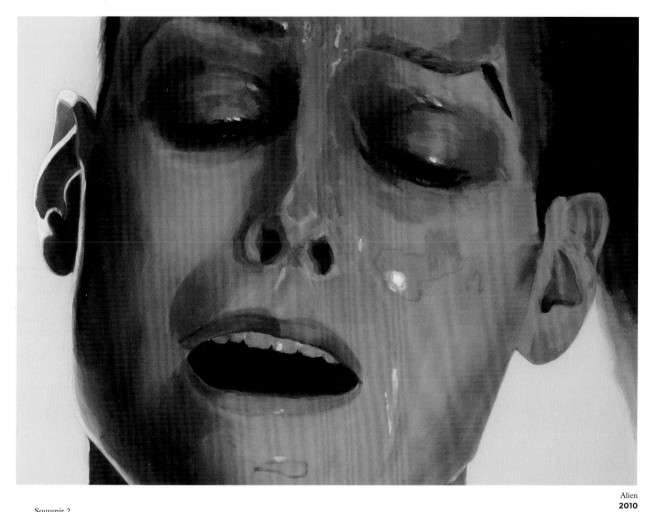

Alien
2010

Souvenir 2
2012

Souvenir 1
2012

CHOW, STANLEY

Long fascinated by Panini stickers, British designer Stanley Chow counts them among his main sources of inspiration. Like many artists, he grew up in the midst of geek culture. His illustrations appear frequently in magazines such as *The New Yorker*, and his work for The White Stripes was nominated for a Grammy in 2008.

WEBSITE: stanleychowillustration.com

CONTACT: info@stanleychow.com

Ripley
2012

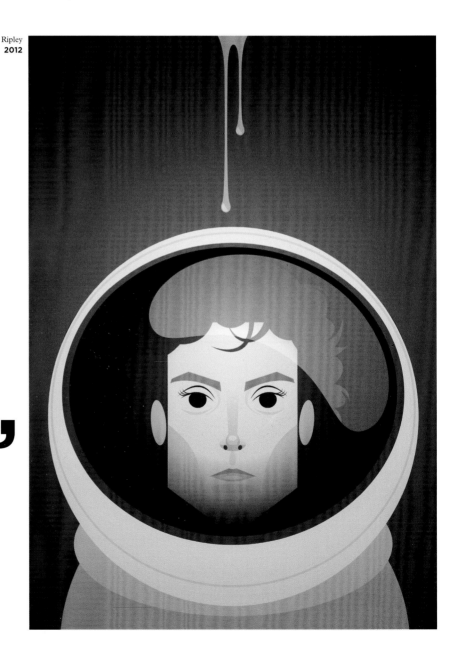

" Ever since I was a kid, I've always loved Superheroes . . . I used to have a Superman bedroom with Superman curtains and wallpaper. I even used to wear Superman underpants. **"**

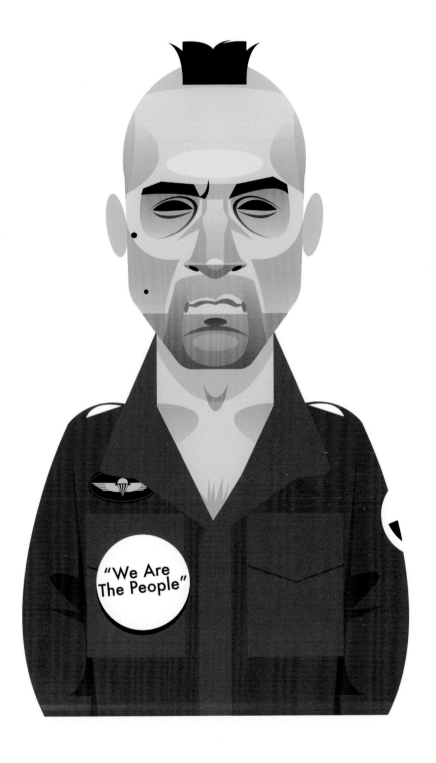

Travis Bickle
2011

He-Man/Made in Hong Kong
2010

Walter White
2011

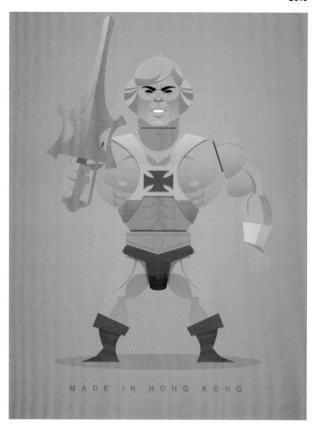

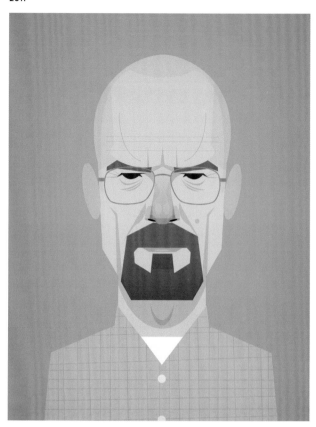

Honey Ryder
2011

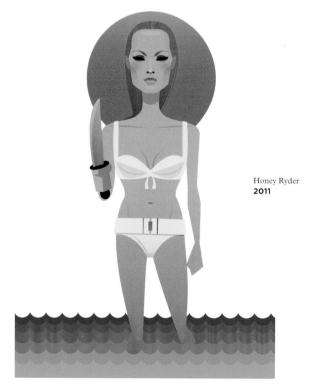

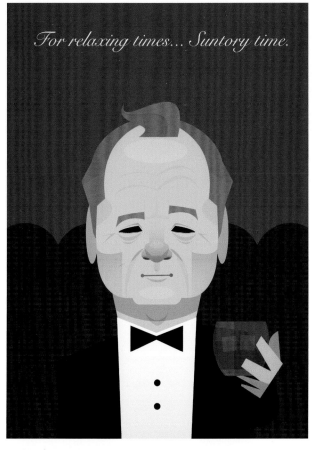

Bill Murray / Suntory Time
2010

For relaxing times... Suntory time.

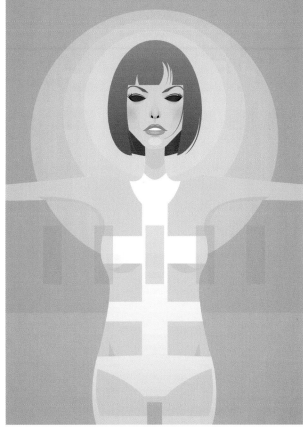

Leeloo
2010

Clark Kent
2011

TELEPHONE

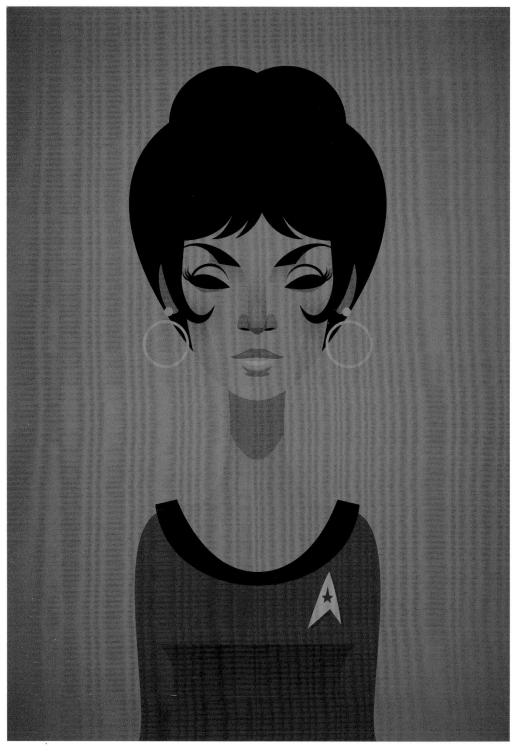

Uhura
2011

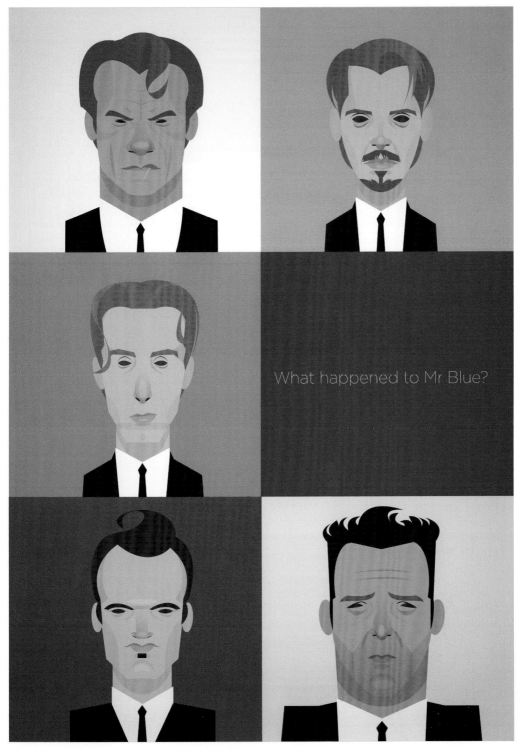

What Happened to Mr Blue
2010

CIRAOLO, FABIAN

Fabian Ciraolo was born in Chile and he lives and works in Santiago. His illustrations merge fantasy, pop culture, and sci-fi on an astral background. Taking his characters from old cartoons and fairy tales, his creations are at once an ode to the past and a futuristic dream.

WEBSITE: fabciraolo.com

BLOG: fabianciraolo.blogspot.com

CONTACT: fabciraolo@gmail.com

Skeletor
2012

Birdman
2012

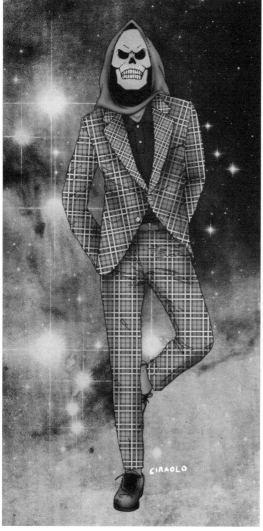
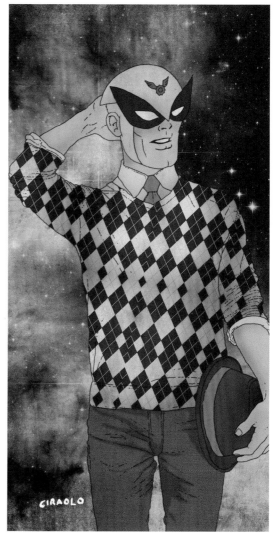

> " My mind is like a sponge, waterlogged with icons and images. I love mixing older things with recent ones and breathing a new life into all of those old characters. "

Thundergirls
2012

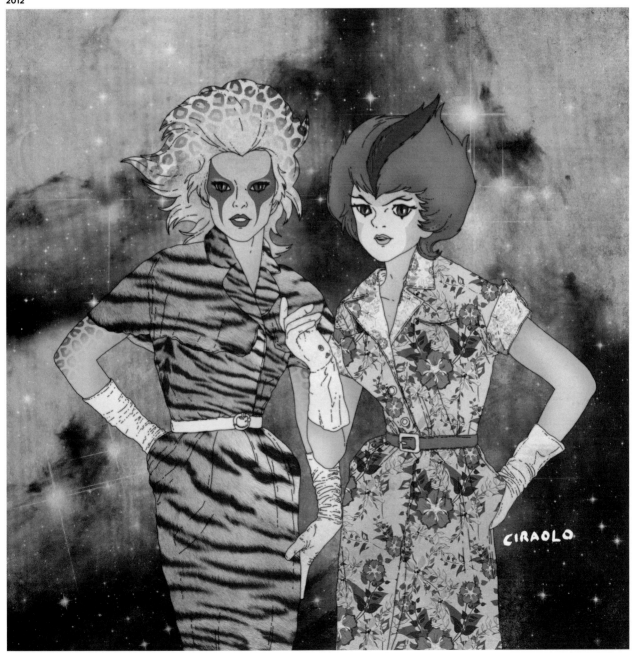

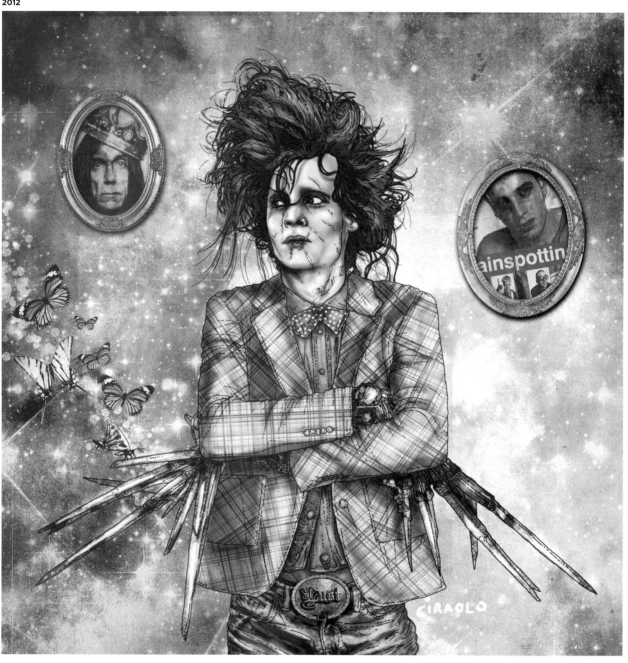

Jem
2012

Sorceress
2012

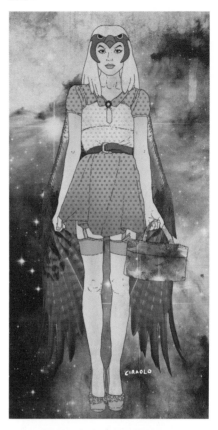

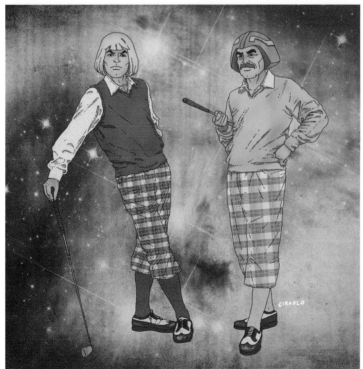

He-Man & Man-at-Arms
2012

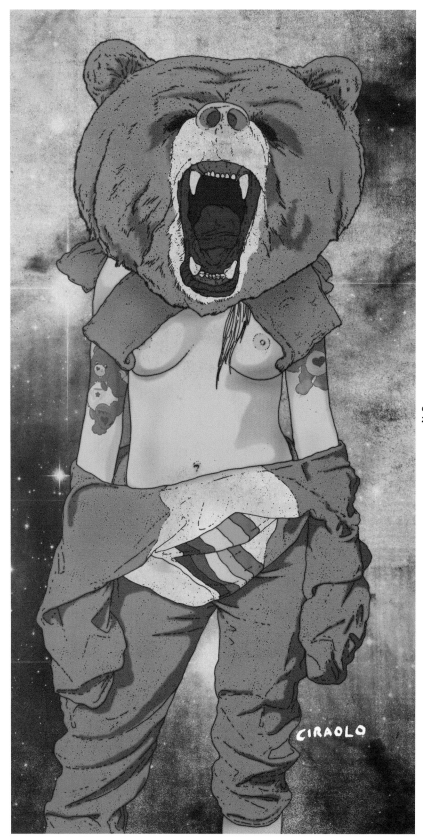

Care Bears
2012

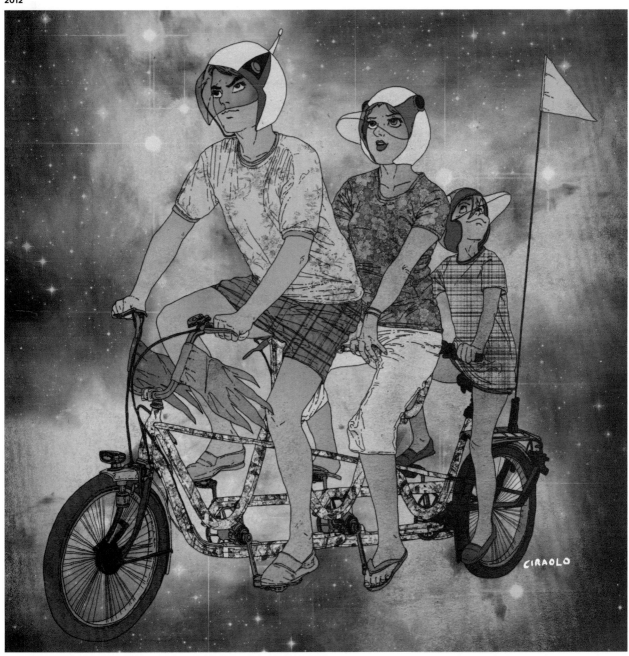

DE FREITAS, ANDRE

Andre De Freitas is a photographer and illustrator who lives and works in Lima, Peru. He has a degree in computer animation from Full Sail University, but paradoxically, he has directed his Geek-Art passion toward depicting more motionless subjects.

WEBSITE: andredefreitas.com

BLOG: andredefreitas.tumblr.com

CONTACT: andre.dft@gmail.com

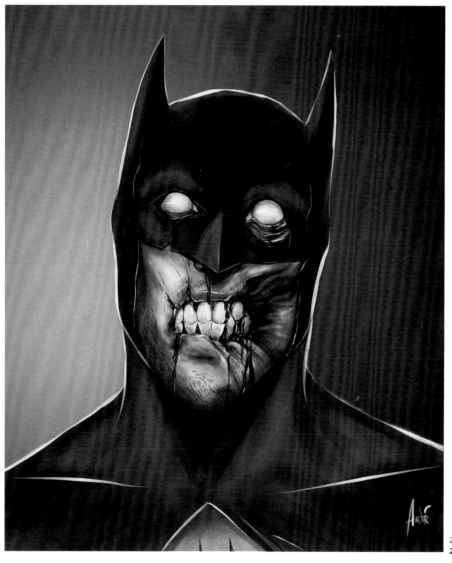

Zombie Batman
2010

> **"** Instead of just drawing, I try to imagine myself taking photos of my subjects. **"**

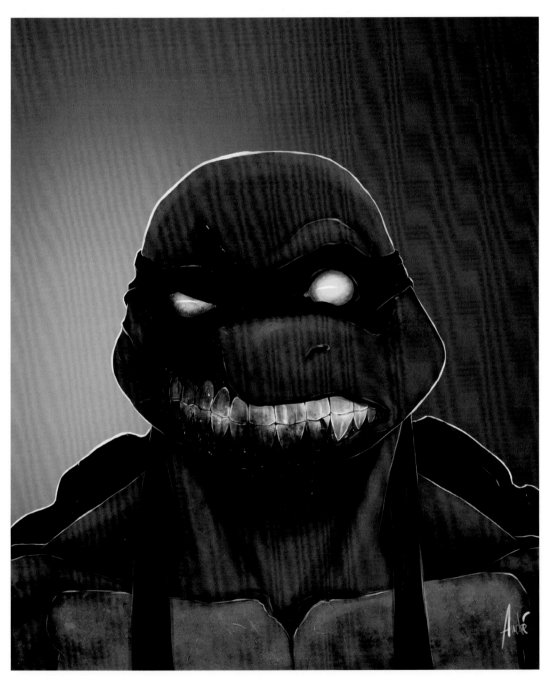

Zombie Raph
2010

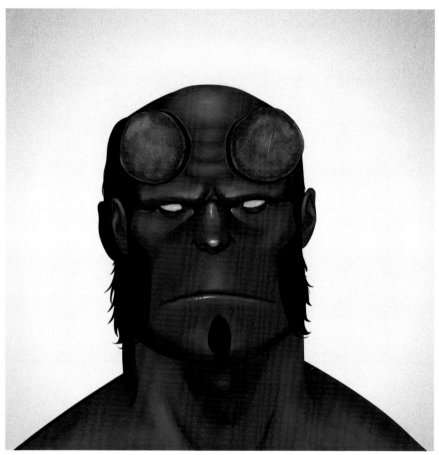

Anung Un Rama
2012

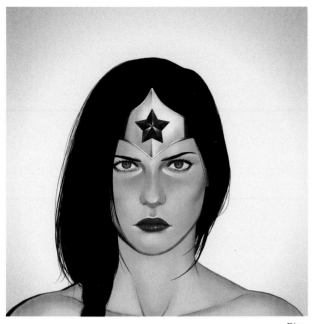

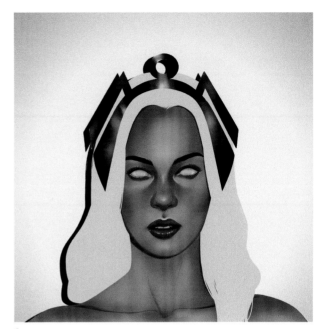

Diana
2012

Ororo
2012

Victor
2012

Barbara
2011

DE STEFANO, GREG

As a photographer who lives and works in Los Angeles, Greg De Stefano has the opportunity to take many pictures of his favorite subject: Geekdom. Defining himself as a "geek at heart," he loves blending his passion and technology, and expresses his art through exhibitions, cosplay, and social events.

WEBSITE: gregdestefano.com

CONTACT: greg@gregdestefano.com

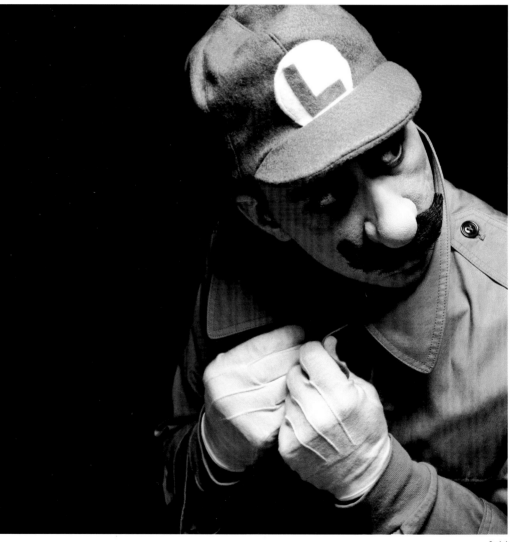

Luigi
2009

> **"** I grew up with video games and computers.
> I was lucky enough to meet a group of cosplayers in L.A.,
> with whom I created the series Brawl,
> and I want to thank them. **"**

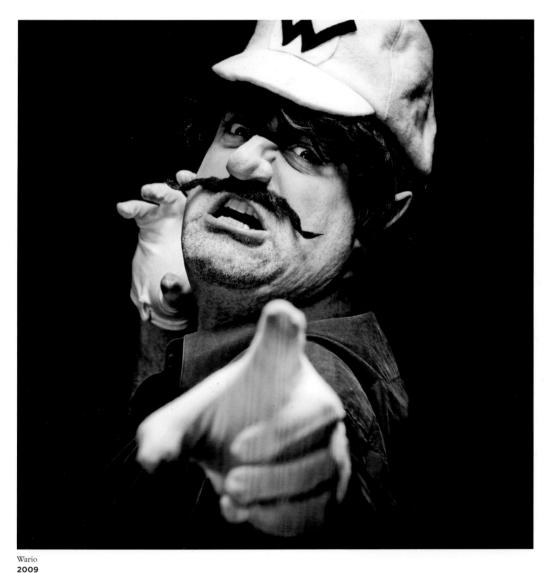

Wario
2009

Star Fox
2009

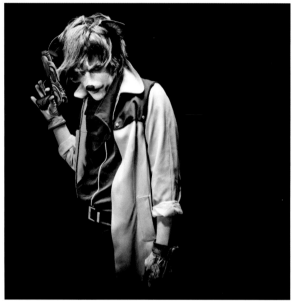

Rosalina
2009

End of Days
2009

Peach
2009

Saria
2009

Police Chief Link
2009

Ganon
2009

Pauline & Donkey Kong
2009

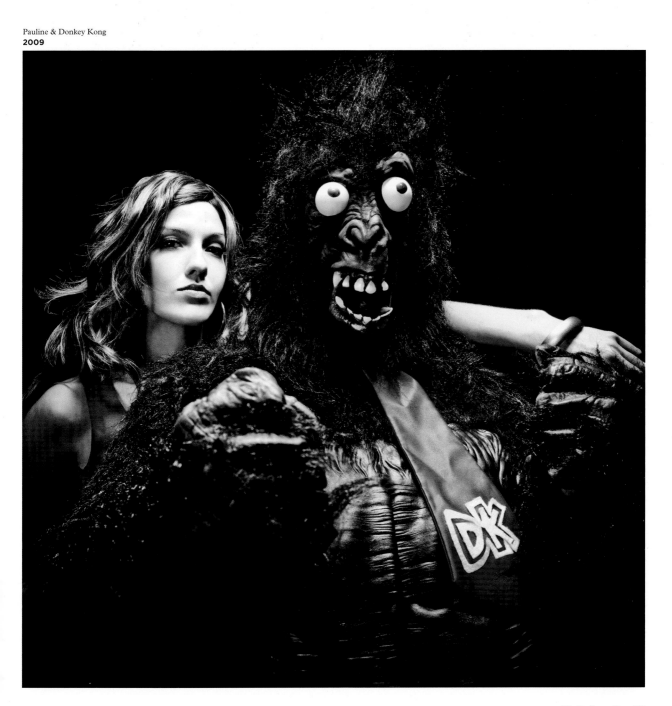

Ice Climbers
2009

Princess Zelda
2009

Malon
2009

Zero Suit Samus Aran
2009

Lakitu
2009

EDMISTON, JASON

Jason Edmiston works in advertising, packaging, and book publishing, and has been painting for more than fifteen years. Working in a traditional mode of painting in acrylic on paper or wood panels, his passion for pop culture shows through his artwork. He currently lives in Toronto.

WEBSITES: jasonedmiston.com and jasonedmiston.deviantart.com

CONTACT: jason@jasonedmiston.com

What a Doll
2011

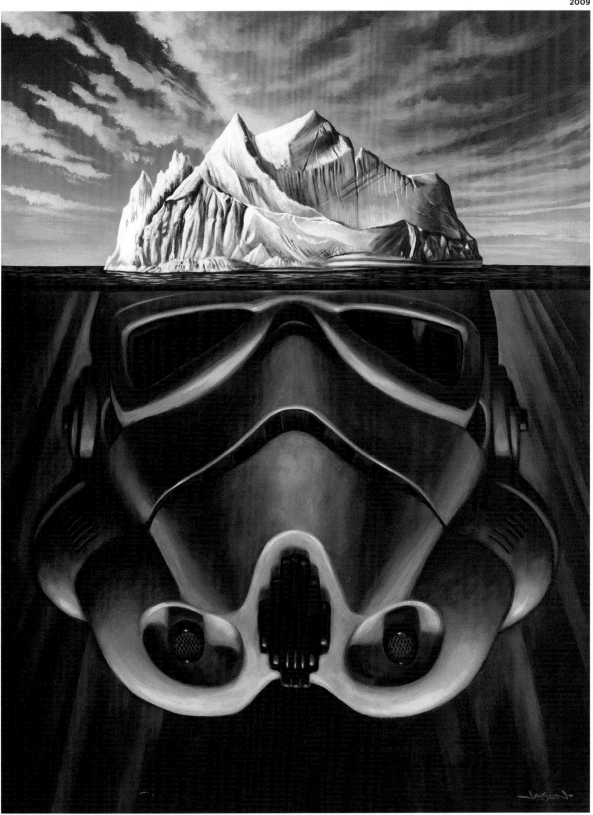

“ Because I grew up with comic books, science fiction movies, glam rock, *Mad* magazine, and action figures, my work tends to be bright, bold, and often has elements of sly humor. ”

Mr. Soaky
2009

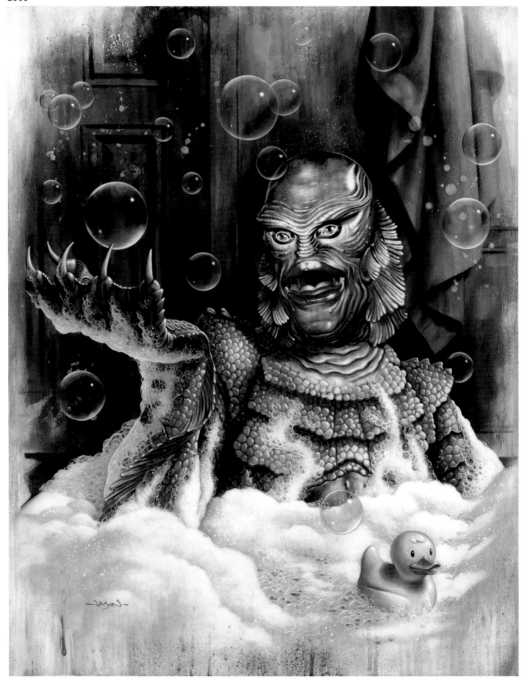

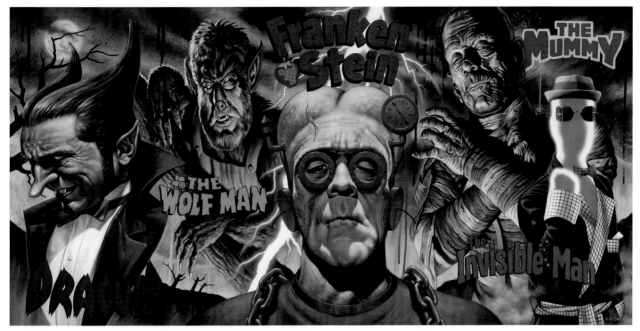

Source of 5 Essential Nutrients
2009

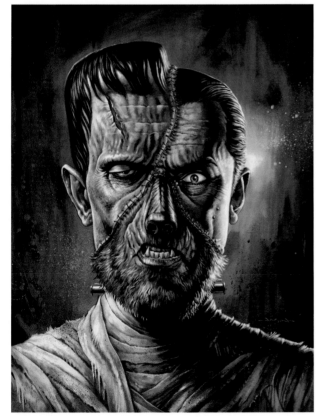

Monster Mash
2010

The Fly
2011

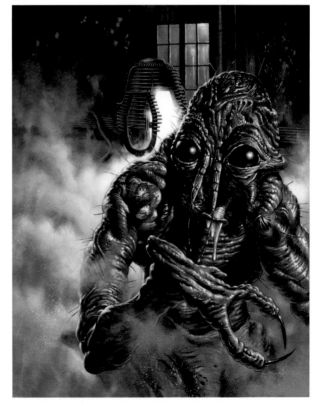

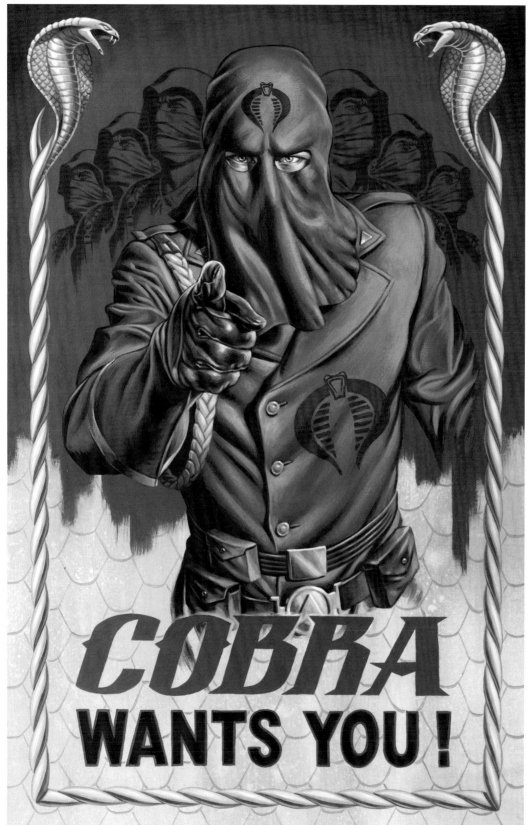

Cobra Wants You
2010

ELSAWI, TAMER

Tamer Elsawi is an art director for advertising in Dubaï. He loves both his job and *Star Wars*, so he decided to spend his free time working in George Lucas' world. Always looking for a new way to observe his favorite heroes, he likes original associations.

WEBSITE: tamerelsawi.tumblr.com

" I like to take the characters or scenes to a completely different place and time and try to make them fit, and sometimes I end up with some crazy sort of twisted stuff. But hey, it's new, right? **"**

Darth Knight
2011

Vader Sama
2011

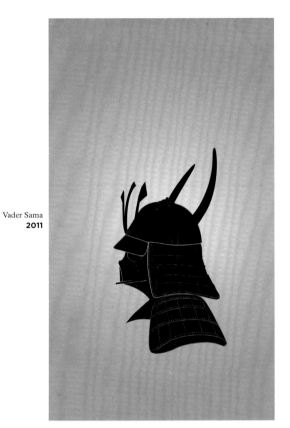

Pharaoh Vader
2011

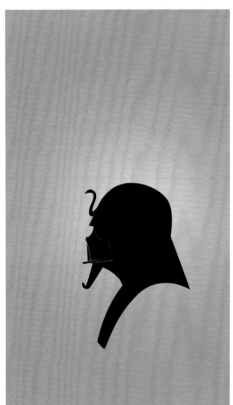

Vaderus Maximus
2011

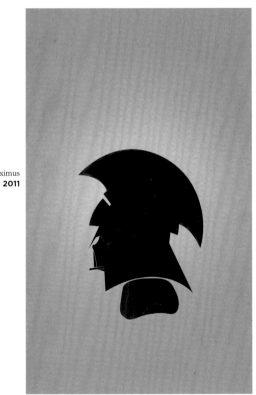

Lieutenant Vader
2011

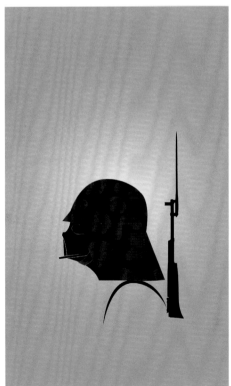

FAIRHURST, ANDY

Andy Fairhurst is a Welsh freelance digital painter who specializes in character art, book covers, and illustrations. He has never forgotten his passion for his favorite 1980s movies, including *The Goonies* and *Back to the Future*.

WEBSITE: andyfairhurstart.com

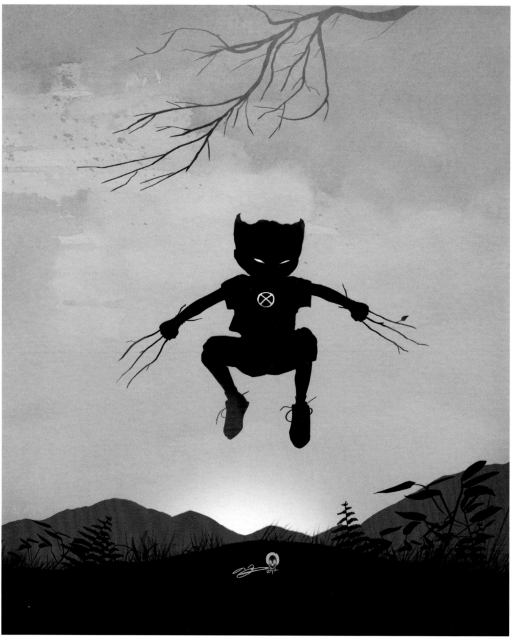

Wolverine Kid
2012

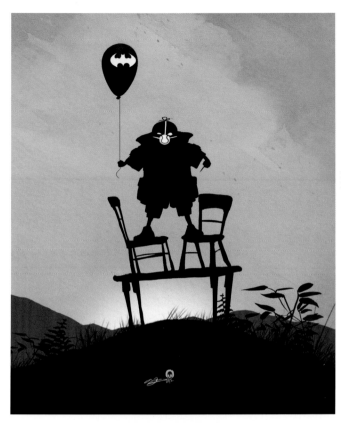

Bane Kid
2012

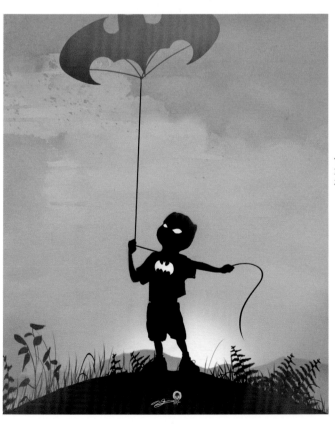

When I Grow Up
I Wanna Be . . . Batman
2012

> " I have found as I have become older that I have embraced the geek in me, which I may have hidden away when I was much younger. "

Harley Kid
2012

Magneto Kid
2012

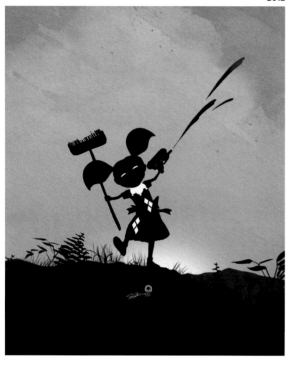

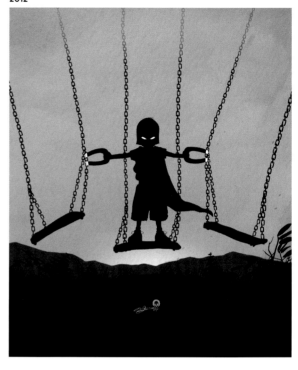

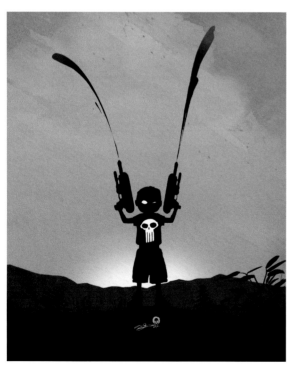

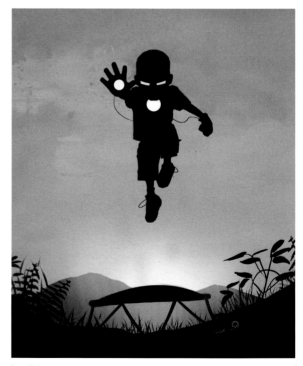

Punisher Kid
2012

Iron Kid
2012

Spider Kid
2012

Storm Kid
2012

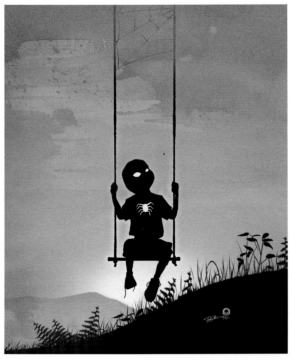

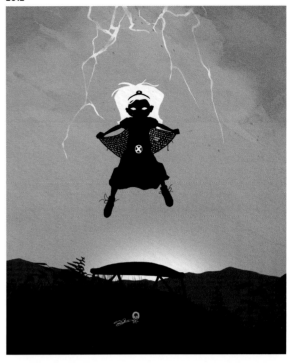

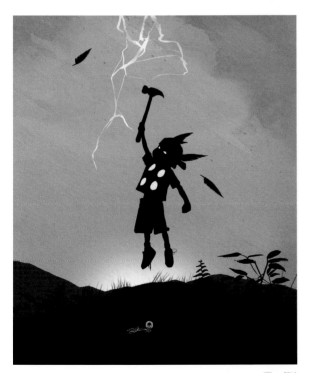

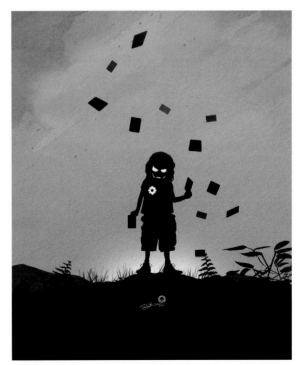

Thor Kid
2012

Joker Kid
2012

FERGUSON, MATT

Matt Ferguson is a U.K.-based graphic designer whose influences include anime, Saul Bass, classic 1950s movie posters, and comic books.

WEBSITE: cakesandcomics.com

CONTACT: arco2002@hotmail.com

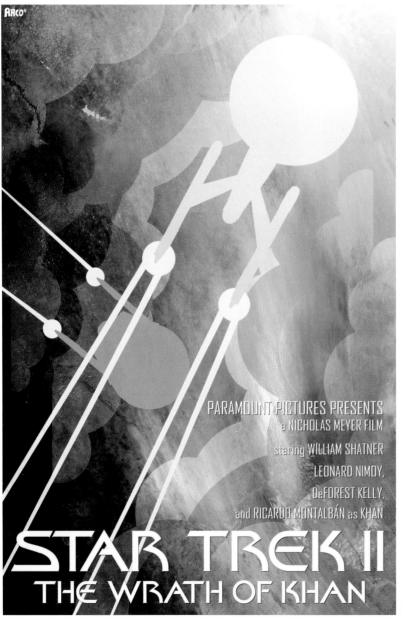

> " My style is at the service of comics and sci-fi, which form the bases of popular culture. "

Battle in the Mutara Nebula
2011

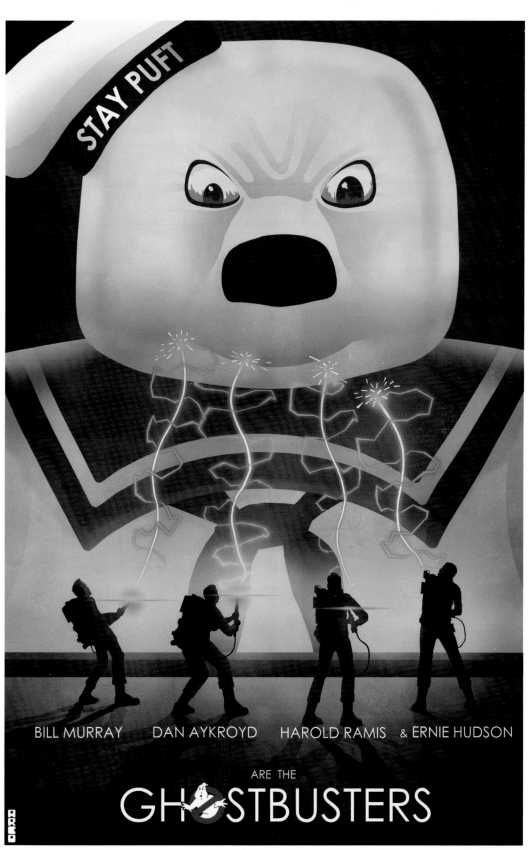

STAY PUFT

BILL MURRAY DAN AYKROYD HAROLD RAMIS & ERNIE HUDSON

ARE THE

GH STBUSTERS

Angry Stay Puft
2012

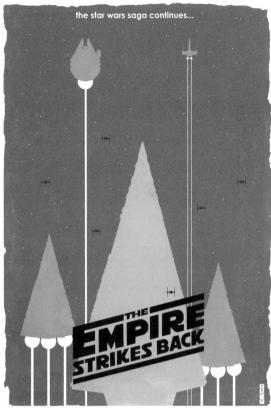

The Empire Strikes Back
2011

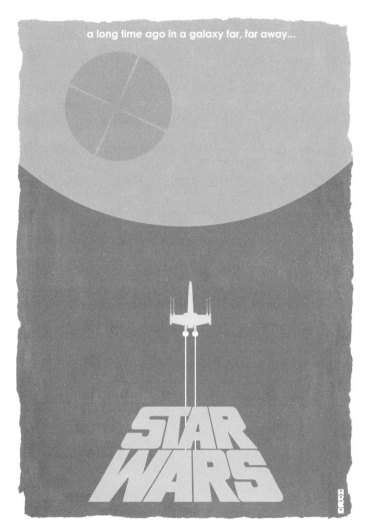

Star Wars
2011

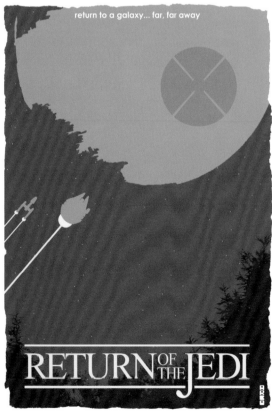

Return of the Jedi
2011

Iron Man MK2
2012

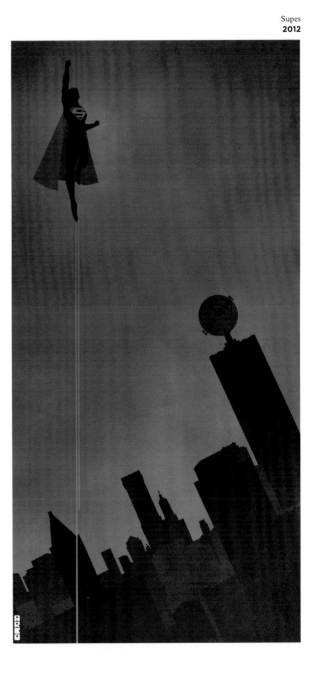

FUENTES, ALEX

A proud child of the 1980s, Barcelona-based Spanish illustrator Alex Fuentes counts among his influences the work of Will Eisner, Jeff Smith, René Goscinny, and Albert Uderzo.

WEBSITE: alejandrofuentes.blogspot.com.es

CONTACT: alexfuentesrodriguez@gmail.com

Howard Wolowitz from
The Big Bang Theory
2010

" I was inspired by
Warner Bros.
series, like
Looney Tunes. **"**

Captain Marvel
2007

Bill Adama from
Battlestar Galactica
2010

Moth of The IT Crowd
2010

Jon Snow and Sam
from Game of Thrones
2012

GARZA, BETO

Beto Garza, a.k.a. Hellbetico, is a Mexican illustrator and graphic designer. Fascinated by comics and movies, he spends most of his free time drawing iconic characters from geek culture, paying tribute to the heroes of his childhood.

WEBSITE: helbetico.deviantart.com

BLOG: helbetico.tumblr.com

CONTACT: helbetico@yahoo.com

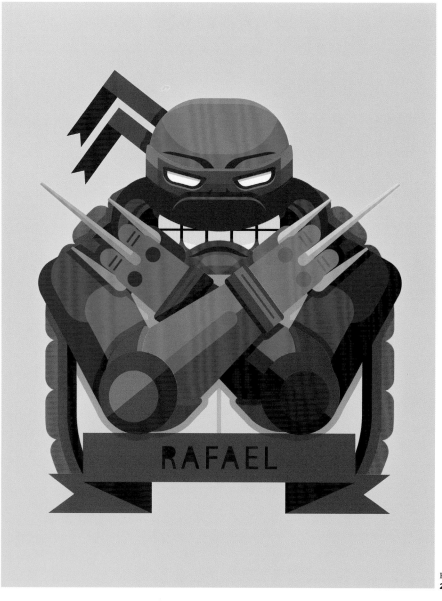

" Keep on drawing, amigos! "

Rafael
2011–2012

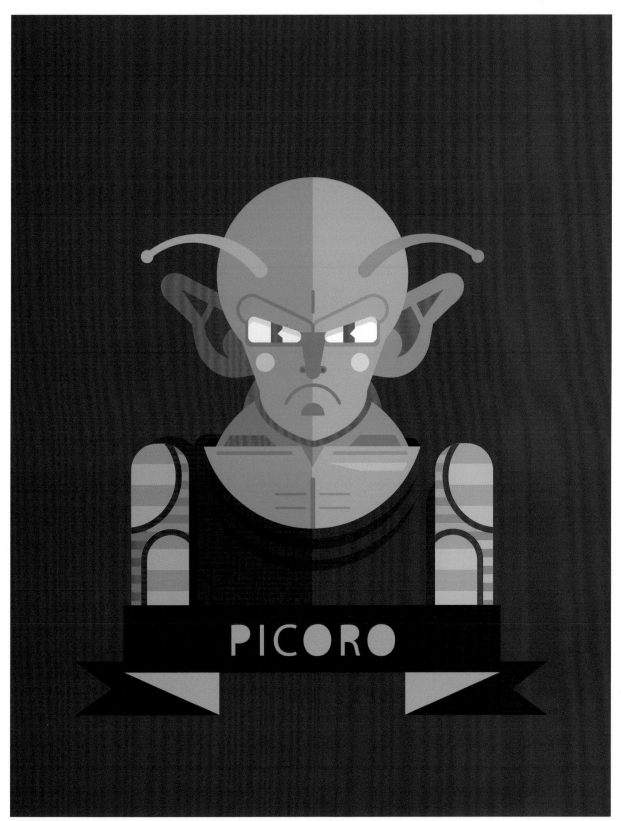

Picoro
2011–2012

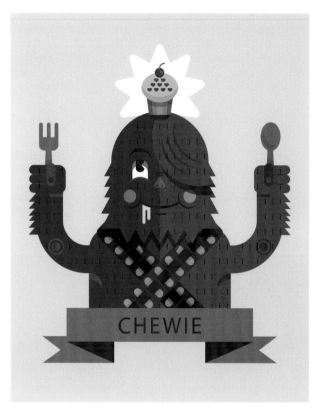

Chewie
2011–2012

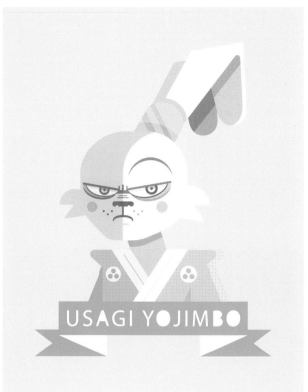

Usagi Yojimbo
2011–2012

Totoro
2011–2012

Hellboy
2011–2012

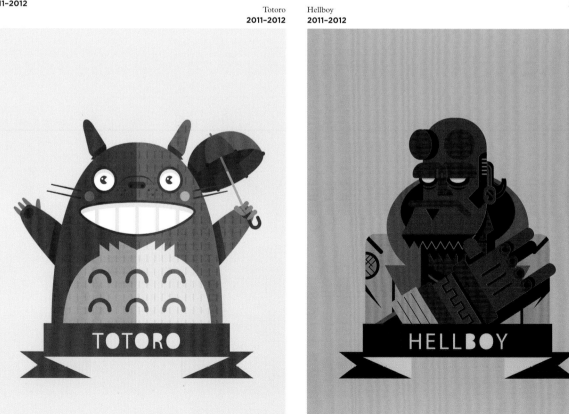

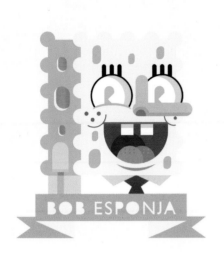

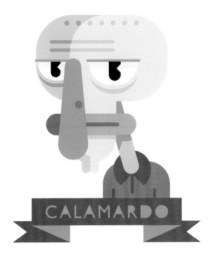

Bob Esponja
2011–2012

Calamardo
2011–2012

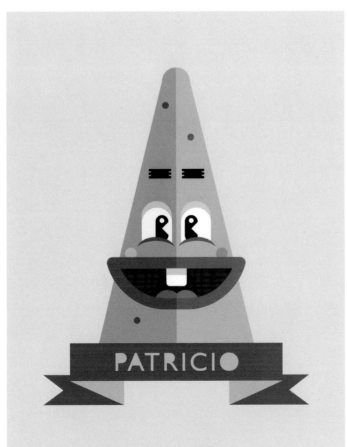

Patricio
2011–2012

GERRINGER, CHRIS

Born in the 1980s, American artist Chris Gerringer is an eager reader and videogame player whose work has been heavily influenced by pop and geek culture.

WEBSITE: paperbeatsscissors.com

BLOG: paperbeatsscissors.tumblr.com

CONTACT: paperbeatsscissors@gmail.com

Expendable Minions
2012

Genetic Experiments
2012

" Video games, comics, and cartoons are part of my childhood. I could try to struggle against their influence on my work, or welcome them with open arms . . . I picked the second option. **"**

Wearing a Visor
2012

Orphan Heroes
2012

Clone of a Bro
2012

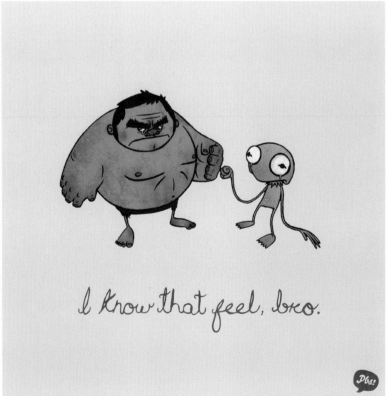

Being Green
2012

Robot Boys
2012

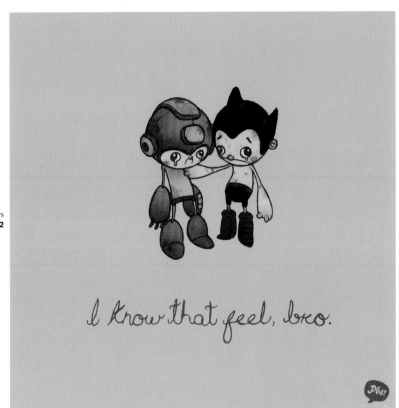

Exaggerated Antiheroes
2012

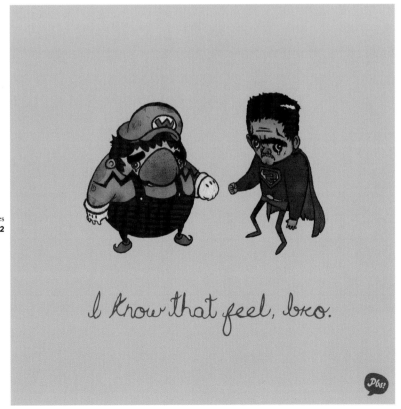

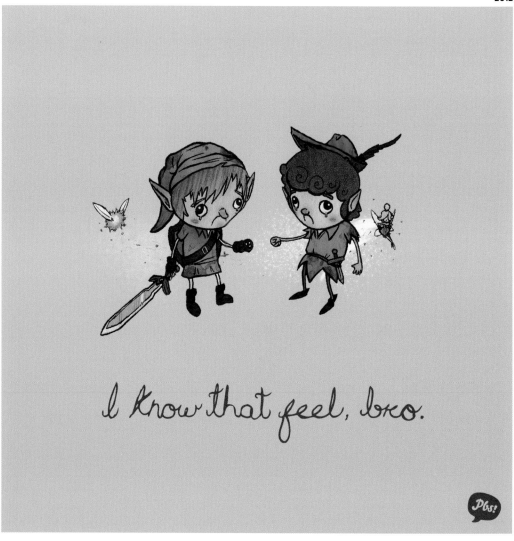

Just a Parasite
2012

Princess Problems
2012

GIBSON, JEROD

Madison, Wisconsin-based creative director and freelance designer Jerod Gibson has worked and collaborated with Urban Outfitters, Cartoon Network, Dirty Disco Kidz, F. Stokes, *New Scientist*, Threadless, Society6, and others. His passion for typography drives him to use famous quotes gleaned in the geek culture to pay tribute to his heroes.

WEBSITE: jerodgibson.com

" I enjoy pop culture. It allows people to connect with one another, no matter their race, creed, sexual orientation, or any social differences. "

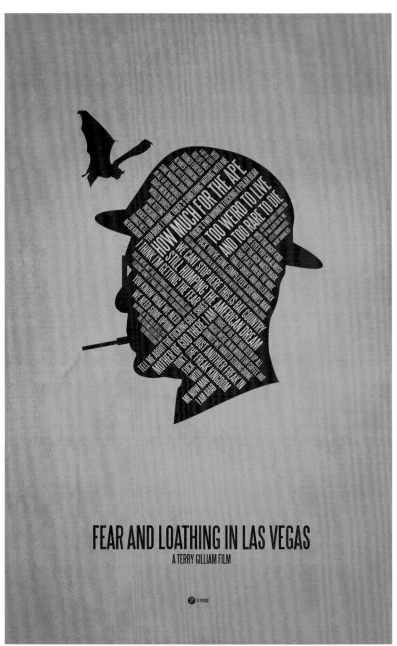

Fear & Loathing in Las Vegas
2010

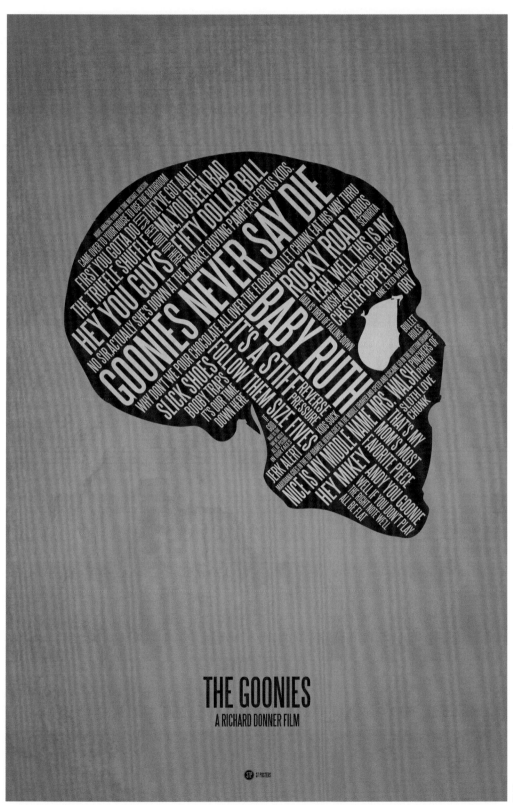

THE GOONIES
A RICHARD DONNER FILM

37 POSTERS

The Goonies
2010

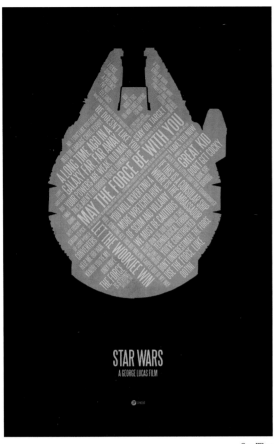

Star Wars
2010

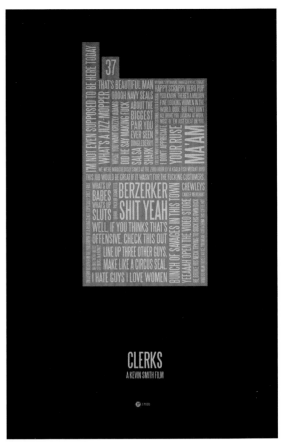

Clerks
2010

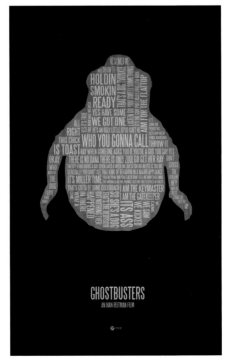

Ghostbusters
2010

Fight Club
2010

The Simpsons
2010

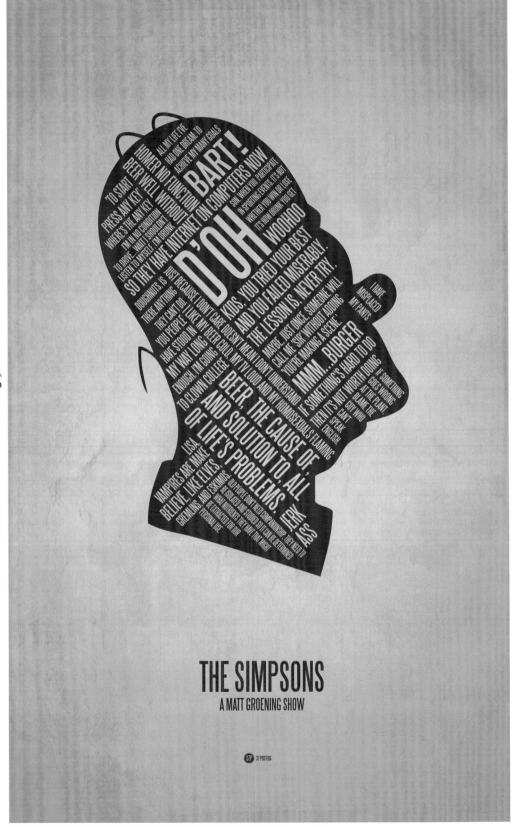

Labyrinth
2010

LABYRINTH
A JIM HENSON FILM

The Hangover
2010

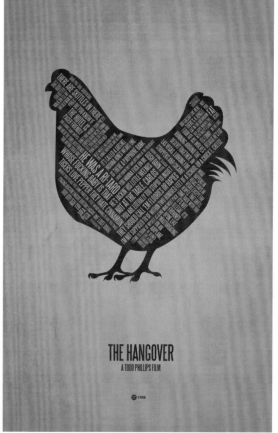

THE HANGOVER
A TODD PHILLIPS FILM

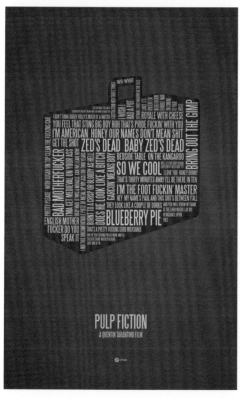

PULP FICTION
A QUENTIN TARANTINO FILM

Pulp Fiction
2010

GILSON, DAVID

David Gilson is a Parisian illustrator who has worked for such animation studios as Walt Disney Feature Animation, Ellipsanime, Marathon, SIP Animation, and Xilam. For the last few years he has also illustrated children's books for Disney Publishing, and he is the illustrator and writer of the comic book *Bichon*.

WEBSITE: davidgilson.com

FACEBOOK: facebook.com/DavidGilsonDrawings

CONTACT: contact@davidgilson.com

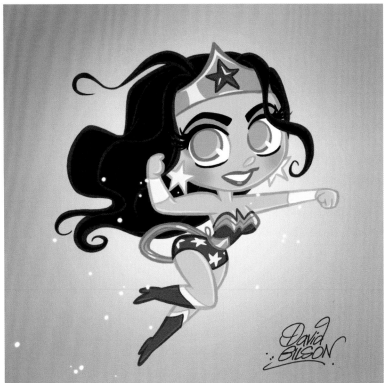

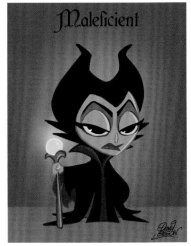

Wonder Woman
2012

Maleficient
2012

" I was four when I went to the movie theater for the first time, to see *The Rescuers*. I fell in love with animated pictures combining fantasy, humor, tenderness, and a fairy's touch. Sometimes I love to "bite" into the characters who moved me, made me nostalgic, or those who made me follow a dream that I saw come to life. **"**

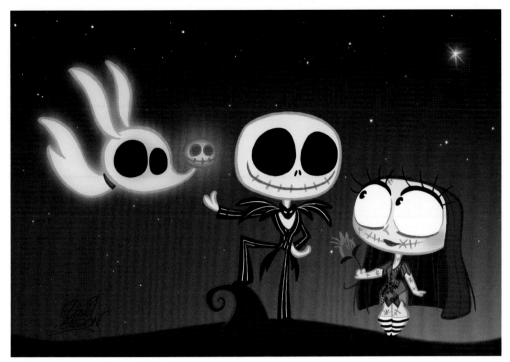

Nightmare before Xmas
2012

Hulk
2012

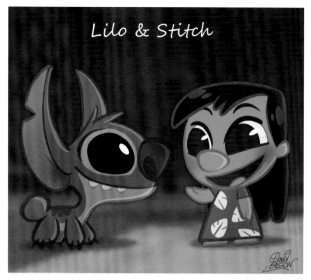

Lilo & Stich
2012

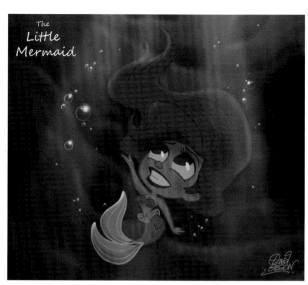

The Little Mermaid
2012

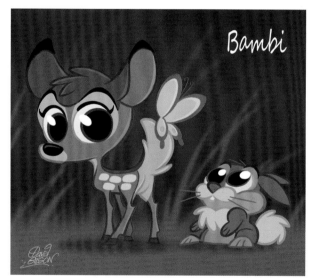

Bambi
2012

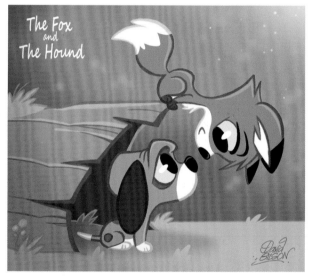

The Fox and the Hound
2012

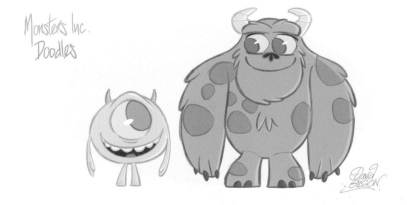

Monsters Inc. Doodles
2012

Maya

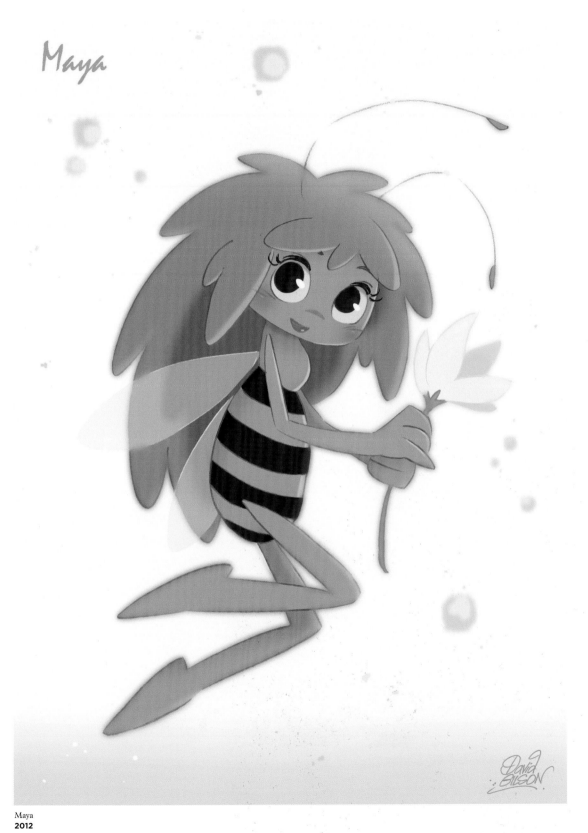

Maya
2012

GODMACHINE

Godmachine was born in Cardiff, South Wales. He grew up on a steady diet of nothing and *2000 AD* comics. He collects animal skulls and horns, crucifixes, and antique castoff black and white photographs.

WEBSITE: godmachine.co.uk

Odin
2011

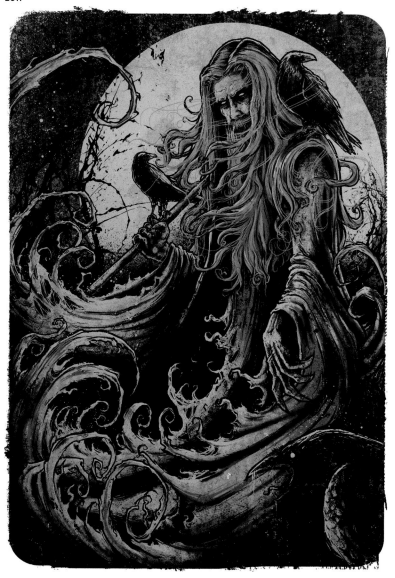

" My art is born of Jim Phillips, raised by Simon Bisley, and adopted by everyday influences: film, literature, and music. "

Nuke Em High
2010

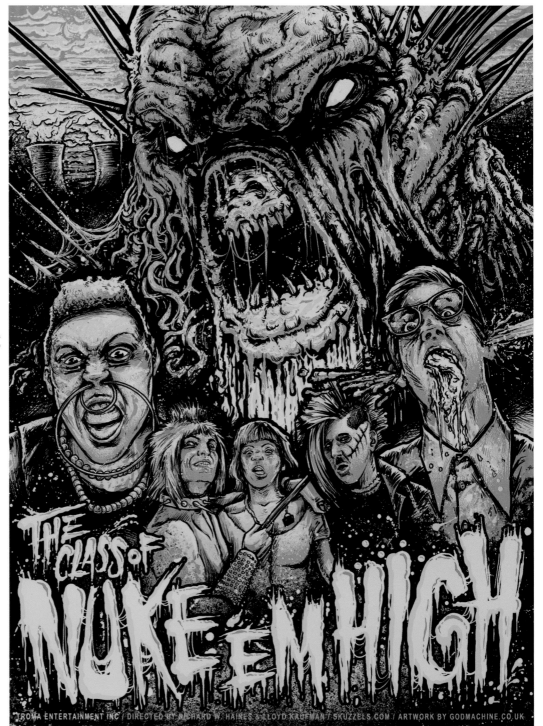

THE CLASS OF NUKE EM HIGH

TROMA ENTERTAINMENT INC / DIRECTED BY RICHARD W. HAINES & LLOYD KAUFMAN / SKUZZELS.COM / ARTWORK BY GODMACHINE.CO.UK

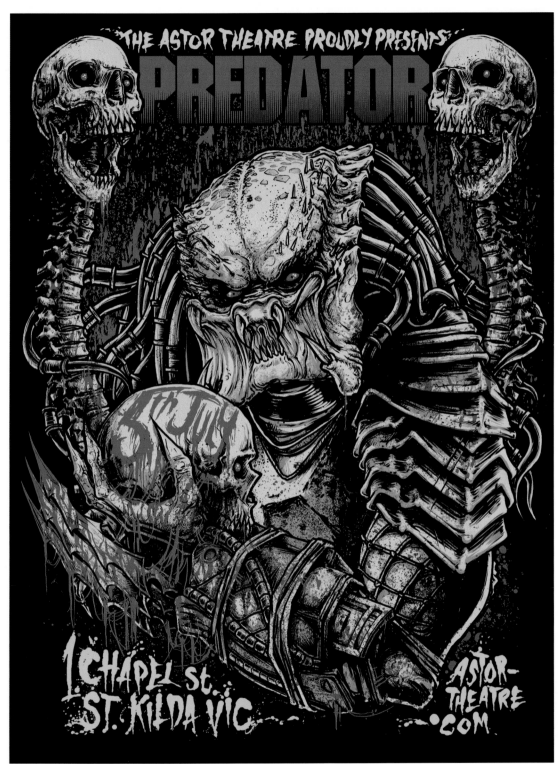

Predator
2010

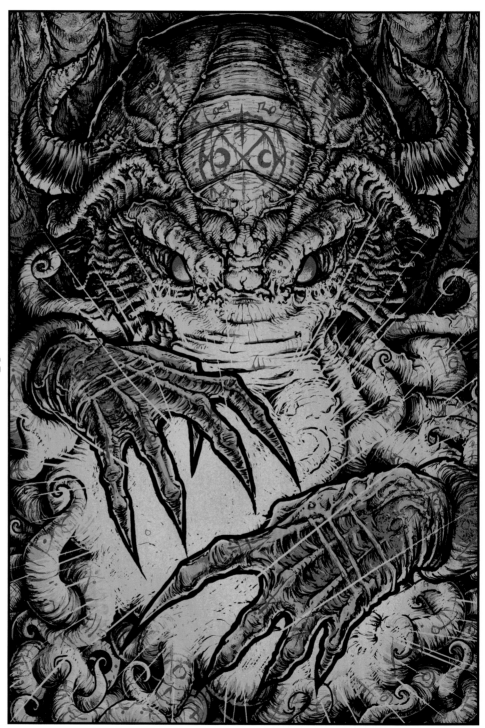

Cthulhu
2011

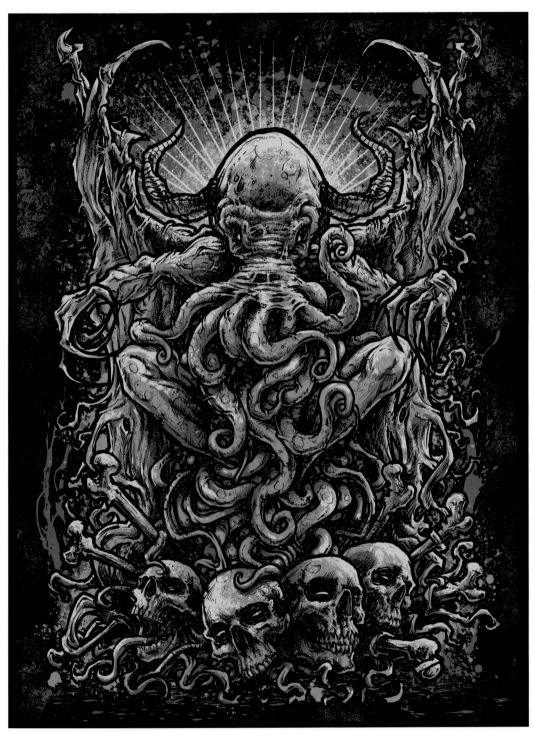

Cthulhu
2010

GROSS, ALEX

Los Angeles-based artist Alex Gross read X-Men, Spider-Man, and Frank Miller's *The Dark Knight* comics as a child. He collects cabinet cards, a form of antique photographic portraiture, and has incorporated the style into his work by painting over them to create hundreds of portraits of his favorite heroes.

WEBSITE: alexgross.com

CONTACT: alex@alexgross.com

> " Thinking about comic book heroes in a different way has been one of the most exciting works of art that I have ever done. "

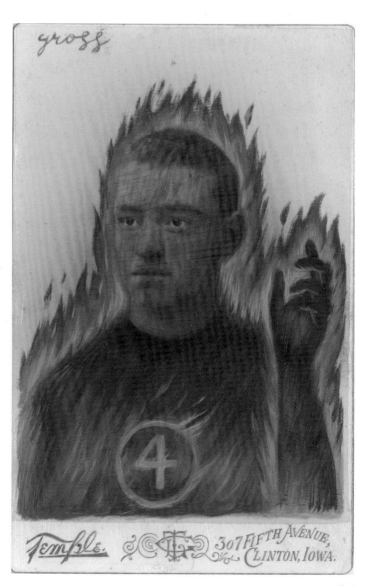

Torch
2012

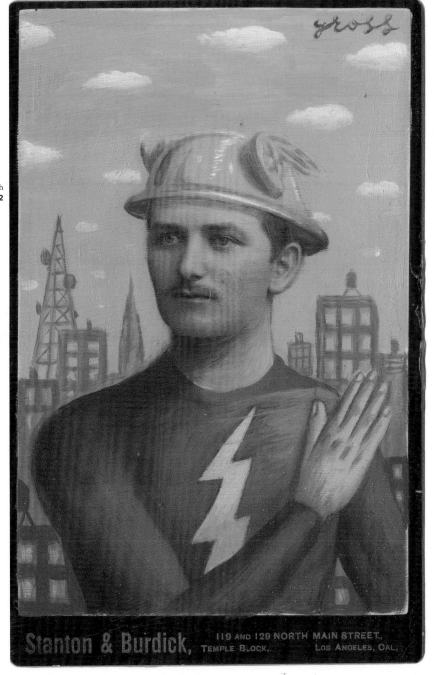

Golden Age Flash
2012

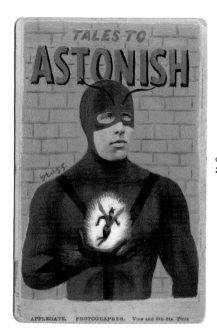

Giant-Man and Wasp
2012

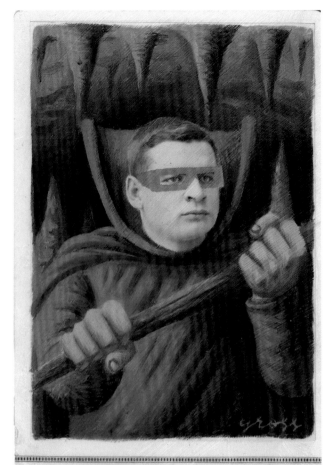

R. D. BAYLEY, 24 West Main St.,
BATTLE CREEK, MICHIGAN.

Mole Man
2012

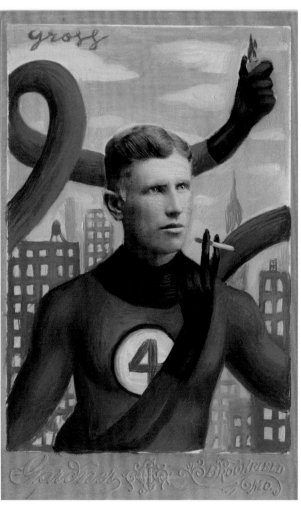

Reed Richards
2012

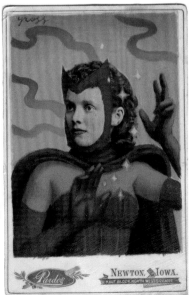

Scarlet Witch
2012

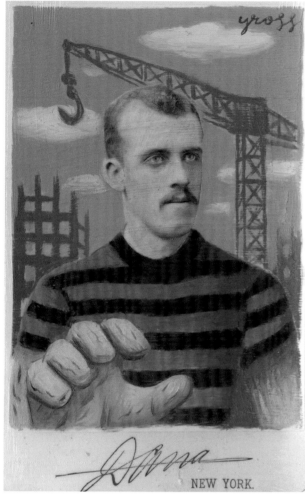

Sandman
2012

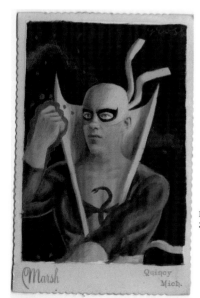

Iron Fist
2012

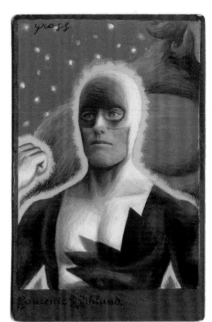

Vindicator
2012

Clark
2012

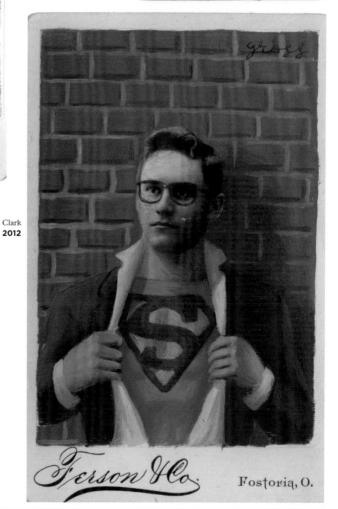

GUILLEMIN, GRÉGOIRE

Grégoire Guillemin is a French artist whose minimalist posters are inspired by the most famous ad illustrators of the 1930s. He is also influenced by cartoonists and illustrators such as Jean Giraud, André Franquin, Régis Loisel, Juanjo Guardino, Frank Miller, and Mike Mignola. He takes great pleasure in playing with toys and figurines from his childhood.

WEBSITES: greg-guillemin.com and behance.net/leon

BLOG: greg-leon.tumblr.com

CONTACT: greg.guillemin@orange.fr

Hellboy—Gropius Spirit
2011

> "Geek-Art is a wonderful playground."

Iron Man—Cassandre Spirit
2011

Batman—Cassandre Spirit
2011

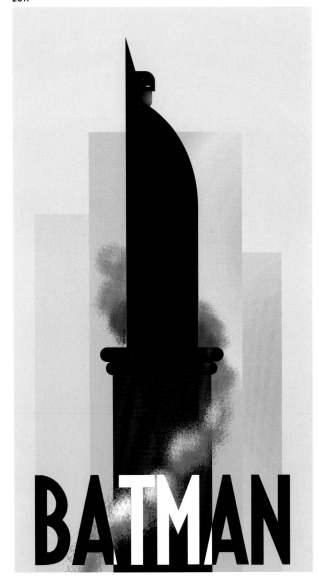

Superman—Soviet Art
2011

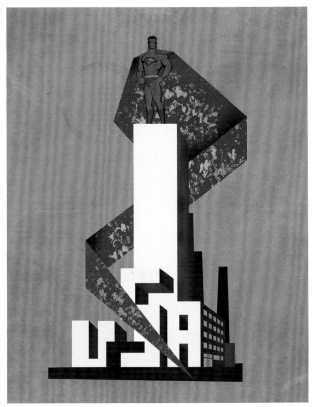

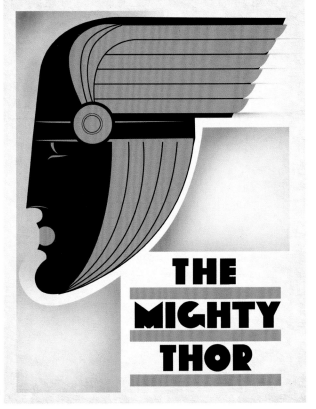

Thor—Cassandre Spirit
2011

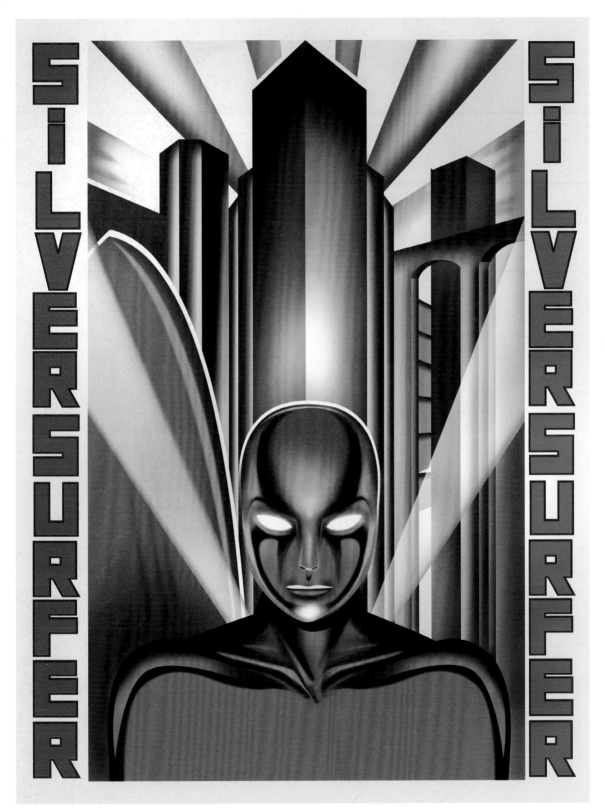

Silver Surfer—Metropolis
2011

GUY, BENJAMIN

Born in London, Ben Guy now lives in Melbourne, Australia. Influenced by *2000 AD*, Marvel, Games Workshop, G.I. Joe, and Japanese robots, his paintings feature children wearing the helmets of iconic geek culture characters.

BLOG: funbeard.blogspot.com

CONTACT: funbeard@hotmail.com

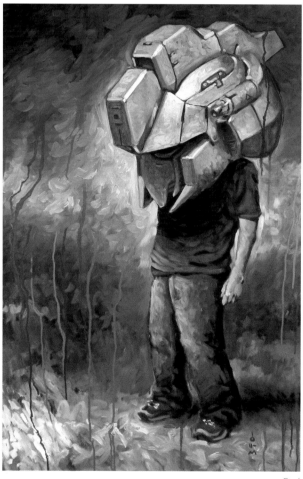 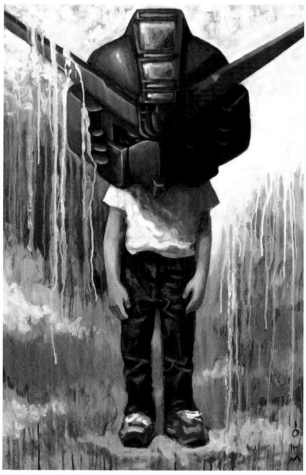

Brad
2011

Ben
2010

> " I blame *Star Wars* for pretty much everything. "

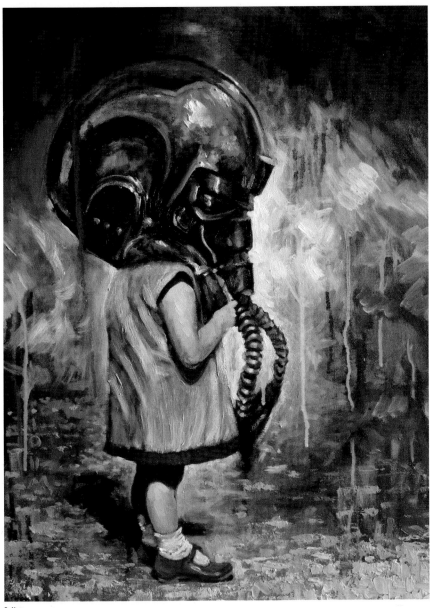

Juliet
2012

Jake
2012

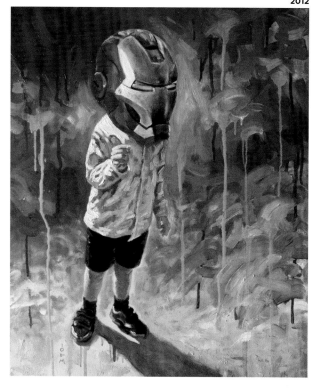

Lucy
2012

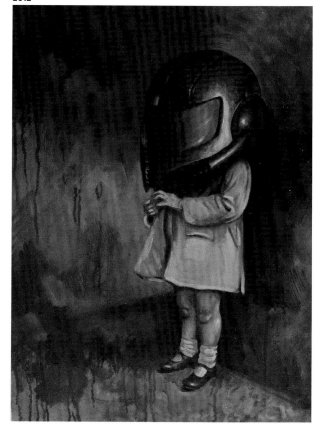

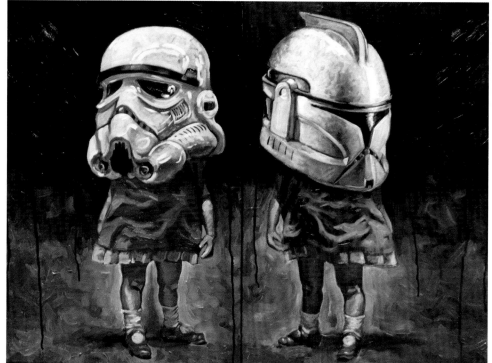

Katie & Grace
2012

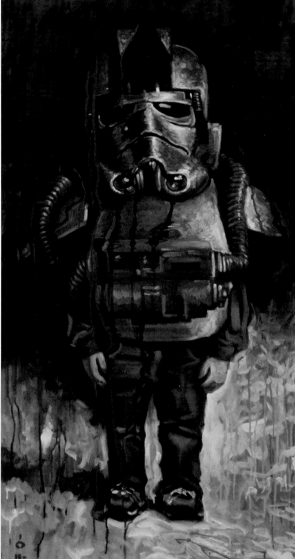

Jacob
2010

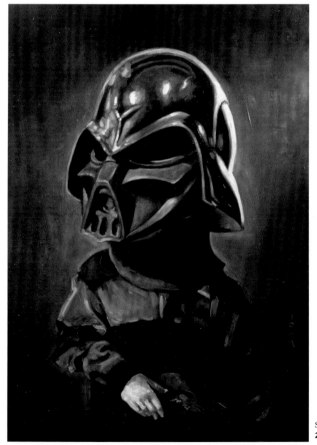

Saturn
2011

HANCOCK, JD

JD Hancock is a cyborg living in Austin, Texas. He enjoys geek culture and has developed a passion for toy photography. His artistic influences include Ralph McQuarrie, Drew Struzan, Steve Ditko, Curt Swan, Syd Mead, Michael Okuda, and Pixar animation.

WEBSITE: jdhancock.com

CONTACT: jd@jdhancock.com

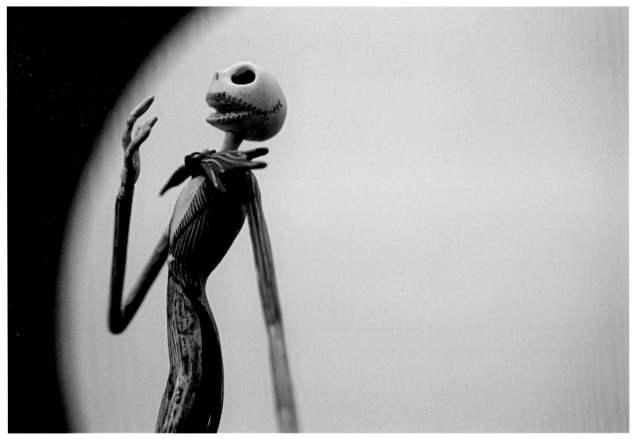

The Wry Song of the Moon
2010

I've always enjoyed geek culture, specifically science fiction storytelling in movies, television shows, and comic books.

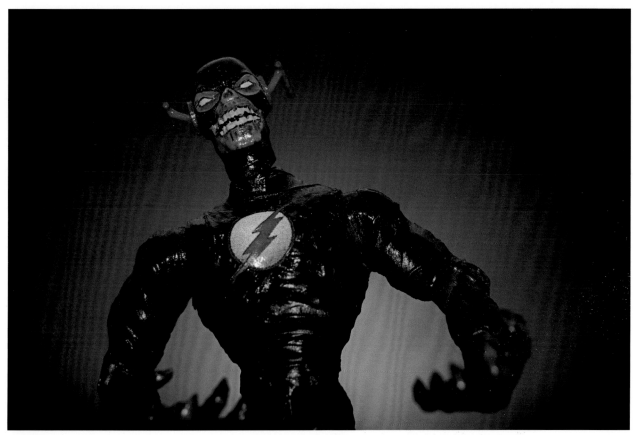

Black Flash
2010

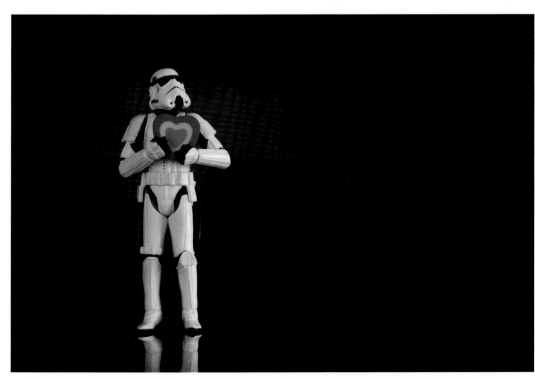

Heart of the Storm
2010

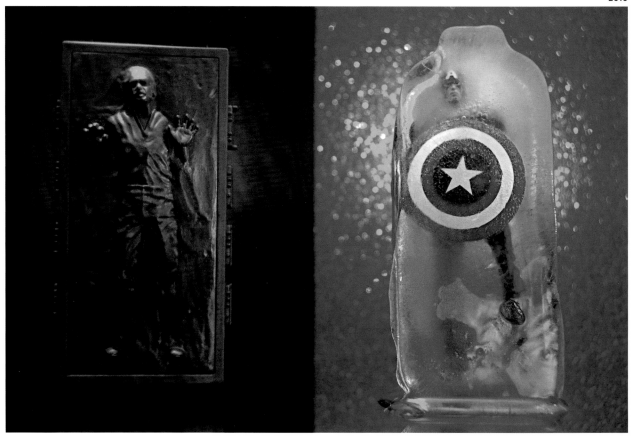

Lex Luthor vs. Cobra
Commander
2010

Belle vs. Beast
2010

Chuck Norris vs.
the Monolith
2010

Mario vs. Super Luigi
2010

Mini-Me vs. Minnie Mouse
2010

Alien vs. Alien
2010

Stormy Romance
2010

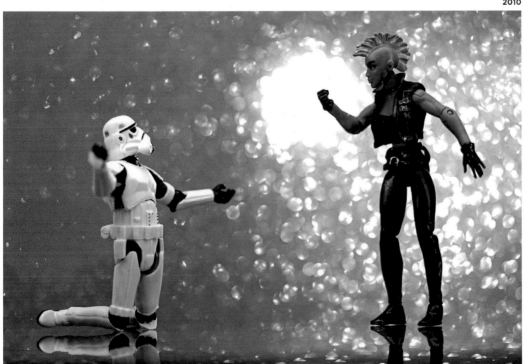

HANNES

Hannes is a German graphic designer based in Stuttgart. He defines geeks as people who didn't lose their childish fascination with and passion for all things creative, including video games, movies, and comic books.

WEBSITE: hannesbeer.de

CONTACT: hallo@hannesbeer.de

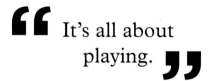 It's all about playing.

The Vest
2011

002/365

Assassin
2011

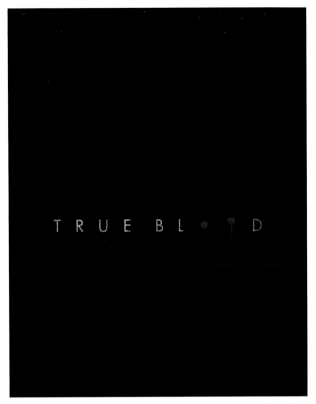

True Blood
2011

Helghan
2011

To Join Is to Survive
2011

Dead Space
2011

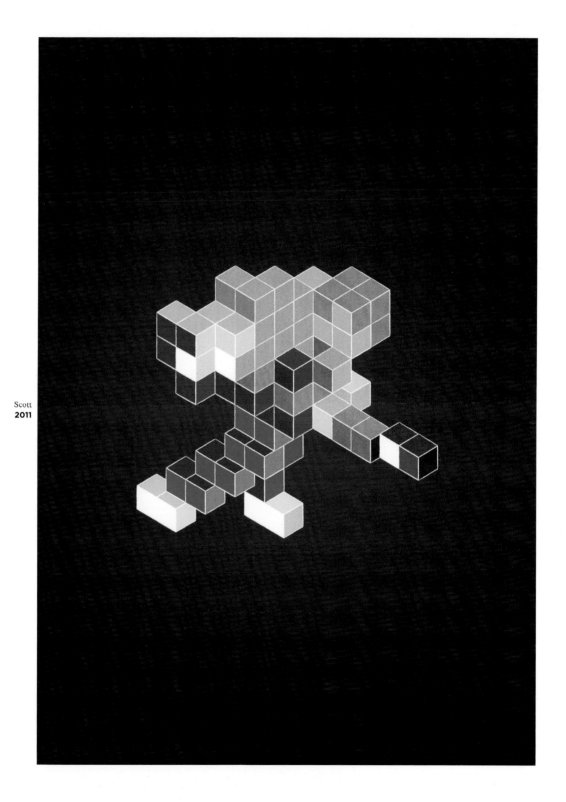

Scott
2011

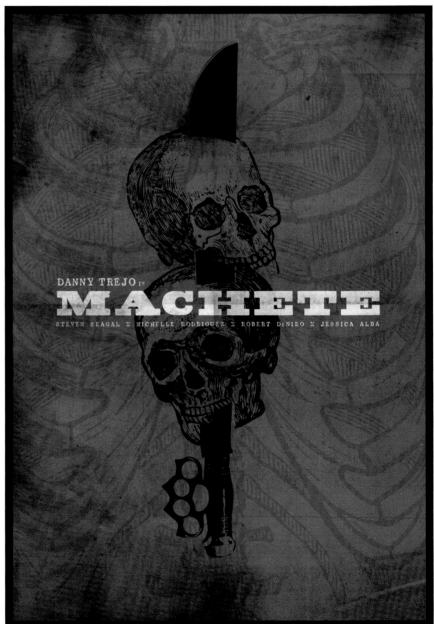

Machete
2011

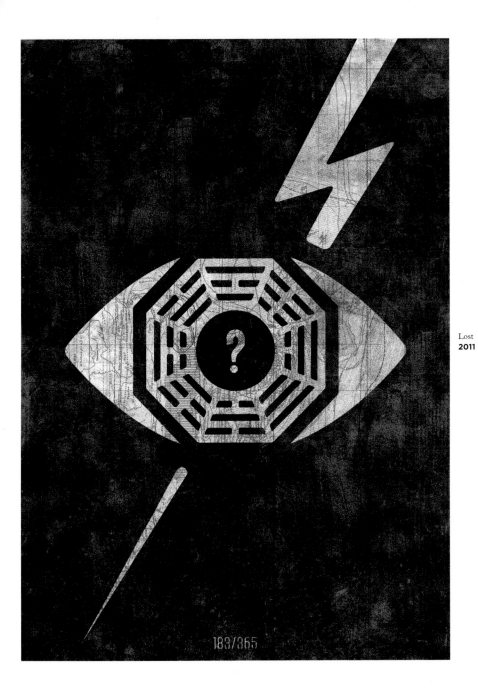

Lost
2011

HELLO I'M WILD!

Caroline Sauvage is a member of the graphic design collective Hello I'm Wild!, based in Lille, France. A child of the 1980s, she grew up among numerous geek influences including *Star Wars*, *Toy Story*, Sega's Game Gear, Pokémon, and many more. Her work takes a subversive pleasure in placing her heroes in real world circumstances.

WEBSITE: helloimwild.com

CONTACT: hey@helloimwild.com

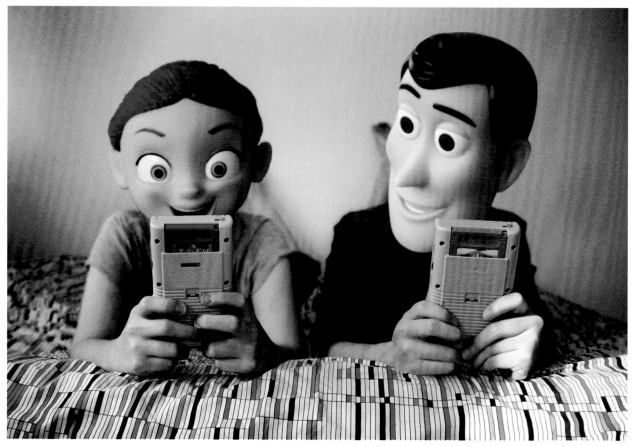

Addicted
2011

❝ Hopefully, Geek-Art will become a full artistic movement for generations to come. **❞**

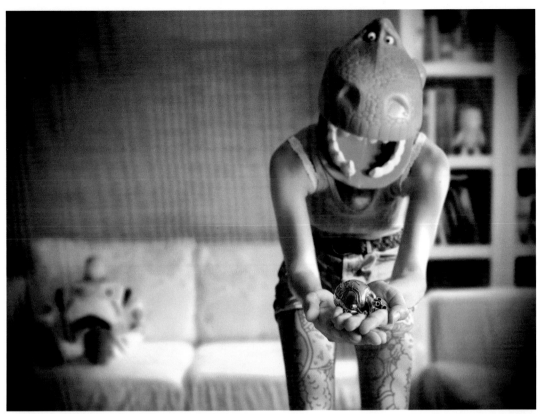

Mon Précieux
2011

Be Paulette
2011

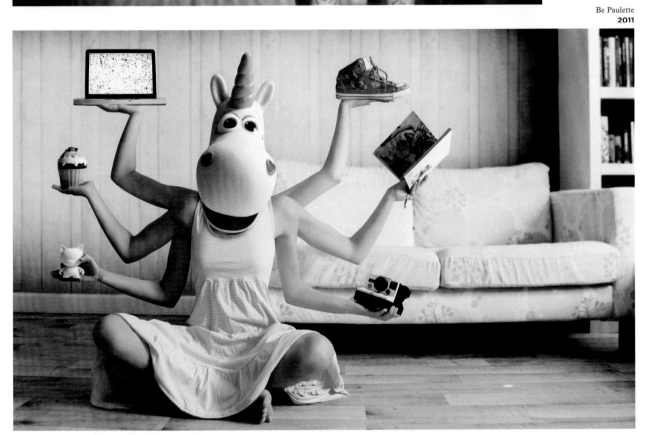

A Bestseller
2012

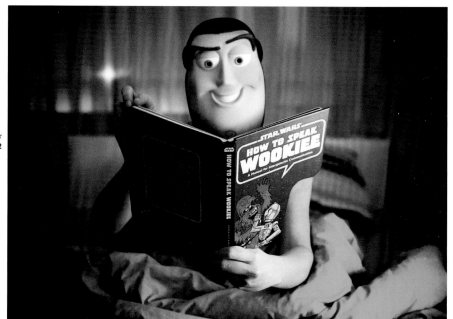

Road(eo) Trip
2012

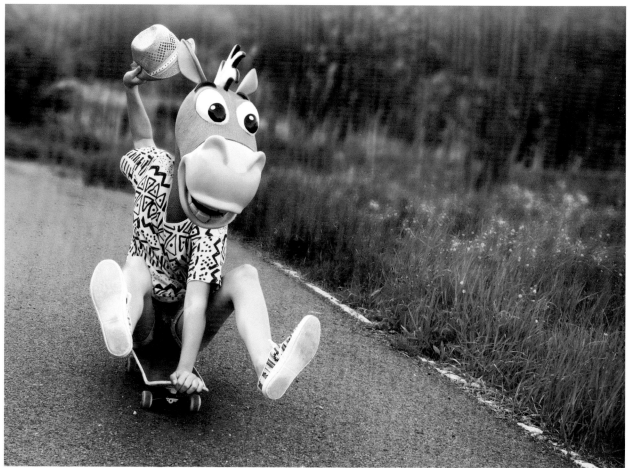

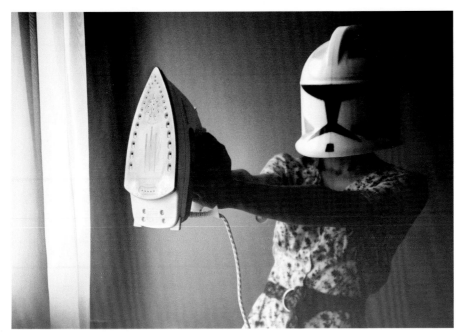

If Only I Were a Jedi
2011

J'essuie Ton Père
2012

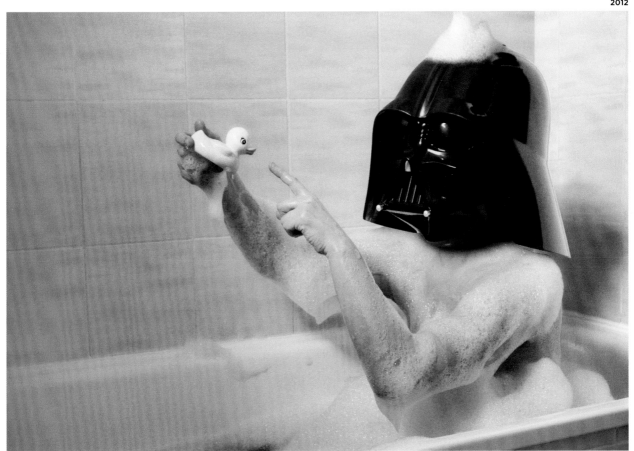

HERTZ, VIKTOR

Viktor Hertz is a freelance graphic designer living in Stockholm, Sweden, who focuses on personal projects inspired by geek culture. Having traveled all around the world, his favorite style is inspired by the international language of sign pictograms and symbols.

WEBSITE: viktorhertz.com

CONTACT: info@viktorhertz.com

❝ I love pop culture–related art. The more subtle the reference is, the better. **❞**

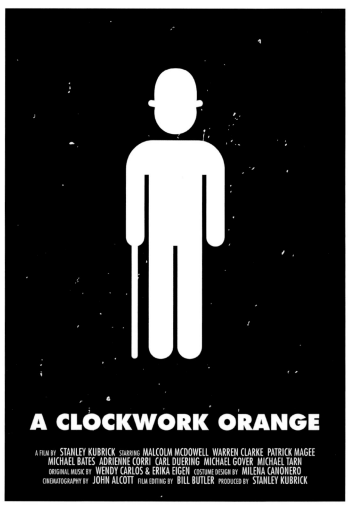

A Clockwork Orange Pictogram Poster
2011

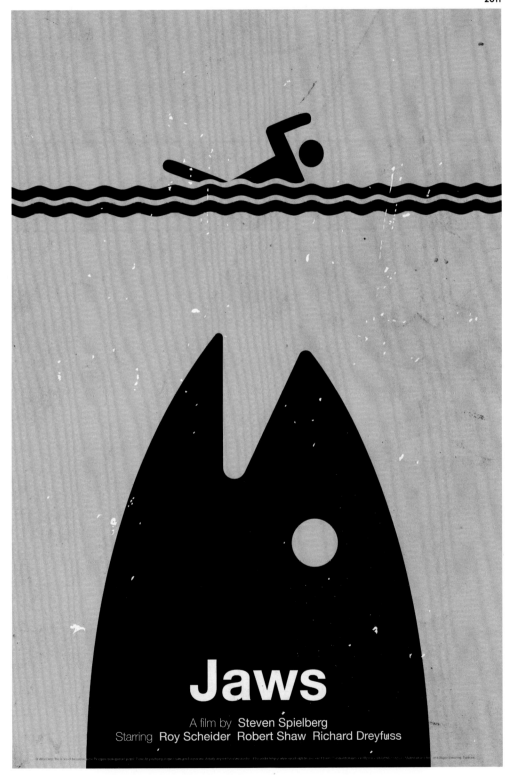

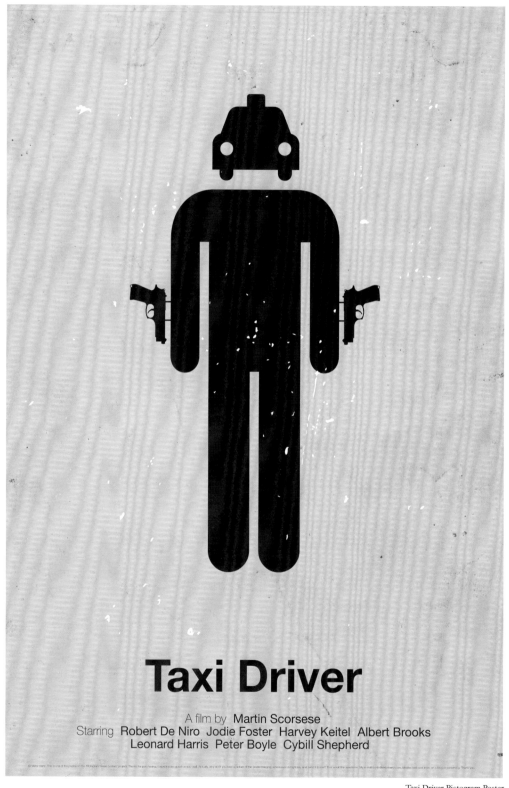

Taxi Driver Pictogram Poster
2011

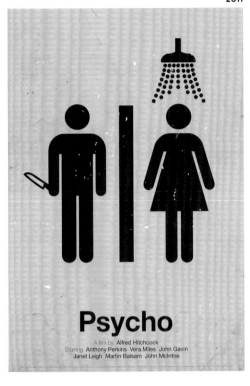

Psycho

A film by Alfred Hitchcock
Starring Anthony Perkins Vera Miles John Gavin
Janet Leigh Martin Balsam John McIntire

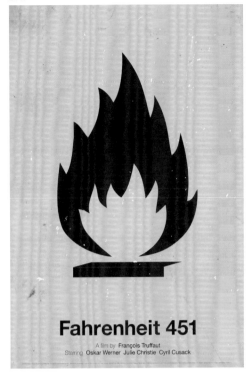

Fahrenheit 451

A film by François Truffaut
Starring Oskar Werner Julie Christie Cyril Cusack

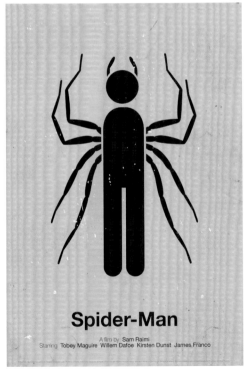

Spider-Man

A film by Sam Raimi
Starring Tobey Maguire Willem Dafoe Kirsten Dunst James Franco

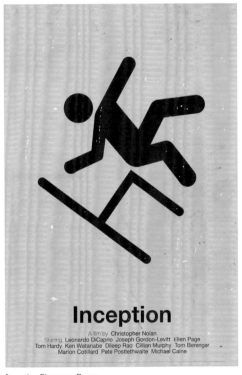

Inception

A film by Christopher Nolan
Starring Leonardo DiCaprio Joseph Gordon-Levitt Ellen Page
Tom Hardy Ken Watanabe Dileep Rao Cillian Murphy Tom Berenger
Marion Cotillard Pete Postlethwaite Michael Caine

HEXAGONALL

Madrid-based Spanish artist Fran Asensio chose the name Hexagonall because he considers the hexagon to be the most perfect geometrical form. Inspired by science fiction and John Carpenter's movies, he uses color as a primary part of his creative process. He also owns Veni, an animation and design studio.

WEBSITE: hexagonall.com

CONTACT: ideasdebombero@yahoo.es

> " I think people want
> more art and
> design nowadays.
> They want it to be
> more intimate,
> more human-like. "

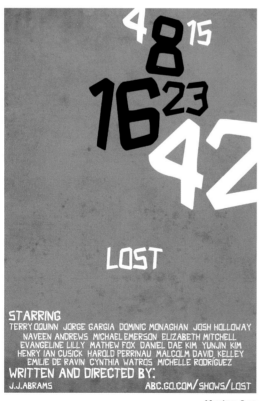

Numbers, Lost
2010

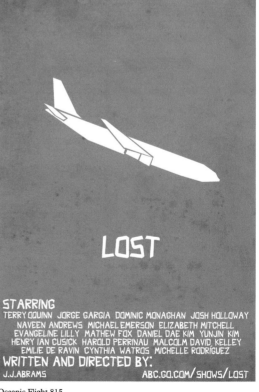

Oceanic Flight 815
2010

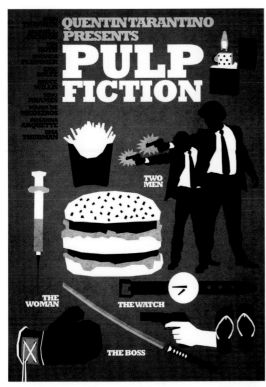

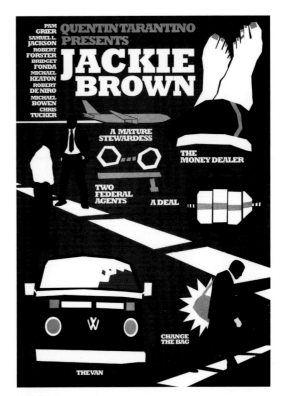

Pulp Fiction
2010

Jackie Brown
2010

Kill Bill 1
2010

Death Proof
2010

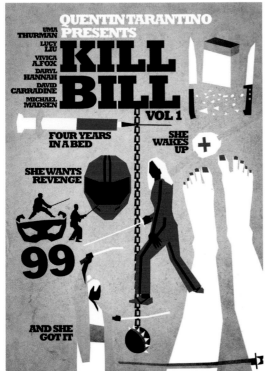

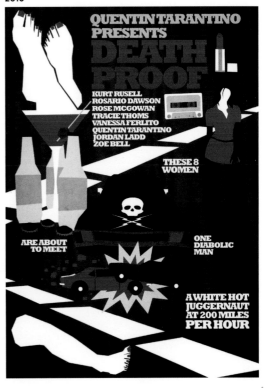

Bettlejuice
2010

Videogames, Tron
2010

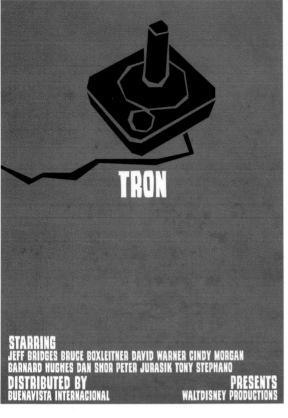

TRON

STARRING
JEFF BRIDGES BRUCE BOXLEITNER DAVID WARNER CINDY MORGAN
BARNARD HUGHES DAN SHOR PETER JURASIK TONY STEPHANO
DISTRIBUTED BY PRESENTS
BUENAVISTA INTERNACIONAL WALTDISNEY PRODUCTIONS

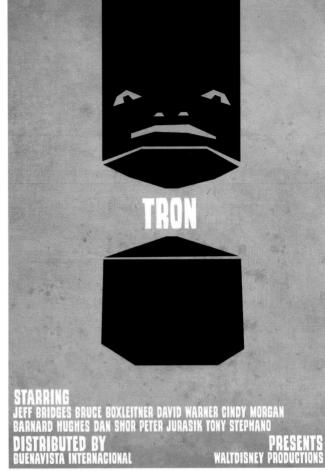

TRON

STARRING
JEFF BRIDGES BRUCE BOXLEITNER DAVID WARNER CINDY MORGAN
BARNARD HUGHES DAN SHOR PETER JURASIK TONY STEPHANO
DISTRIBUTED BY PRESENTS
BUENAVISTA INTERNACIONAL WALTDISNEY PRODUCTIONS

MCP, Tron
2010

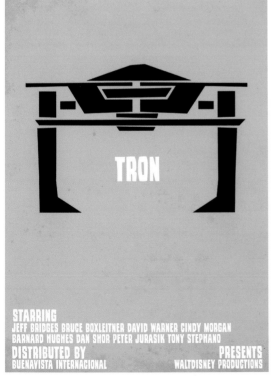

TRON

STARRING
JEFF BRIDGES BRUCE BOXLEITNER DAVID WARNER CINDY MORGAN
BARNARD HUGHES DAN SHOR PETER JURASIK TONY STEPHANO
DISTRIBUTED BY PRESENTS
BUENAVISTA INTERNACIONAL WALTDISNEY PRODUCTIONS

Light Cycles Race, Tron
2010

TRON

STARRING
JEFF BRIDGES BRUCE BOXLEITNER DAVID WARNER CINDY MORGAN
BARNARD HUGHES DAN SHOR PETER JURASIK TONY STEPHANO
DISTRIBUTED BY PRESENTS
BUENAVISTA INTERNACIONAL WALTDISNEY PRODUCTIONS

Recognizer, Tron
2010

HILLGROVE, JUSTIN

American artist Justin Hillgrove was raised on *Dungeons & Dragons* and war games. Mostly self-taught, he works as an illustrator for books, magazines, video games, collectible card games, and toys, and his art can be found hanging in many locations and galleries in the United States.

WEBSITE: impsandmonsters.com

CONTACT: impsandmonsters@gmail.com

Bad Company
2010

Priori Incantatum
2010

Duel
2010

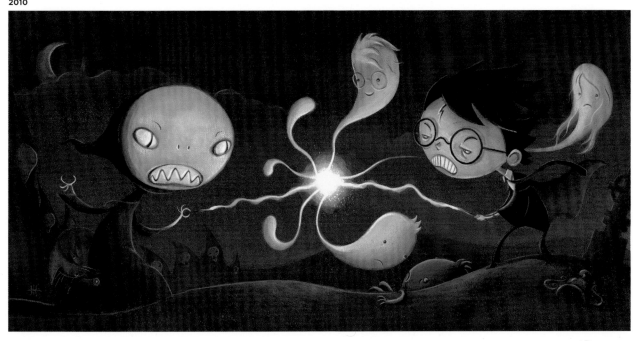

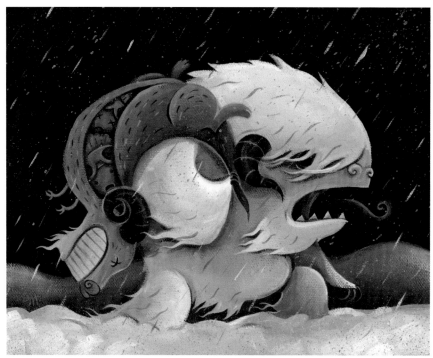

Wampa Encore
2010

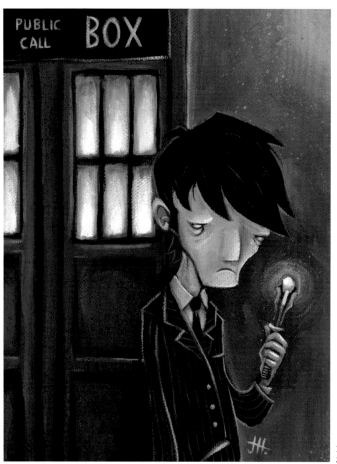

Doctor Who
2010

"All those things: the countless hours of role-playing games, the tabletop war games, Nintendo games, cartoons, books, comics, and movies—they all mixed together to form an amazing potion of influence and inspiration."

Gandalf's Descent
2010

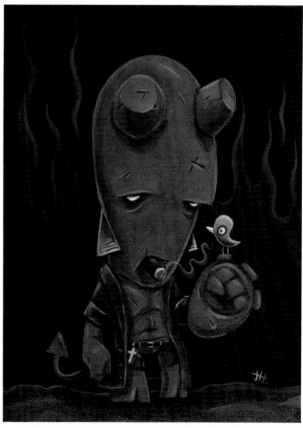

Hellboy
2008

HURRI, BJÖRN

Björn Hurri is a Latvian concept artist who has established a successful career working for the leading names in the industry, with experience across all genres, including characters, props, and environments. He is now the lead artist at Opus Artz.

WEBSITE: bjornhurri.com

CONTACT: björnhurri@hotmail.com

> " I always liked traveling in imaginary worlds. What an enjoyment when I realized that I could create mine! "

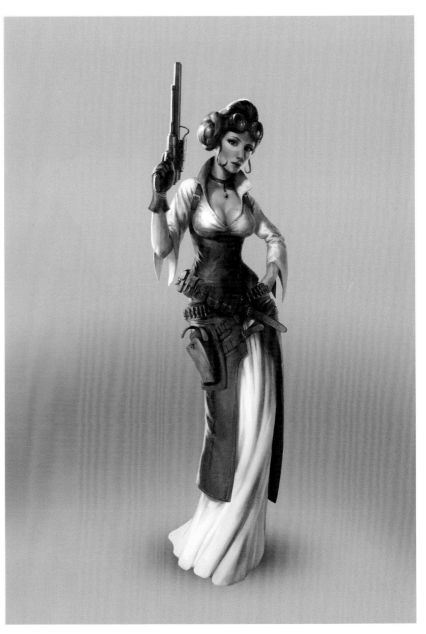

Leia
2012

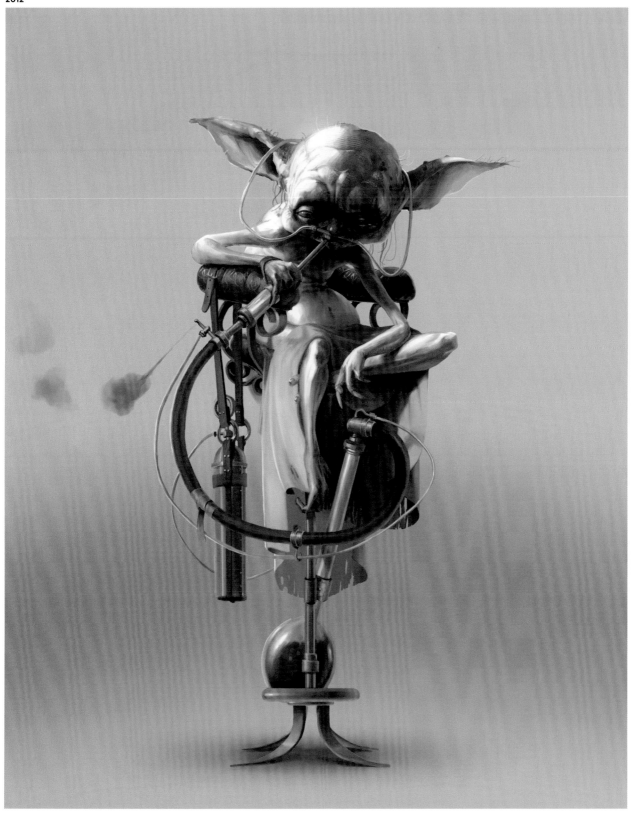

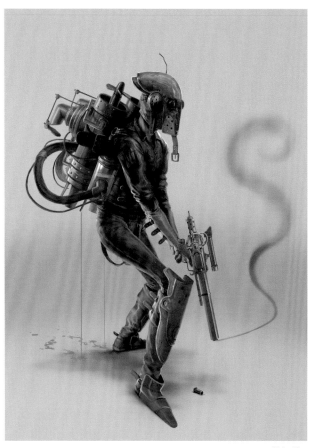

Boba Fett
2012

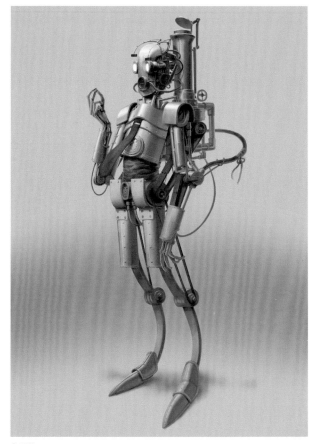

C-3PO
2012

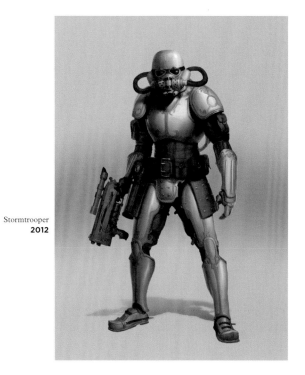

Stormtrooper
2012

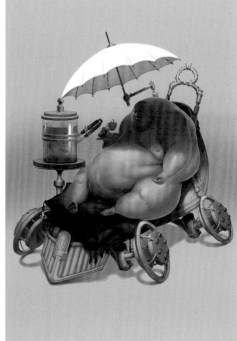

Jabba the Hutt
2012

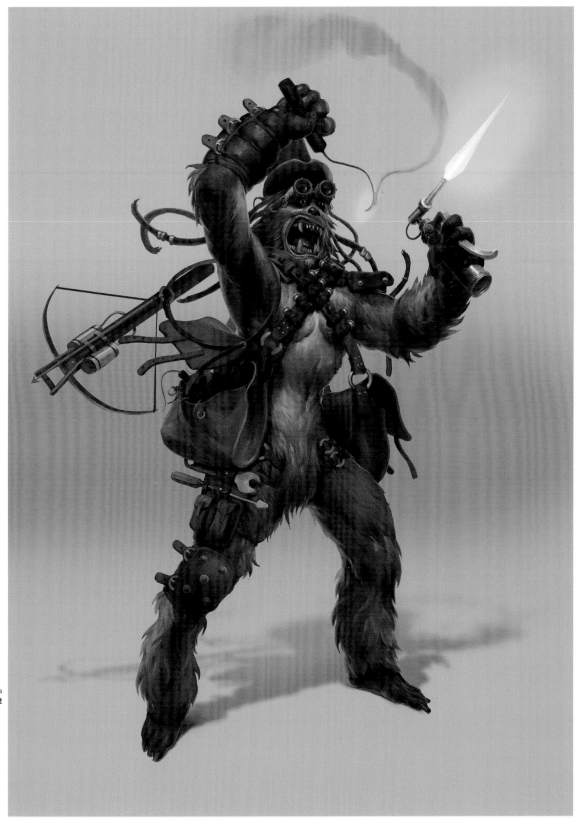

Chewbacca
2012

INFINITE CONTINUES

Ashley Browning, a British designer obsessed by video games since her childhood, hides behind the alias Infinite Continues. Her passion for video games has intensified through the years, ever since she commandeered her sister's Commodore 64.

WEBSITE: infinitecontinues.net

BLOG: ashbrowning.wordpress.com

CONTACT: ash@ashleybrowning.com

> **❝** I wondered whether the myriad of well-recognized characters from various video games would hold up to a pared-back, ultra-minimal style.
> The answer was a resounding yes.

Luigi
2009

Mario
2009

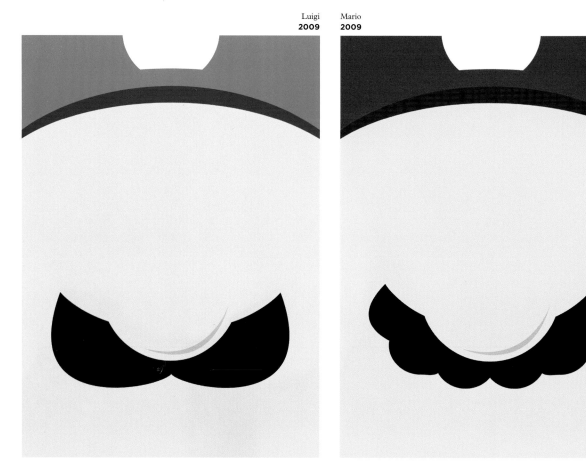

Sagat
2009

Vega
2009

Bison
2009

E. Honda
2009

JASINSKI, AARON

Aaron Jasinski grew up in a family of musicians and has designed many album covers. Having more than one string to his bow, he also illustrates children's books and creates electronic music. Strongly influenced by geek culture, he lives and works outside Seattle, Washington.

WEBSITE: aaronjasinski.com

CONTACT: jasinskione@gmail.com

Octamegatron
2010

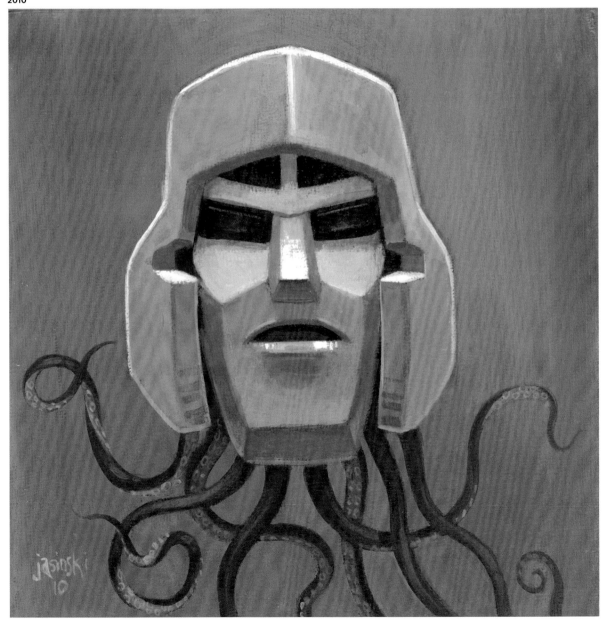

Octanator
2010

" I imagine my painting as one piece of a two-part puzzle. The puzzle is completed by the unique experience and perspective each viewer brings. "

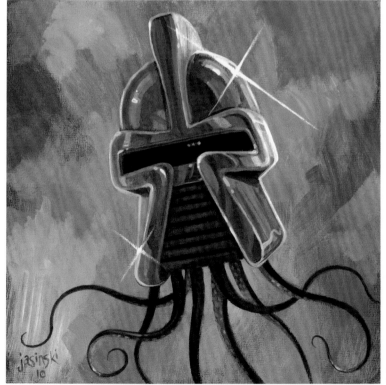

Octacylon
2010

KASURINEN, MARI

Mari Kasurinen is the artist behind the famous "My Little Pop Icons" series, which depicts pop culture icons (My Little Ponies) as pop culture icons (superheroes, film characters, etc.). Her artwork has been featured widely on the Internet and TV, as well as in newspapers and magazines, and has been exhibited in galleries and museums worldwide. She lives and works in Berlin.

WEBSITE: marikasurinen.com

CONTACT: info@marikasurinen.com

" Popular culture is
my television. "

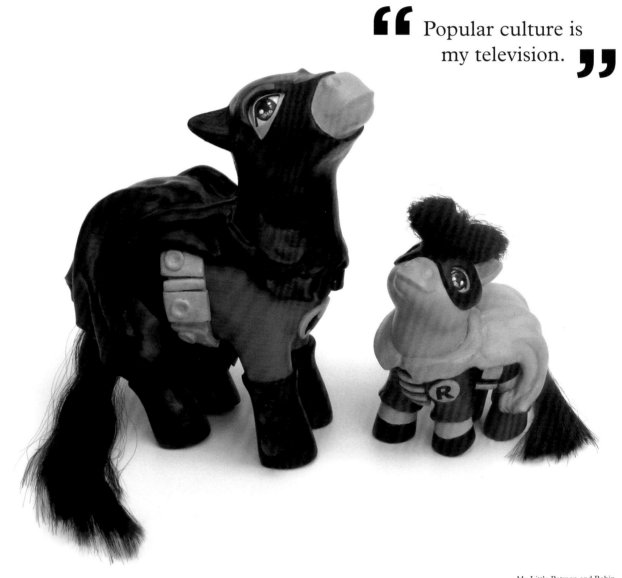

My Little Batman and Robin
2009

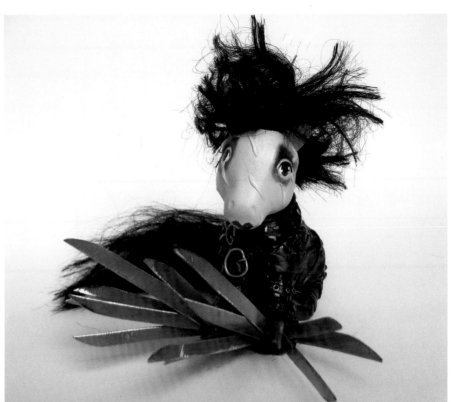

My Little Edward Scissorhands (3rd.)
2011

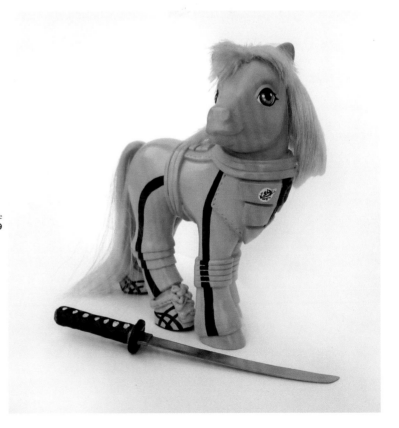

My Little Bride
2009

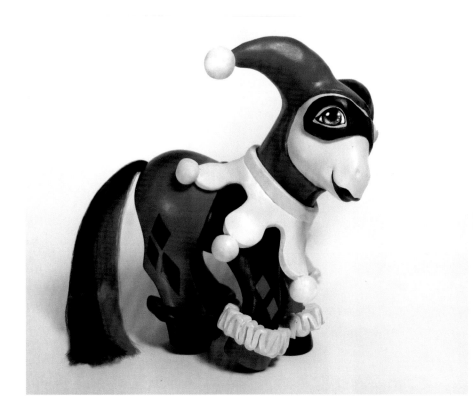

My Little Harley Quinn
2008

My Little Spock
2009

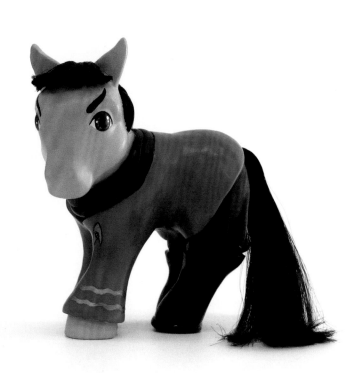

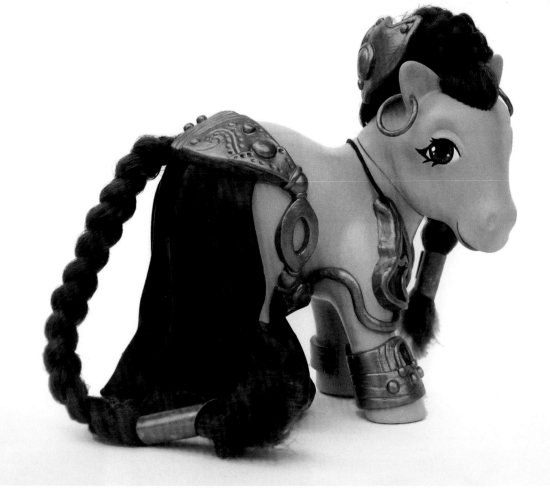

My Little Slave Princess Leia
2009

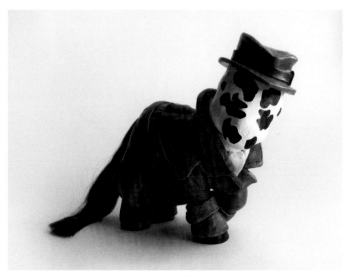

My Little Rorschach
2010

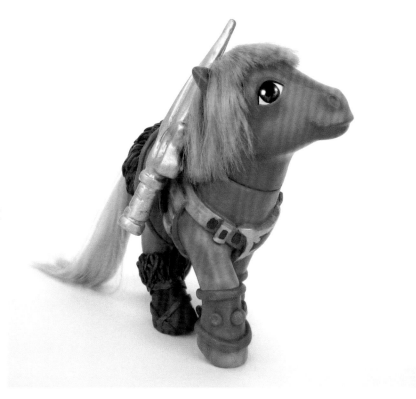

My Little He-Man
2008

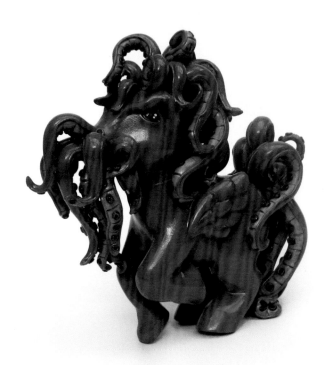

My Little Cthulhu
2012

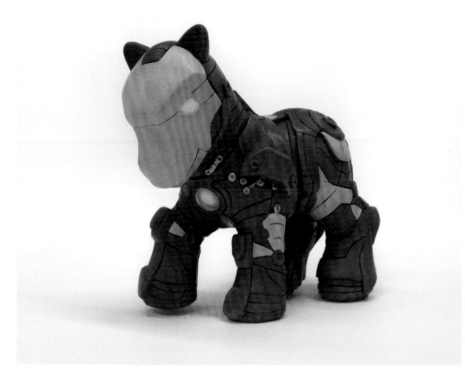

My Little Iron Man
2011

My Little Skeletor
2009

KING PANPAN

Julius Santiago, a.k.a. King Panpan, is an American artist based in San Francisco. Fascinated by design and pop culture, he likes to work according to the mantra "less is more" and the premise that a minimum of information is sometimes enough to convey ideas and feelings.

WEBSITE: kingpanpan.com

Totoro
2010

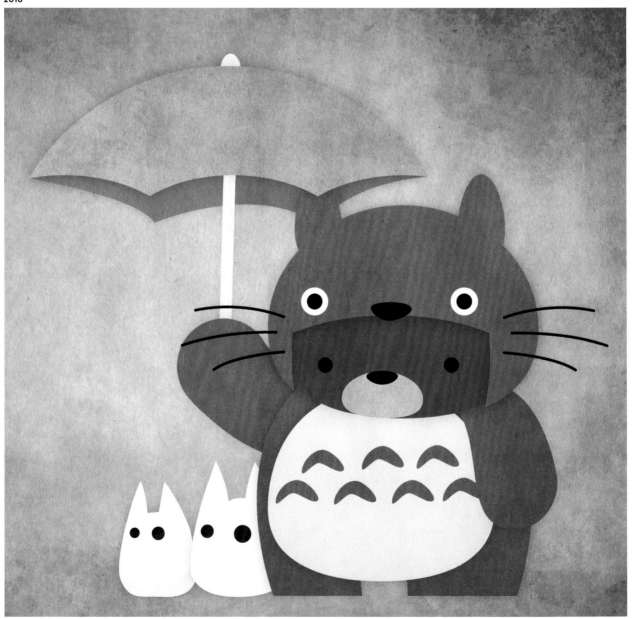

Porkins
2010

Buzz
2010

Galactus
2010

Soundwave
2010

Captain
2010

> " I like to
> draw things
> that make
> me laugh. "

Batman
2010

KING, PATRICK

Since his childhood in a small town in south central Texas, Patrick King was fascinated by comic books, a passion that remains intact and has been broadened by his interests in Soviet propaganda posters, religious icons from the medieval era, and art from the mid-20th century. He lives and works in Austin, Texas.

WEBSITE: patrickkingart.com

CONTACT: patking13@gmail.com

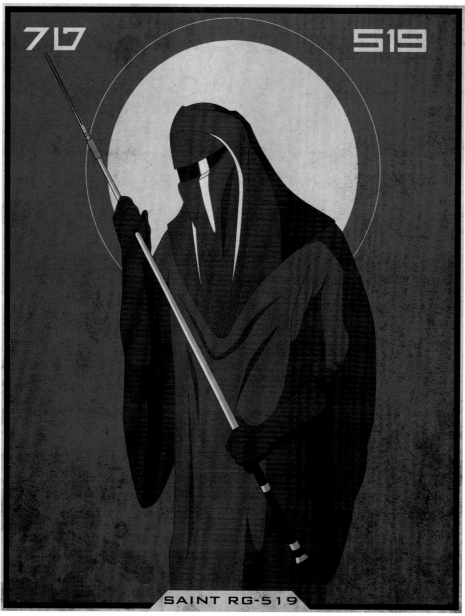

Imperial Saints—Royal Guard
2011

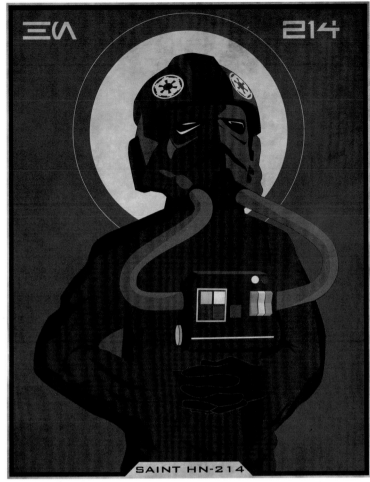

Imperial Saints—TIE Fighter Pilot
2009

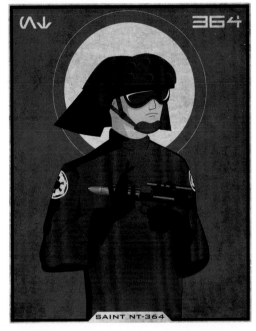

Imperial Saints—Navy Trooper
2011

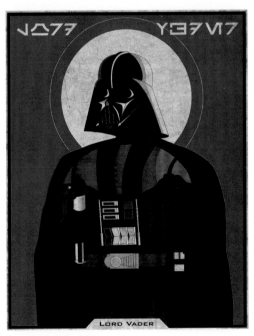

Imperial Saints—Lord Vader
2011

" It began at age nine when
I was introduced by
a friend to *Star Wars* . . . **"**

Imperial Saints—Stormtrooper
2009

Imperial Saints—Scout Trooper
2009

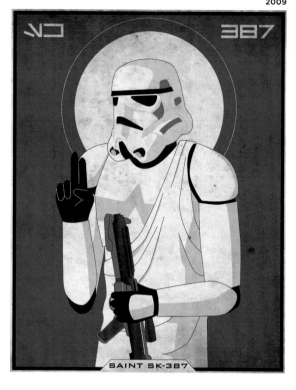

SAINT SK-387

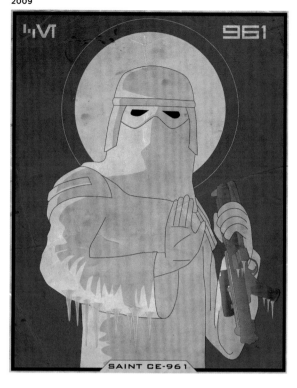

SAINT CE-961

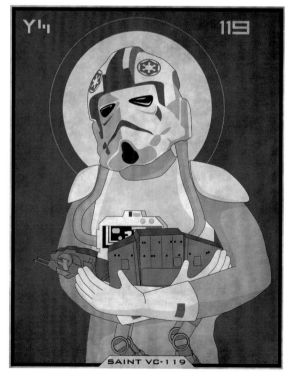

SAINT VC-119

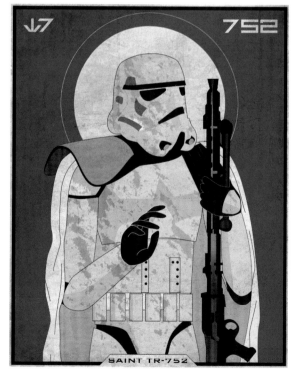

SAINT TR-752

Imperial Saints—AT-AT Driver
2010

Imperial Saints—Sandtrooper
2010

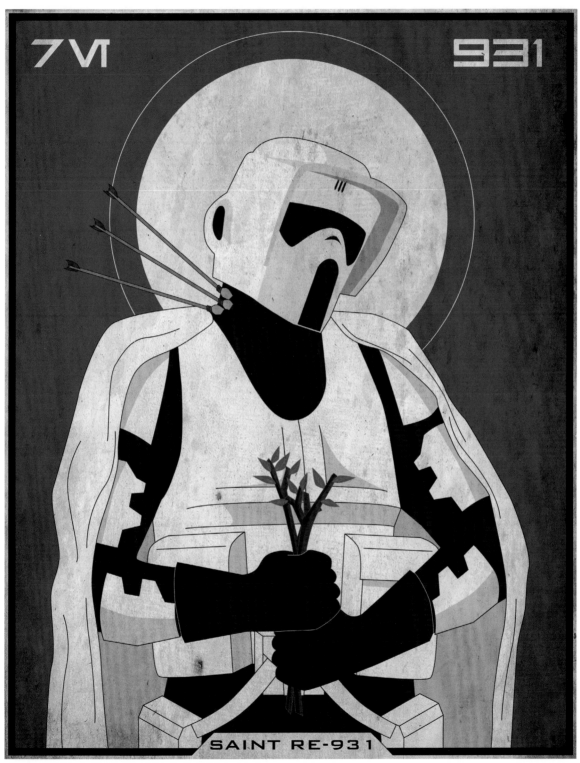

Imperial Saints—Scout Trooper
2009

KODYKOALA

Donald Kennedy, a.k.a. Kodykoala, is an American artist living in Texas. He has lasting memories of his childhood, when he used to go to school with his Nintendo lunchbox and eat his Nintendo fruit snacks. He ended up combining his passions—toys and video games—to make sculptures.

WEBSITE: kodykoala.com

CONTACT: donald.c.kennedy2@gmail.com

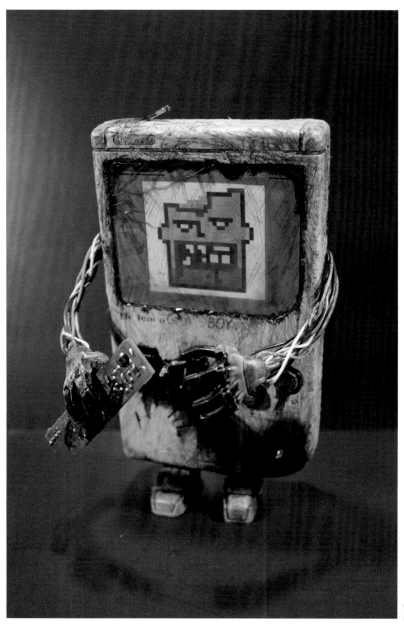

" I like to let
my imagination
be my guide. **"**

Gameboy Zombie
2011

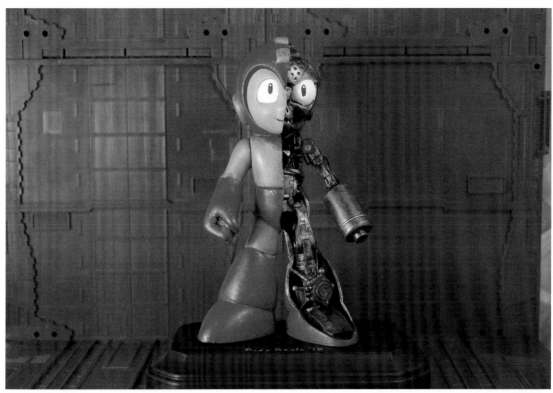

Anatomy of Megaman
2010

Cyborg Donkey Kong
2011

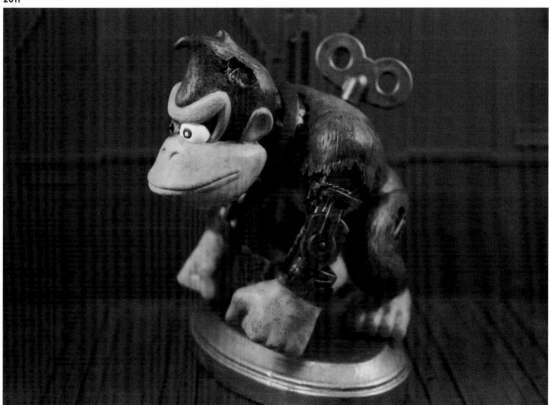

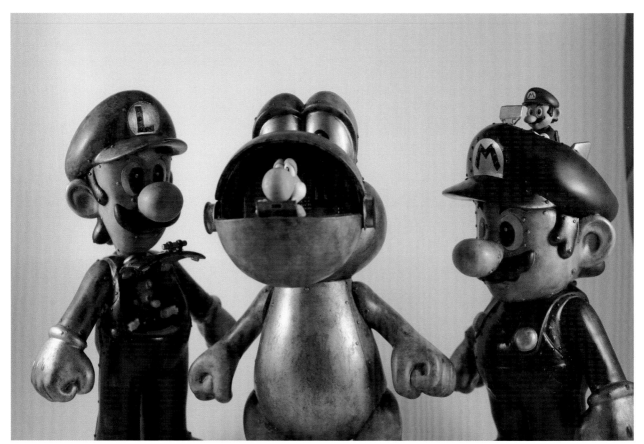

Mario, Yoshi, and Luigi Mechs
2010–2011

Kirby Eating Mario
2011

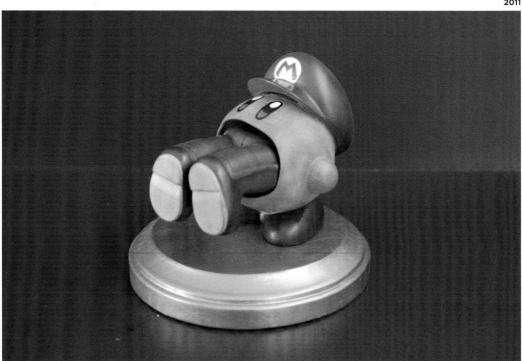

KOLB, ANDREW

Canadian artist Andrew Kolb lives and works in Kitchener, Ontario. His passion for design and pop culture helped him to produce creative experiments such as remixing *Street Fighter* and the Disney attraction "It's a Small World."

WEBSITE: kolbisneat.com

CONTACT: andrew@kolbisneat.com

" *The Street Fighter* / It's a Small World pairing made total sense to me. **"**

Street Fighting World—Ryu
2011

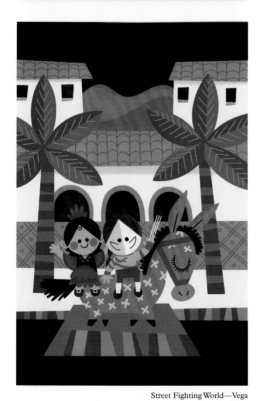

Street Fighting World—Vega
2012

Street Fighting World—Sagat
2012

Street Fighting World—Guile
2012

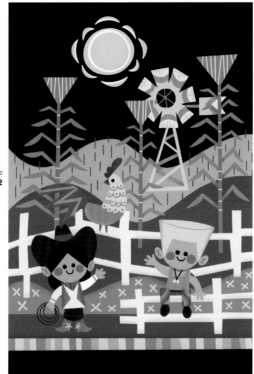

Street Fighting World—Blanka
2012

Street Fighting World – Dee Jay
2011

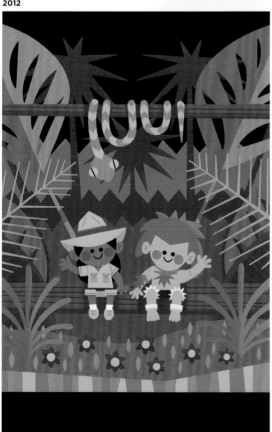

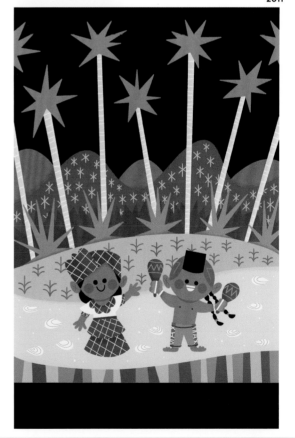

KOSHI, JONATHAN

Jonathan Koshi divided his childhood between Hawaii and California, and his travels around the world have imprinted his work. His primary influences come from the 1950s New York School, mid-century modernism, and street art. His work mixes modern technology with old processes in order to put a new spin on the culture around him.

BLOG: notesfromthezeitgeist.blogspot.fr

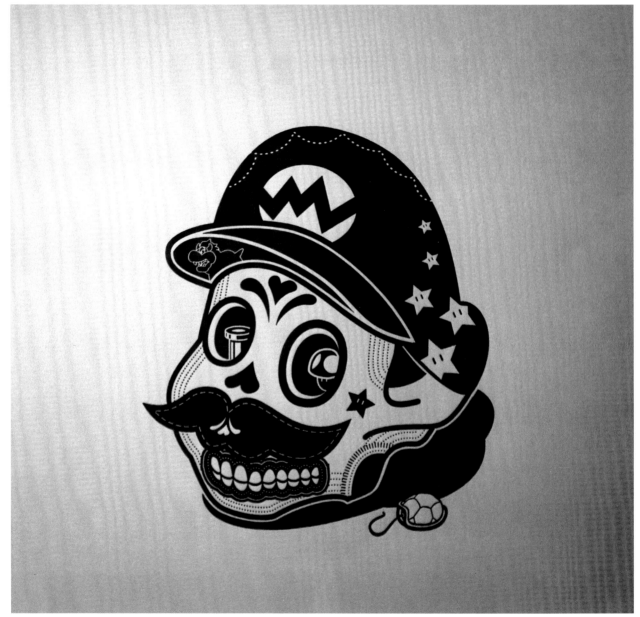

Sugar Plumber
2011

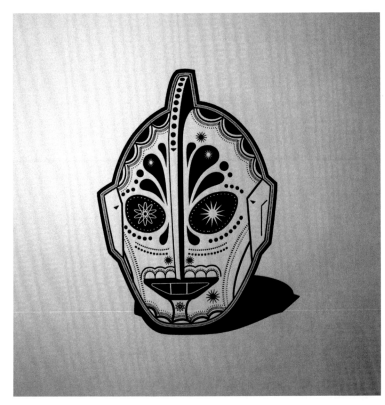

Ultrasugar
2011

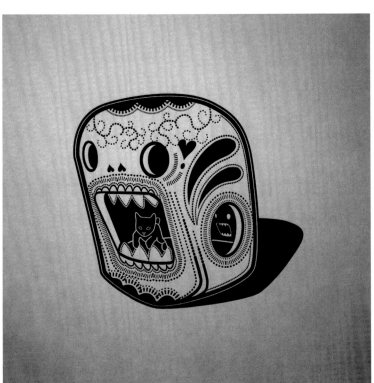

Sugarkun
2011

Piggy's Sugar
2011

Lego My Sugar
2011

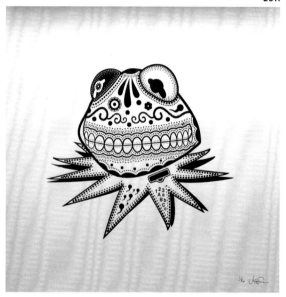

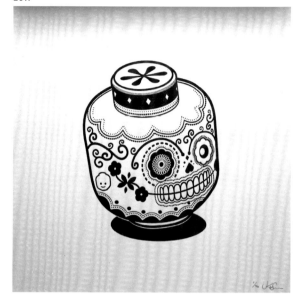

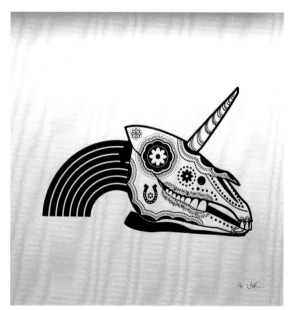

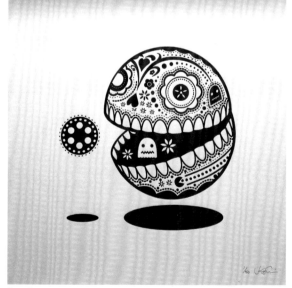

Sugarcorn
2011

Sugar Pellet
2011

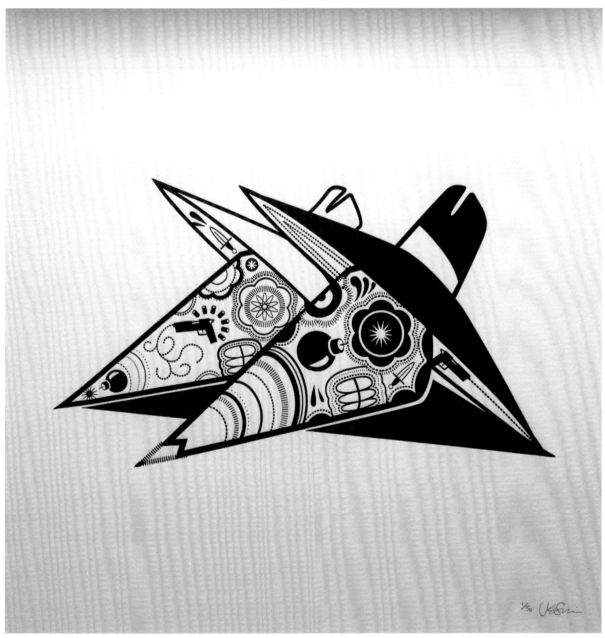

Sugar vs. Sugar
2011

LECHAFTOIS, BORIS

As a child, Boris Lechaftois fell asleep at night listening to the *Back to the Future* soundtrack, loved *Ghostbusters*, and his loyal Game Boy never left his side. Today he is a freelance graphic designer living in Toulouse, France, whose early interest in Geek-Art now shows in his video game illustrations.

WEBSITE: lechaftoisbo.com

BLOG: lboris.blogspot.com

CONTACT: lechaftois.bo@gmail.com

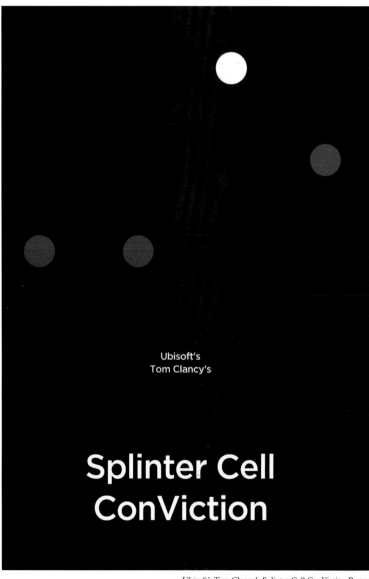

" Obviously I will always be that kid with bright eyes every time he opens his latest video game or DVD. **"**

Ubisoft's Tom Clancy's Splinter Cell ConViction Poster
2010

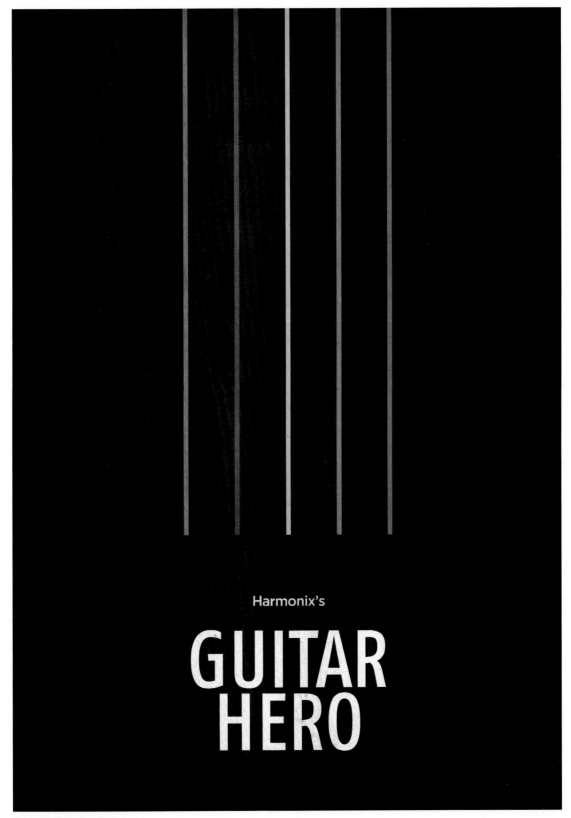

Harmonix's Guitar Hero Poster
2010

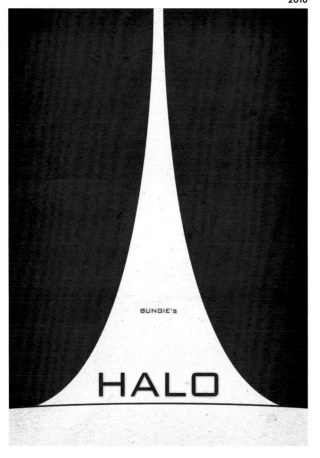

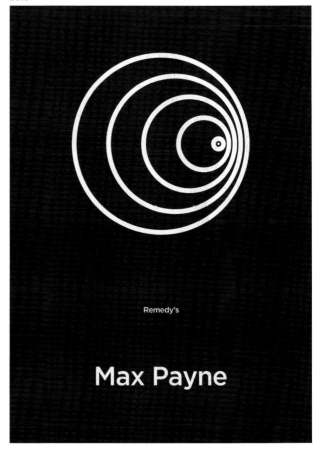

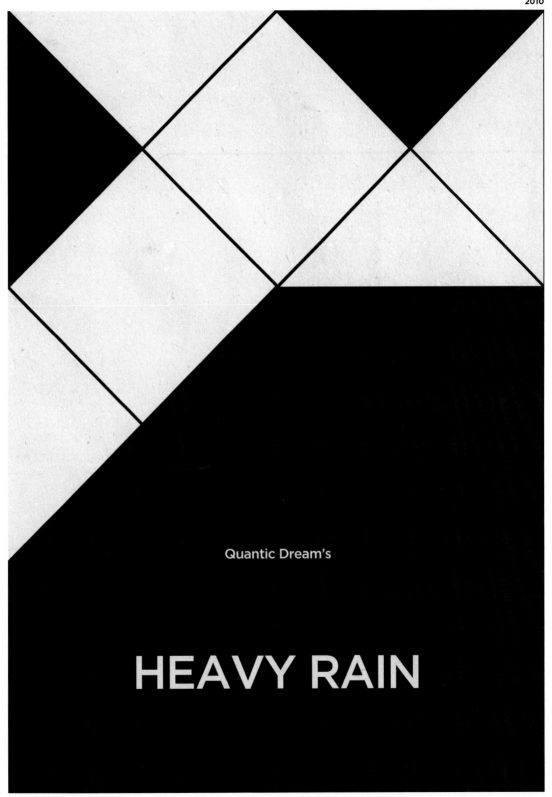

Quantic Dream's

HEAVY RAIN

LEIGHTON, ALEX

Alex Leighton lives and works in Auckland, New Zealand. Growing up on a steady diet of cartoons, *The Muppet Show*, and *Star Wars*, he knew what he wanted to do with his life: After college, he created the animation studio Mukpuddy, along with two friends. His work allows him to pay tribute to the heroes who fed his passion.

WEBSITES: xander13.com and www.mukpuddy.com

Hoggle
2010

> **"** As a kid, I enjoyed video games
> and toys. All of them helped
> shape the artist
> I am today! **"**

ET
2011

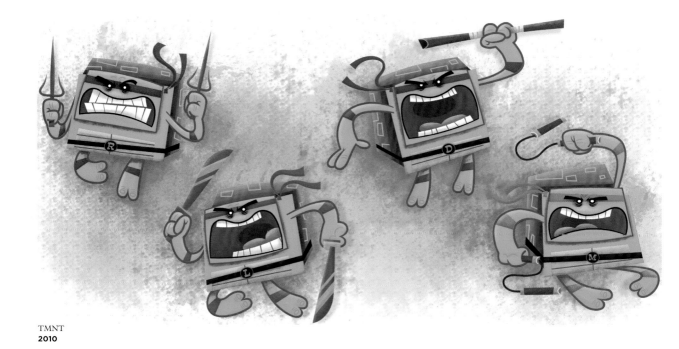

TMNT
2010

The Precious
2012

"It's So Fluffy!"
2011

IT'S SO FLUFFY

Vader vs. Obi-Wan
2011

Where the Wild Things Are
2009

Christopher Johnson
2011

LN, JOSH

Josh LN works as a graphic designer in Kansas City, Missouri. Obsessed with *Teenage Mutant Ninja Turtles*, *Robocop*, *Ghostbusters*, and *Voltron* since an early age, he likes to mix pop culture and minimalist design.

WEBSITE: society6.com/joshln

CONTACT: josh@joshlanedesign.com

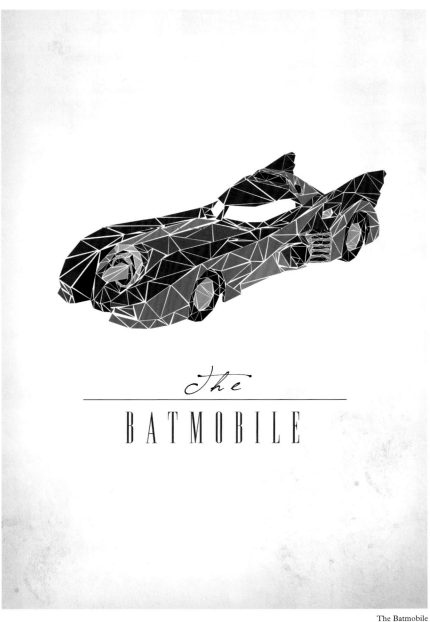

The BATMOBILE

The Batmobile
2012

> **"** My passion began when I was a child in the '80s when art, clothing, and movies all had really bright colors and sci-fi themes. **"**

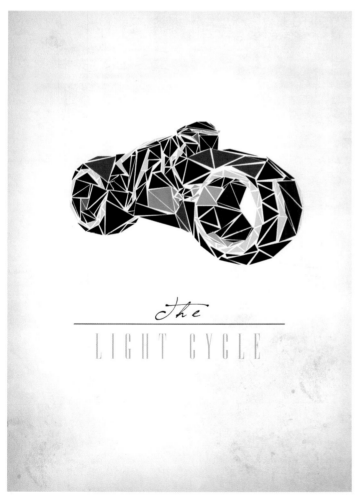

The Light Cycle
2012

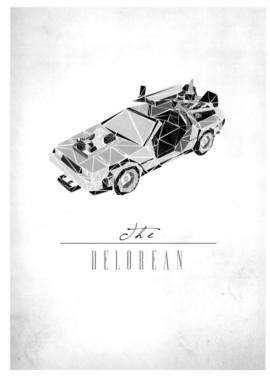

The Delorean
2012

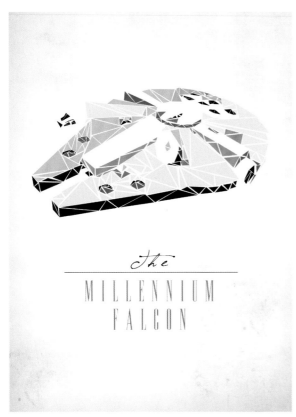

The Millennium Falcon
2012

The
MILLENNIUM
FALCON

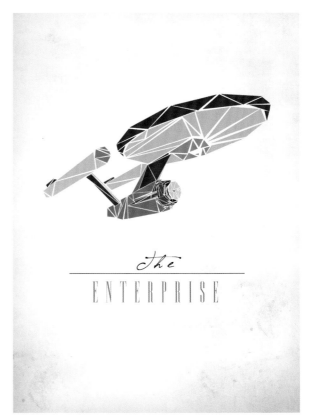

The
ENTERPRISE

The Enterprise
2012

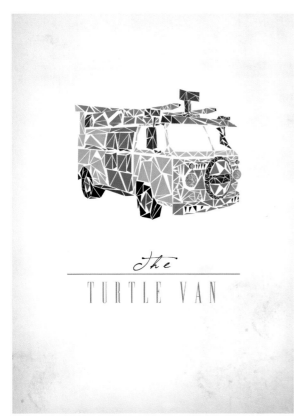

The
TURTLE VAN

The Turtle Van
2012

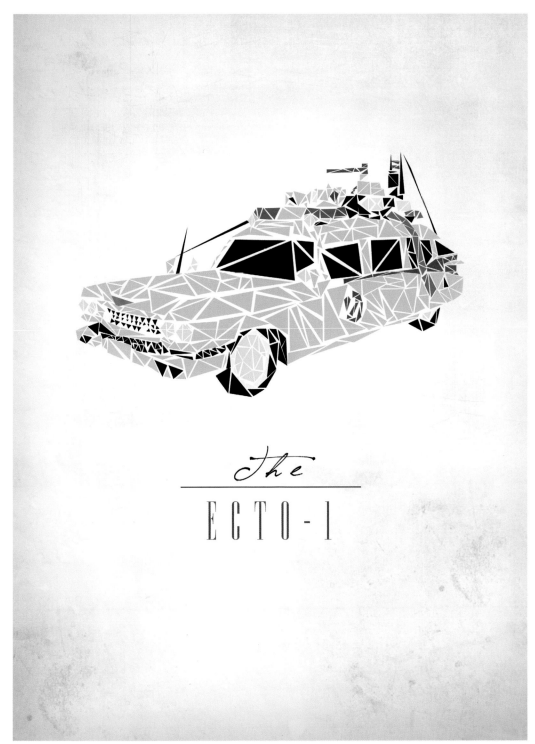

The

ECTO-1

The Ecto-1
2012

MA, CALVIN

An artist based in San Francisco, Calvin Ma studied sculpture at the Academy of Art University. Since his childhood, he has been fascinated by toys and action figures, and his work is heavily centered around a longtime passion for toys.

WEBSITE: calvinmasculpts.com

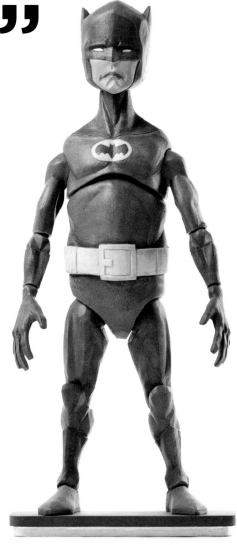

> " My work taps into this childlike sense of exploration. "

Wolverine
2010

Batman
2010

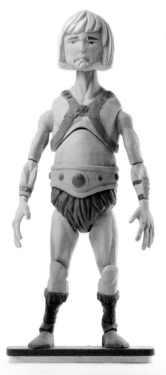

He-Man Lion-O
2010 **2010**

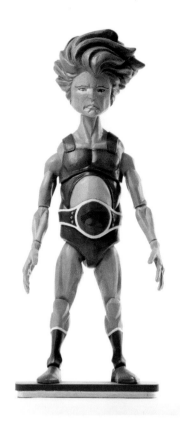

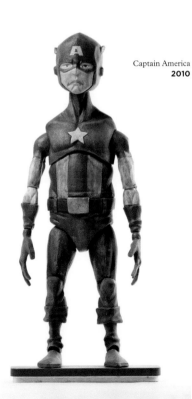

Captain America Spider-Man
2010 **2010**

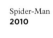

MALGORN, YVES-JOSÉ

French freelance graphic designer Yves-José Malgorn is influenced by music, movies, and literature. His love for science fiction, manga, anime, and graphic design is also clear throughout his work.

WEBSITE: ym-graphix.com

CONTACT: ym-graphix@hotmail.fr

Terminatrix
2012

C-3PO
2012

Bender
2012

> **"** I was programmed to be
> a geek, play video games,
> watch movies, read manga
> and comic books,
> draw robots . . . **"**

Arale
2012

MANEV, MARKO

Living in Skopje, Macedonia, Marko Manev didn't like pens or crayons until he discovered comics, but since he started drawing, he has been unstoppable. Today he is a sculptor, painter, writer, and graphic designer.

WEBSITE: behance.net/markomanev

CONTACT: superiorityproject@gmail.com

Spider-Man

Minimalist Spider-Man
2011

> **"** All because of comics . . . and *Star Wars* of course. **"**

SILVER SURFER

Minimalist Dr. Manhattan
2011

Minimalist Iceman
2011

Minimalist Nite Owl
2011

Minimalist Cyclops
2011

Minimalist Daredevil
2011

Minimalist Iron Man
2011

Minimalist Galactus
2011

Minimalist Magneto
2011

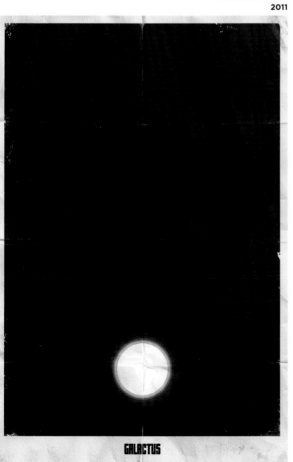

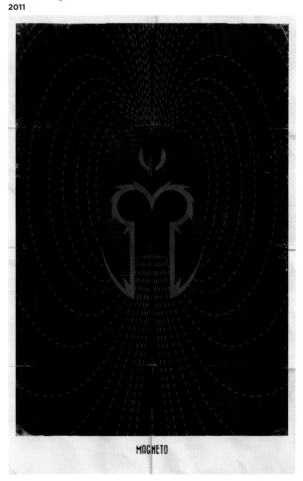

MANUHELL

Manuel Augusto Dishinger Moura, a.k.a. Manuhell, lives and works in São Paulo. As a child of the '80s and the '90s, he had a soft spot for geek culture. For a long time he drew his favorite heroes, before turning to his own creations and world, but he still continues to apply his own personal twist to the supermen who used to roam his dreams.

WEBSITE: manuhell.deviantart.com

" Geek culture linked all children who didn't like soccer or 'normal' worlds. "

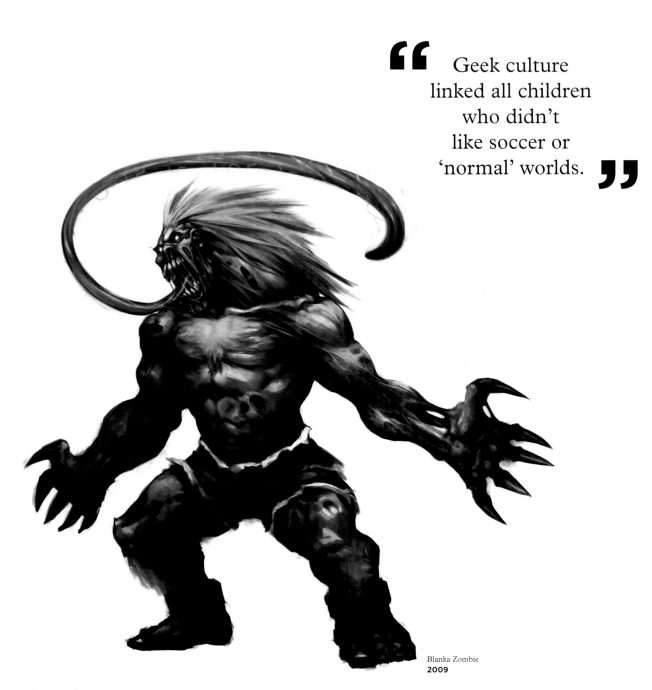

Blanka Zombie
2009

Cammy Zombie Vega Zombie
2009 **2009**

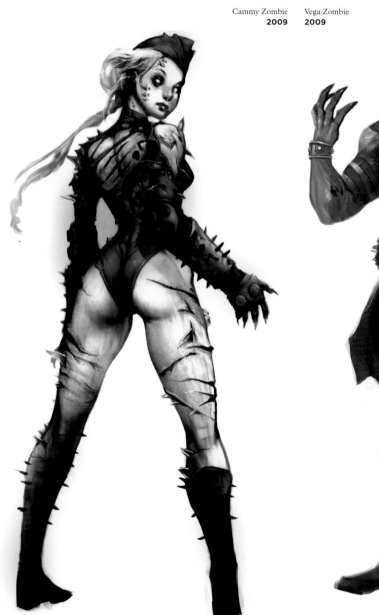
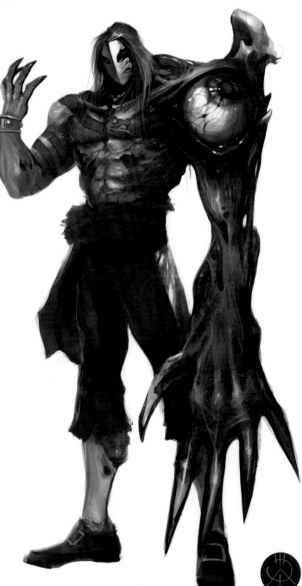

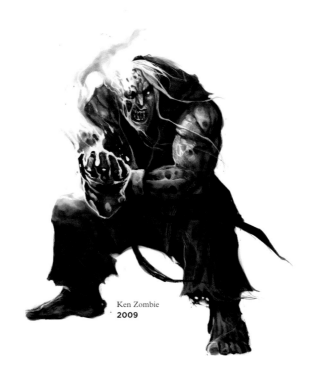

Ken Zombie
2009

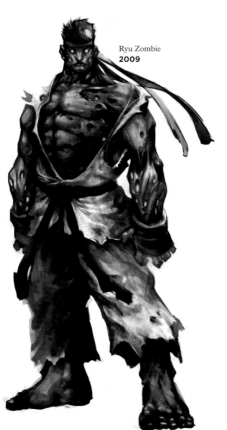

Ryu Zombie
2009

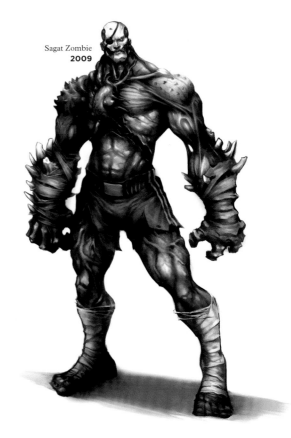

Sagat Zombie
2009

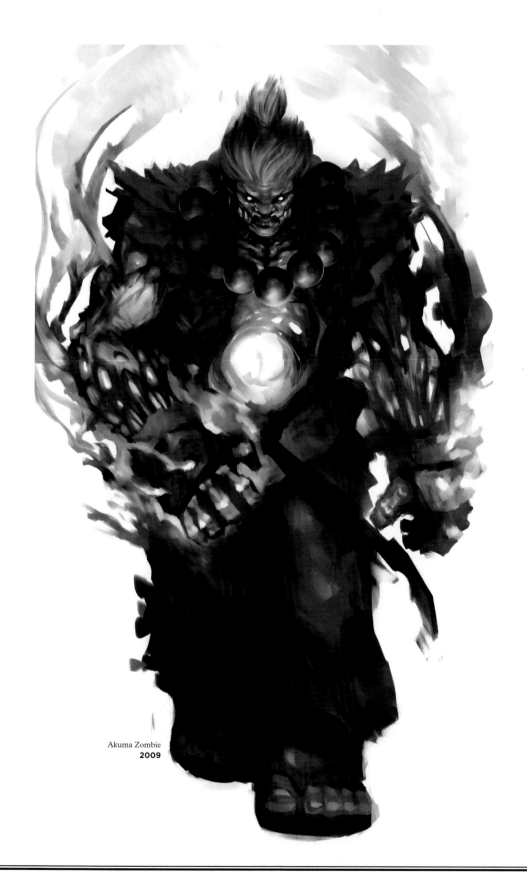

Akuma Zombie
2009

McALISTER, JACOB

Jacob McAlister is a British illustrator fond of George Lucas' work, so fond in fact that he named his website after a meal offered to Doctor Jones in the movie *Indiana Jones and the Temple of Doom*.

WEBSITE: youfoundjacob.com

BLOG: trythemonkey.blogspot.com

Dichotomy
2012

Grand Moff Tarkin Icon
2010

> **" ** One day, geeks
> will rule
> the world, that's
> obvious.
> When that day
> comes, I would
> gladly accept the
> title of official
> spokesman. **"**

Stormtrooper Icon
2010

The Avengers
2012

The Womp Rat Pack
2011

Grail Knight
2011

TriForce and Master Sword
2012

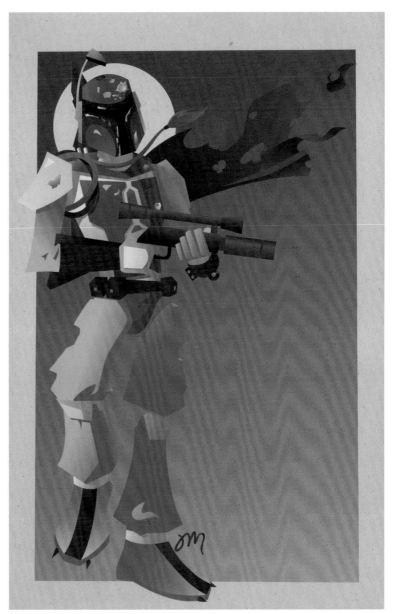

Boba Fett
2011

MISTER HOPE

Mister Hope is a British artist from the small town of Buxton who has been drawing for as long as he can remember. In 2010, he accepted the challenge of drawing a picture from scratch every day for a year. Then he published the book *365: A Year in the Imagination of Mister Hope*. His influences include Tim Burton, Quentin Blake, and Maurice Sendak.

WEBSITE: misterhope.com

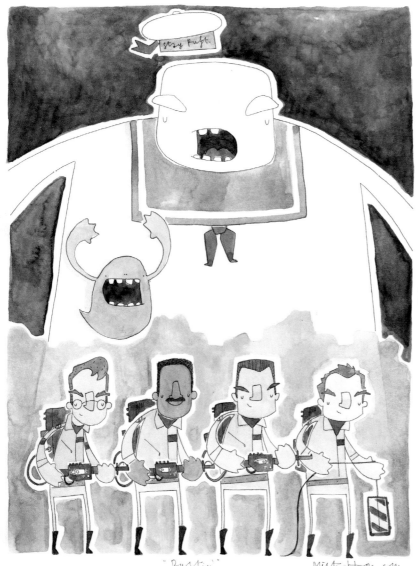

Ghostbustin'
2011

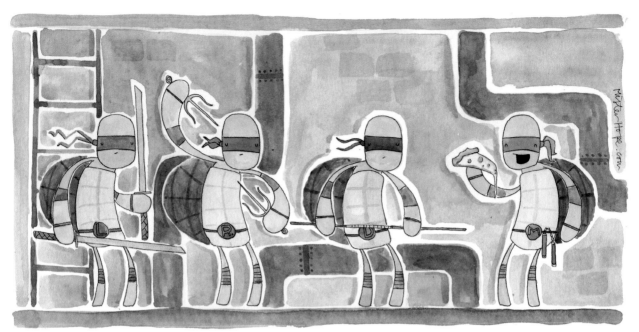

Cowabunga!
2010

Billions of Blistering Blue Barnacles
2011

Blistering Barnacles!

MisterHope.com

> " My art is the world I live in: where mice can talk, magic is real, robots are everywhere, and Batman fights crime every goddamn day. "

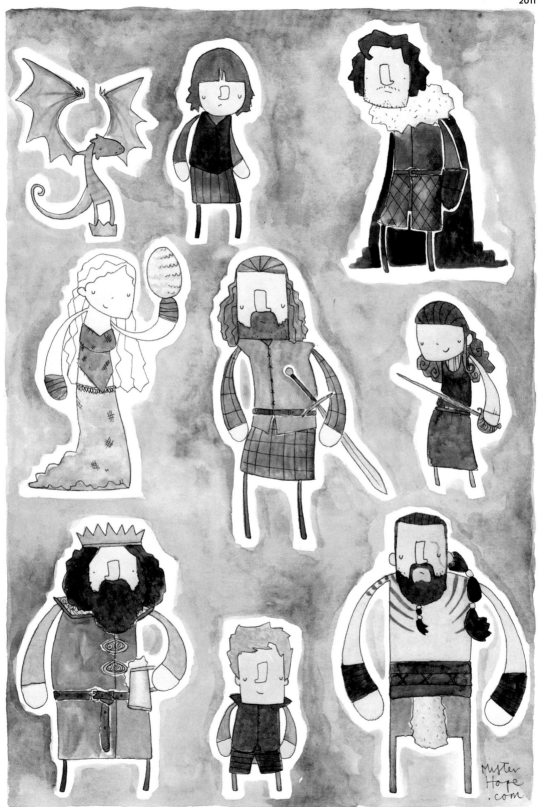

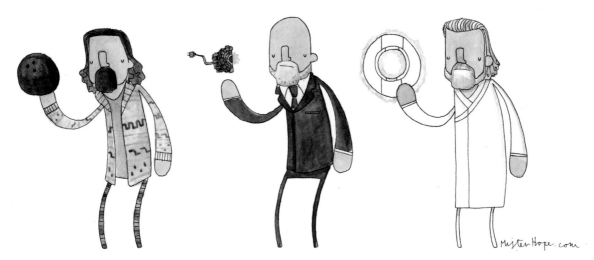

The Dude
2011

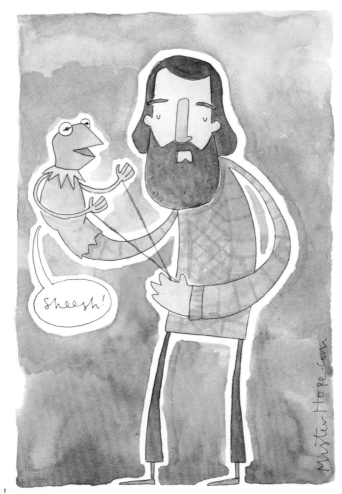

Jim Henson
2012

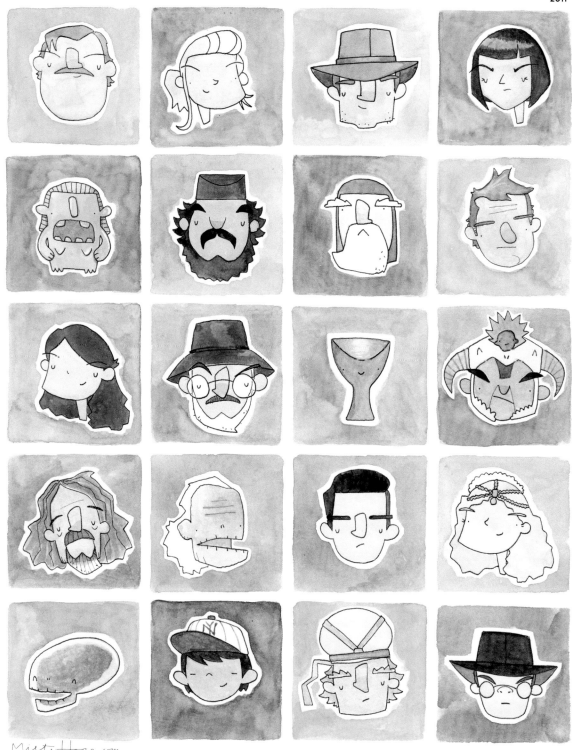

MisterHope.com

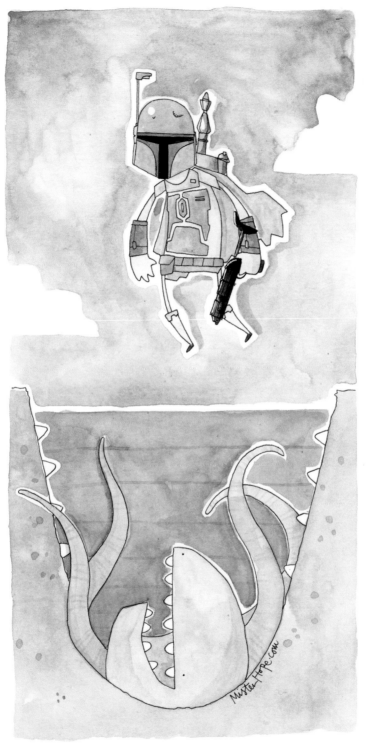

Boba vs. the Sarlacc
2012

MOLINA, NACHO

Nacho Molina studied art at the Polytechnic University of Valencia, Spain. He works as a digital painter for games such as *World of Warcraft*, *Warhammer*, *Lord of the Rings*, and *Call of Cthulhu*. He currently lives in Liverpool, England.

BLOG: nachomolinablog.blogspot.com

CONTACT: nachomolinaparra@gmail.com

Babidi and Bu
2009

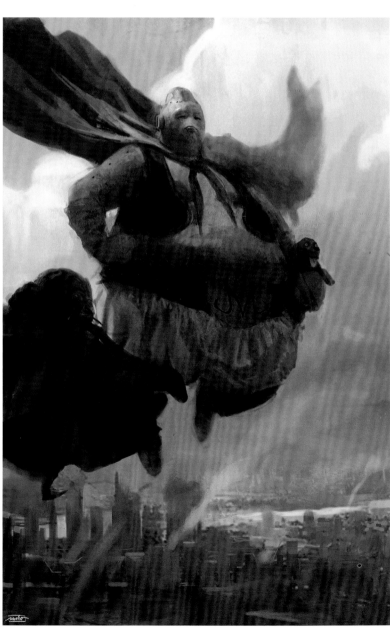

" I was born in 1985 and I grew up in the '90s and I suppose that most of you know what that means. **"**

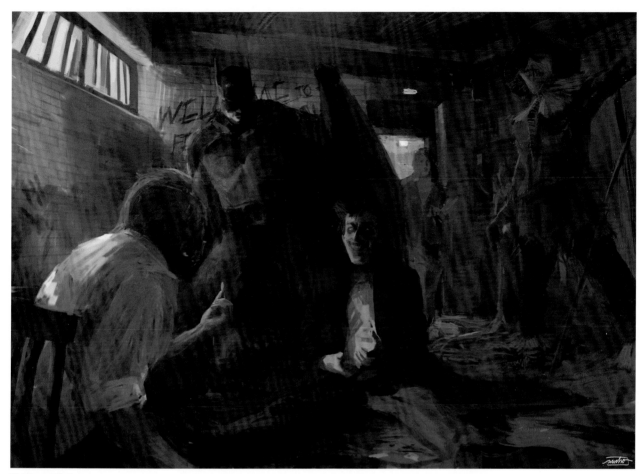

The Feast of Fools
2009

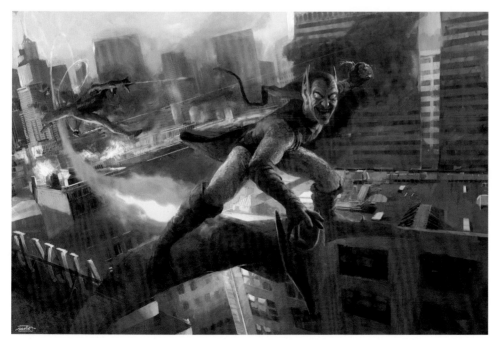

Chasing the Green Goblin
2009

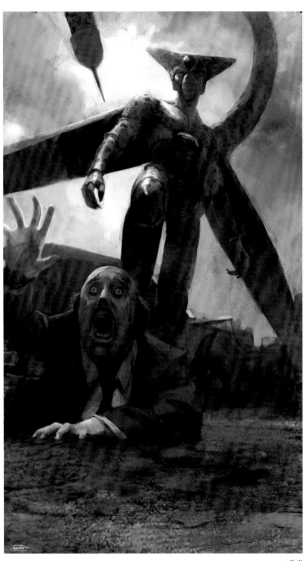

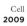

Cell
2009

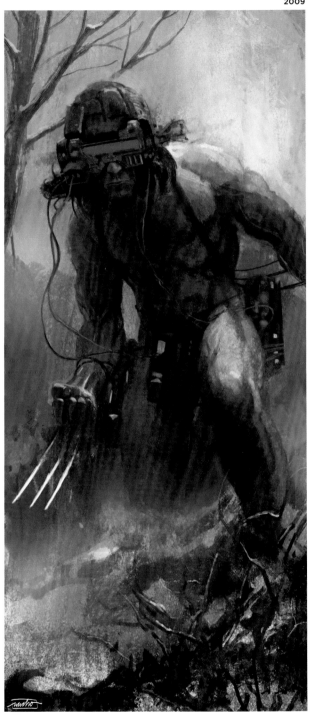

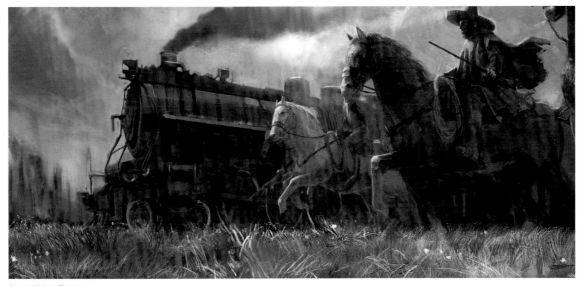

Sunset Riders Cormano
2009

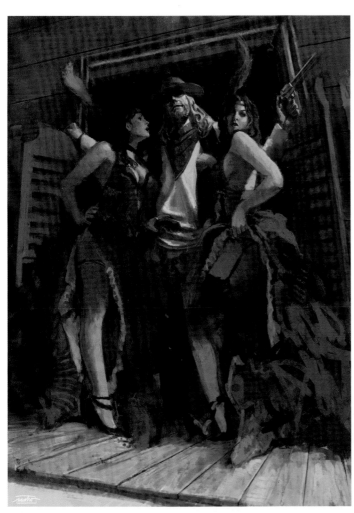

Sunset Riders Steve
2009

MONK, SIMON

Simon Monk is a British painter who at one time taught art history at the university level, but has since left teaching to focus on his own painting. With a technique inspired by Renaissance art, his work has found a wide audience.

WEBSITE: simonmonk.com

CONTACT: simonmonk66@gmail.com

> **"** I discovered the fascinating world of comic books in 1973, and I never stopped reading them. I also love the Italian Renaissance. I successfully mixed both obsessions, and I hope to continue for a long time! **"**

Dr. Bruce Banner
2011

Clark Kent
2011

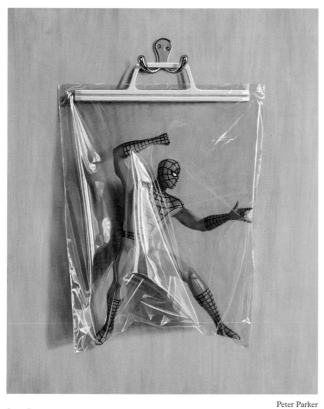

Steve Rogers
2011

Tim Drake
2012

Peter Parker
2011

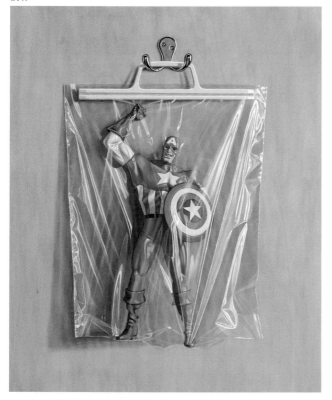

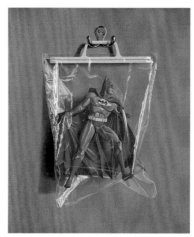

Bruce Wayne
2012

MYERS, MICHAEL

Working and living in Waterloo, Iowa, Mike Myers is a freelance illustrator and designer who works full time as a 2D/3D artist and animator for Phantom EFX. He confesses the influence of video games, books, and RPGs with steampunk elements.

WEBSITE: drawsgood.com

BLOG: drawsgood.tumblr.com

CONTACT: mbmyers@gmail.com

Steve Jobs
2011

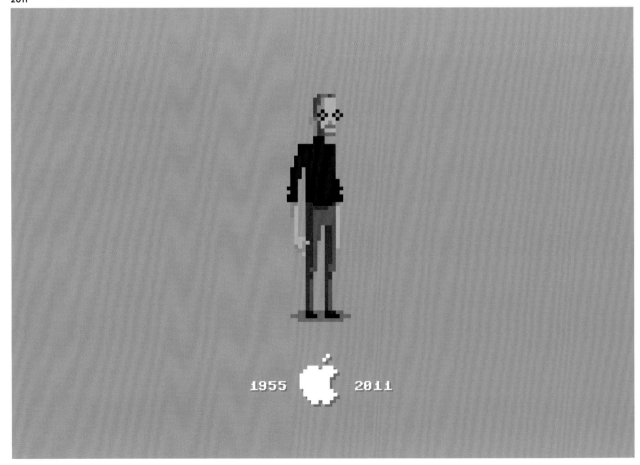

Big Daddy
2011

 I love creating
pop culture
and have a passion
for concept art.

Killzone
2011

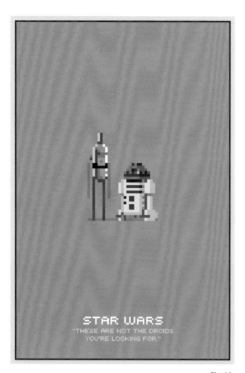

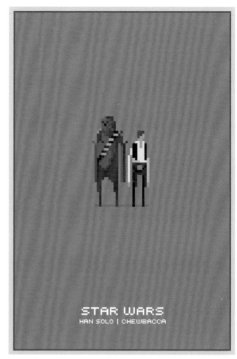

Droids
2011

Han & Chewie
2011

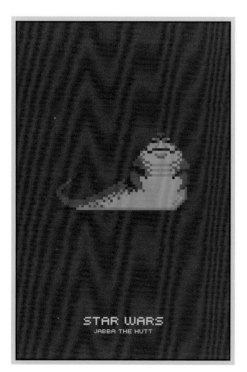

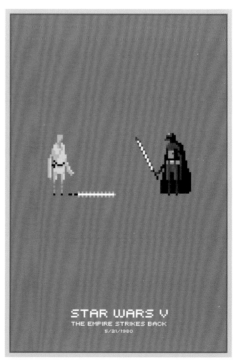

Jabba
2011

I'm Your Father. Really.
2011

Dead Space
2011

Gordon Freeman
2011

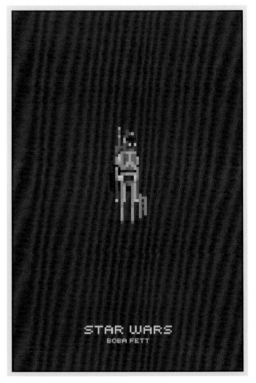

Samus
2011

Bounty Hunter
2011

The Chief
2011

Marcus
2011

Doctor Who #4
2011

NCT, CARLOS

Carlos NCT is a prolific Spanish artist specializing in fantasy and science fiction-influenced work. He has collaborated on RPGs and collectible card games including *Legend of the Five Rings*. He works at Mercury Steam, the game development company behind *Jericho* and *Castlevania: Lords of Shadow*.

WEBSITE: carlosnct.com

BLOG: bucetoz.blogspot.com

CONTACT: contact@carlosnct.com

Joker
2010

❝ I love what I can't understand. **❞**

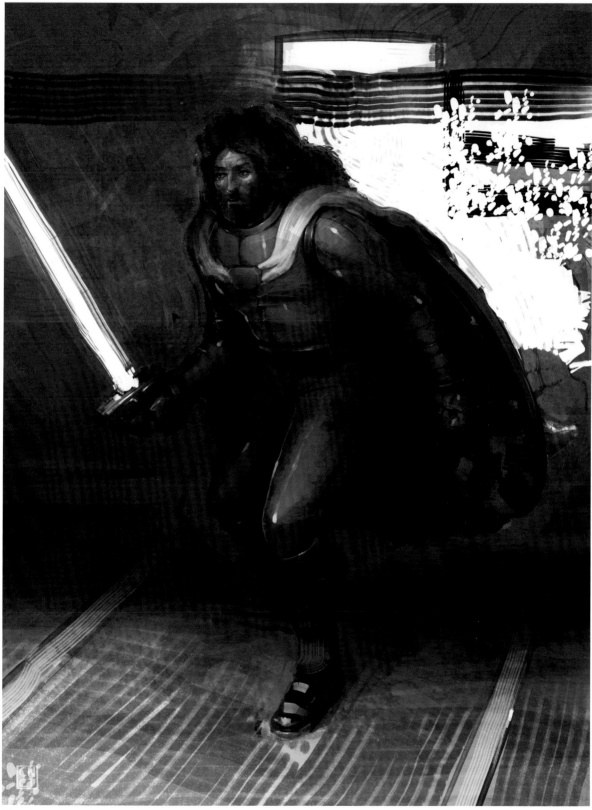

Ulysses 31
2010

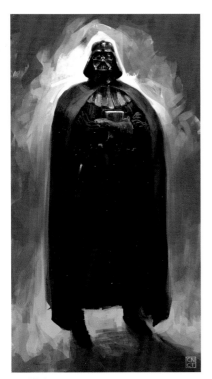

Darth Vader
2010

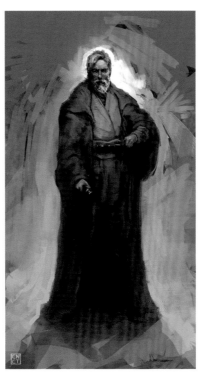

Obi-Wan Kenobi
2010

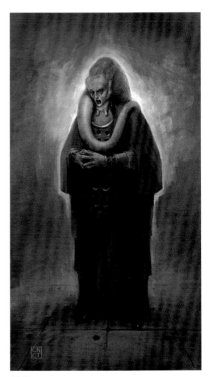

Bib Fortuna
2010

The Return of the Jedi
2011

Moradores de las Arenas
2010

Vader & Kenobi
2011

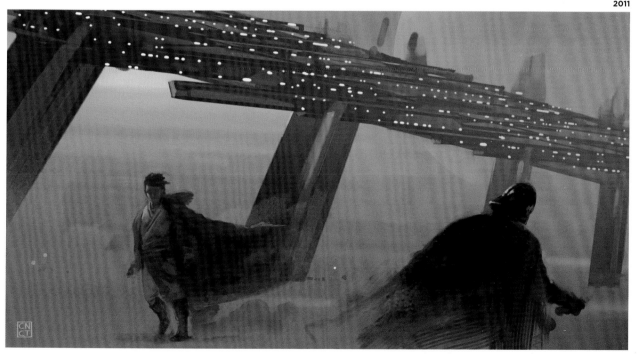

NOVEIR, ARIAN

Arian Noveir is a French graphic designer, web designer, and photographer. His discovery of Disney movies as a child was an epiphany, and he has since continued drawing and experimenting with his art. He particularly draws inspiration from music.

WEBSITE: noveir.com

BLOG: arian-noveir.tumblr.com

CONTACT: arian-noveir@gmail.com

Spider-Man (Peter Parker)
2011

"80% video games,
15% cult movies,
5% Internet."

Hellboy (Anung Un Rama)
2011

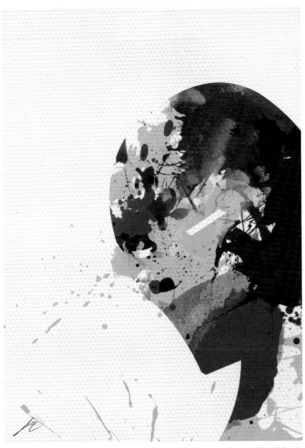

Iron Man (Anthony Edward "Tony" Stark)
2011

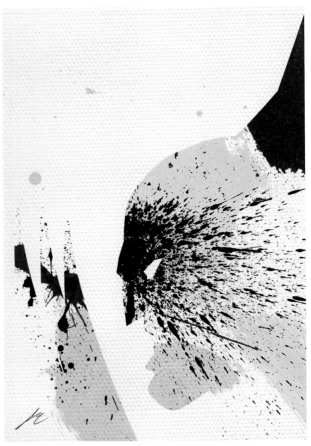

Wolverine (James "Logan" Howlett)
2011

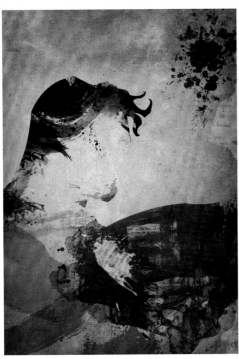

Superman (Clark Joseph Kent)
2011

Thor (Donald Blake)
2011

OCONNELL, JAMES

James Oconnell is a British designer and illustrator living in Manchester. His father was a carpenter, which influenced his creative path, as did movies such as *Star Wars*, *Blade Runner*, and *The Thing*.

WEBSITES: james-oconnell.com and anonymousmag.co.uk

BLOG: james-oconnell.com/blog

CONTACT: wave@james-oconnell.com

> " Geek-Art to me is an explanation of the *Star Trek* ships I used to draw in school, the type of drawings that nearly got me beaten up because they weren't seen as being 'cool.' "

Saving the Galaxy Time and Time Again
2011

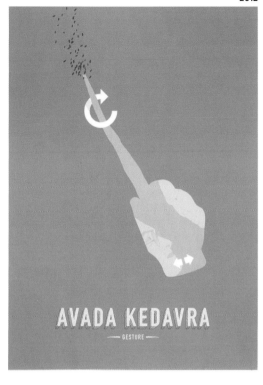

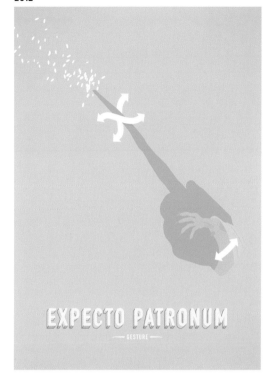

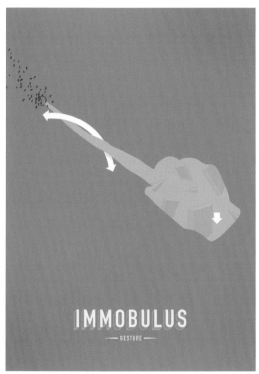

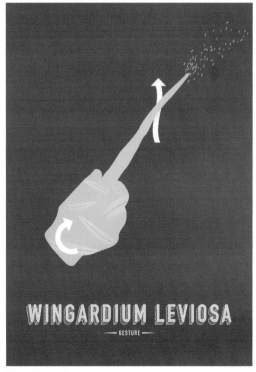

A Lover, Not a Fighter No Hope Like New Hope
2011 **2011**

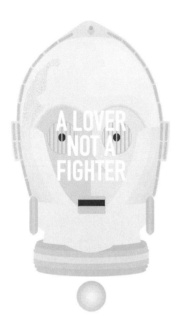

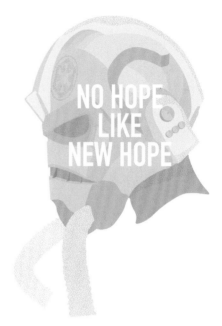

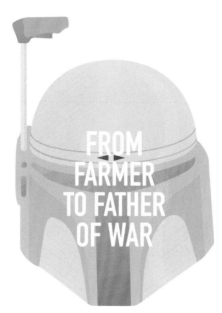

From Farmer to Father of War
2011

To Live and Die as a Jedi
2011

OLIVER, PATRICIO

Patricio Oliver studied graphic design at the University of Buenos Aires, where he has been a professor of typography since 2000. He is fascinated by the Victorian culture, comic books, manga, and artists such as Bruce Timm. As a designer and illustrator, he has worked with clients such as BBDO Argentina, *Rolling Stone*, Kid Robot, and the Cartoon Network, and he has participated in exhibitions and conferences around the world. With the work here, he pays tribute to *Saint Seiya: Knights of the Zodiac*.

WEBSITE: patriciooliver.com.ar

BLOG: patriciooliver.blogspot.com

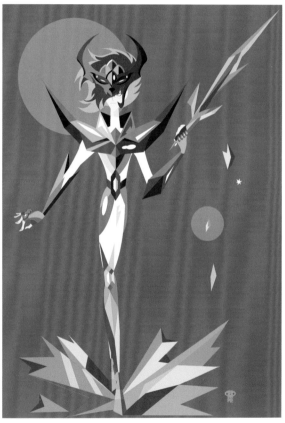

Alberich de Megrez Delta
2009

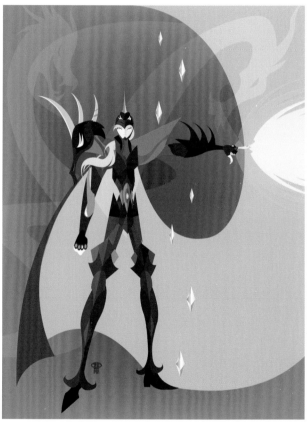

Hagen de Megrez Delta
2009

> **"** I have always tried to be a
> generator of new worlds,
> centered on fantasy
> and collective imagination. **"**

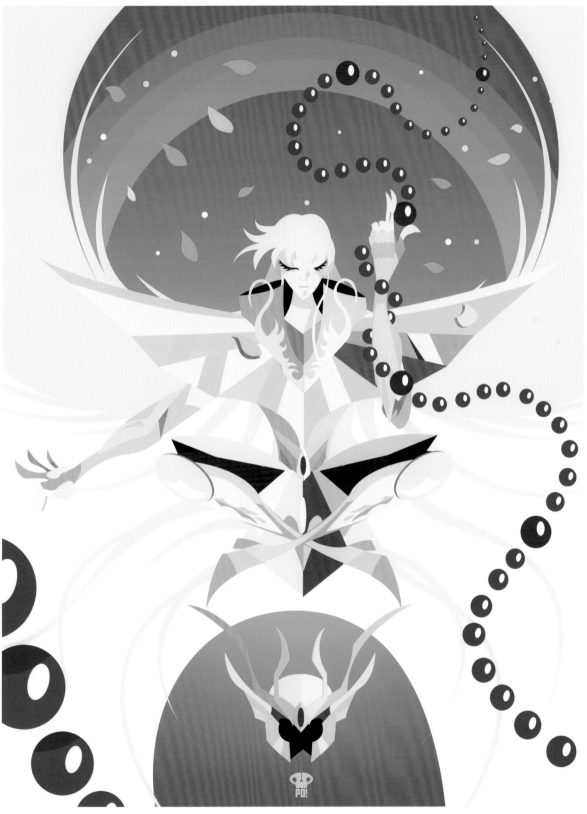

Virgo Shaka
2009

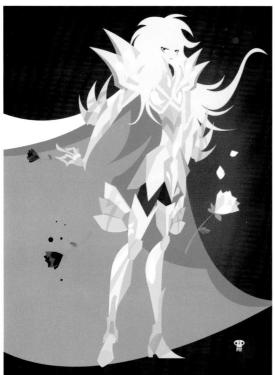

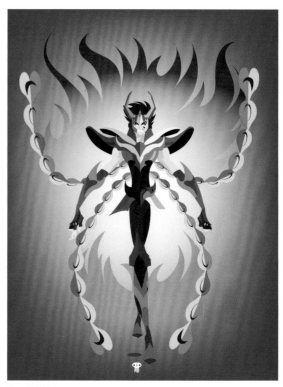

Afrodita
2009

Phoenix Ikki
2009

Tauro
2010

Aquarius Camus
2009

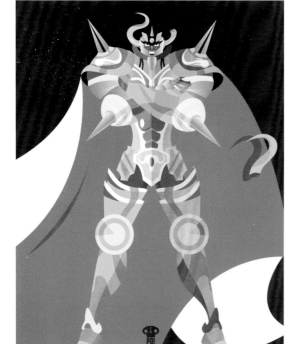

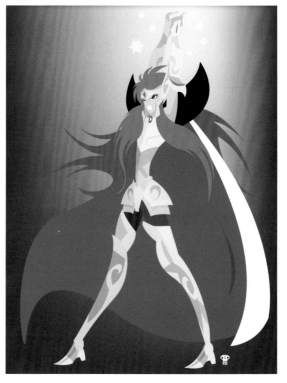

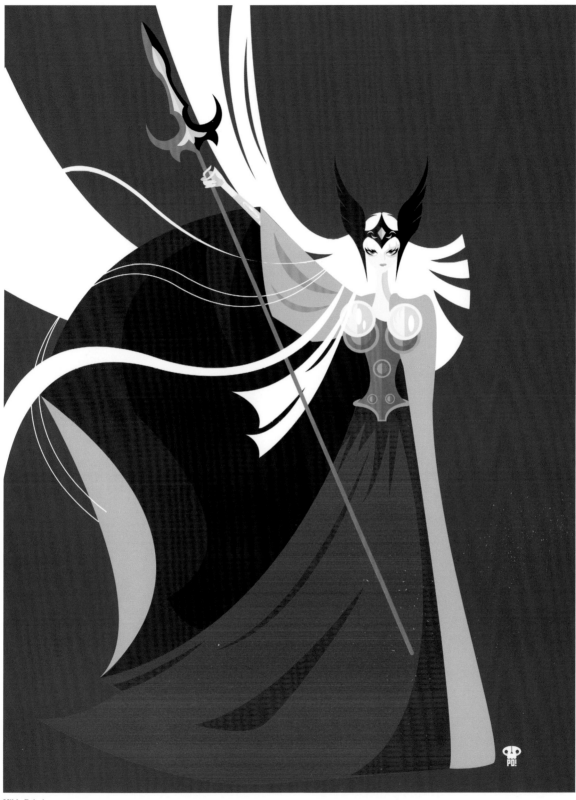

Hilda Polaris
2009

OPASINSKI, TOMASZ

Tomasz Opasinki is the head of the creative department at RevCreative in Hollywood, California. He is heavily involved in the world of advertising as a graphic designer and consultant, and has always put his creative skills to good use in his personal art and design work.

WEBSITE: tomasz-opasinski.com

CONTACT: www@tomasz-opasinski.com

Matrix Poster
2011

" I just . . .
love movie
posters . . . :) "

Aliens Poster
2012

Birds Poster
2011

Titanic Poster
2011

Paris Je T'aime Poster
2011

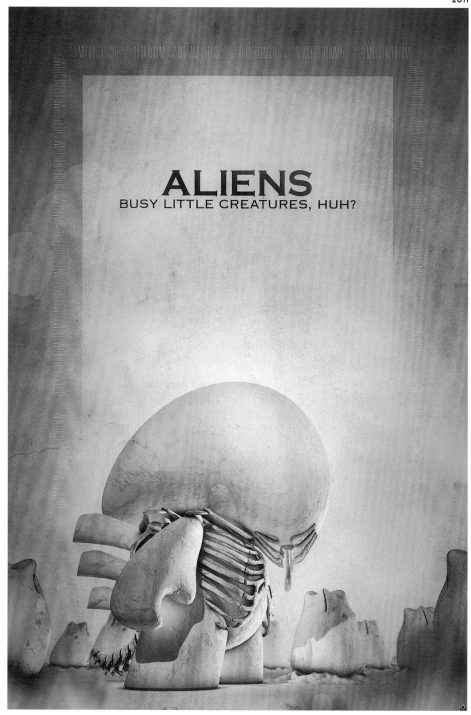

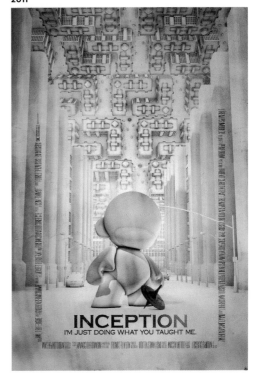

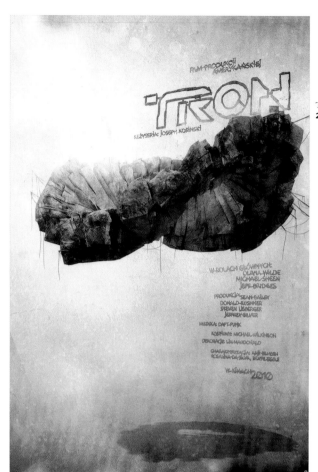

Tron Poster
2011

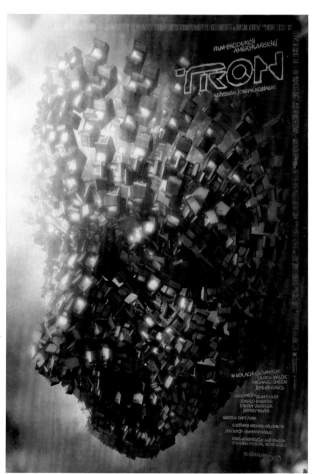

Tron Poster
2011

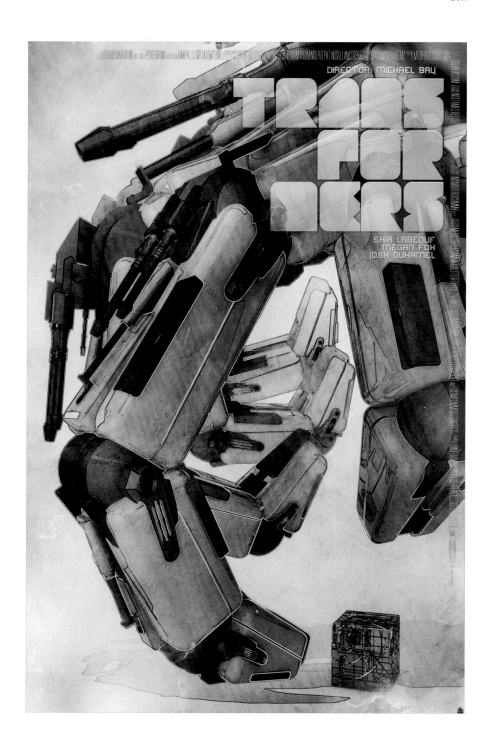

ORIOTO

A French artist based in Paris, Orioto made his reputation with his video game-based work, which consists of classic game screenshots that he updates to more modern visual standards.

TWITTER: twitter.com/orioto

BLOG: orioto.tumblr.com

CONTACT: orioto@online.fr

> **"** I think that what defines our generation is that we appraise and value the references of our childhood. More than nostalgia, it's the sign of a deep legacy. **"**

Crystal Catacomb
2009

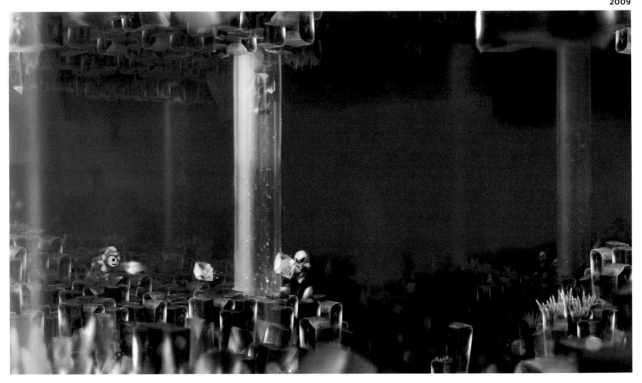

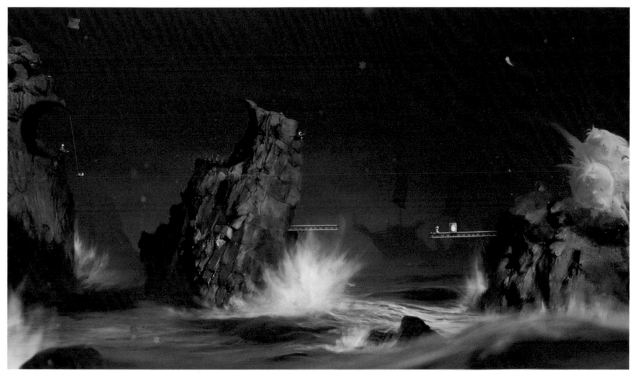

Sea Battleground
2009

Toxic Planet
2009

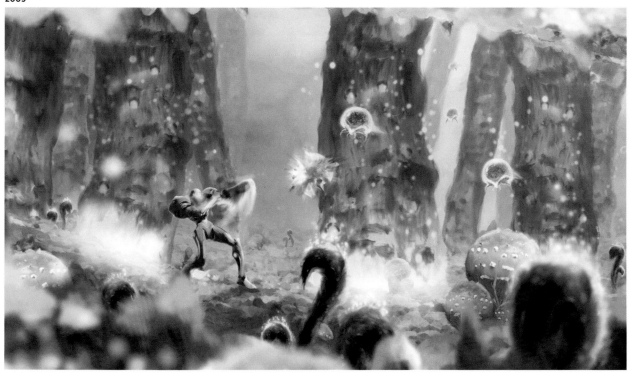

Another World
2009

Beast Reunion
2010

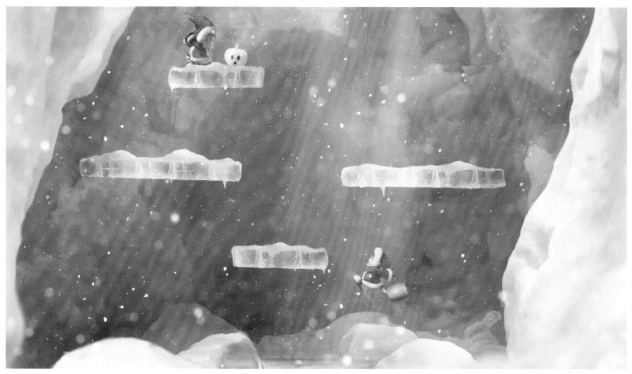

Ice Climbers
2009

Through the Night
2008

PACALIN

Pauline Acalin, a.k.a. Pacalin, has a BA in Graphic Design from California Polytechnic State University, and is the co-founder 72pins.com, which creates retro NES cartridge art. Fascinated by visual effects, she also studied at the Gnomon School of Visual Effects in Hollywood. Her work focuses on pixel art and retro game designs.

WEBSITES: 72pins.com and pacalin.com

BLOGS: it8bit.com, herochan.com, and tiefighters.com

CONTACT: pauline.acalin@gmail.com

 The Atari joystick is more than a retro controller, it is an American icon. The NES was more than a phase in my life, it was a movement.

Glitch in the Matrix
2011

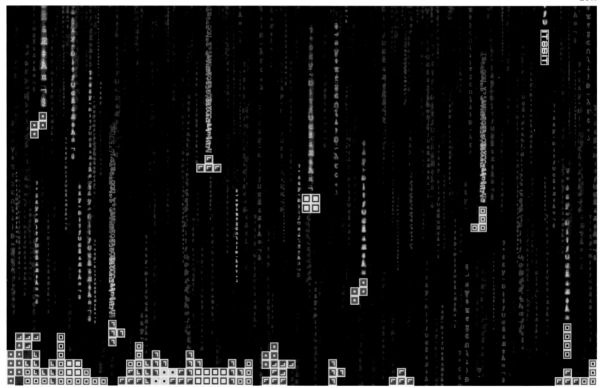

Wire Invaders
2011

Mario in Soho
2011

Game Over
2011

SEÑOR PINKY

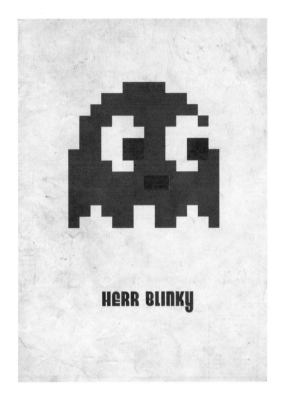

HERR BLINKY

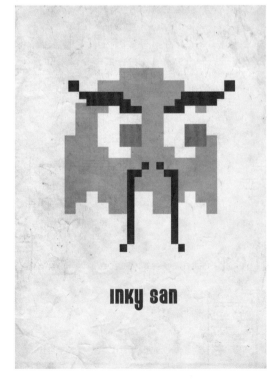

INKY SAN

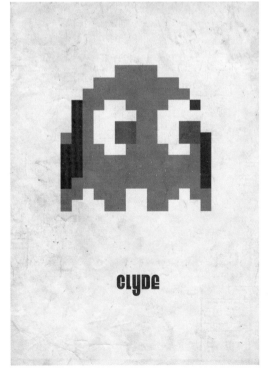

CLYDE

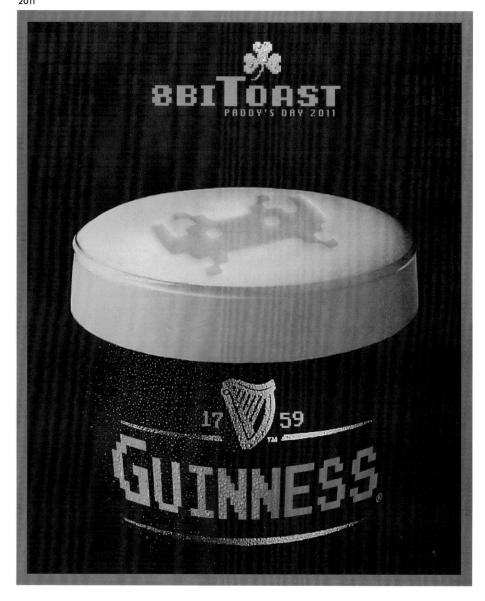

NEStalgia: Bioshock
2011

NEStalgia: Shadow of the Colossus
2011

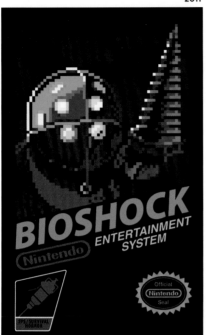

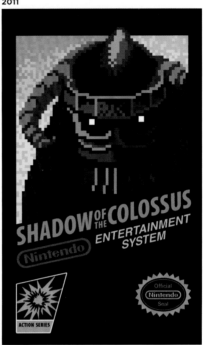

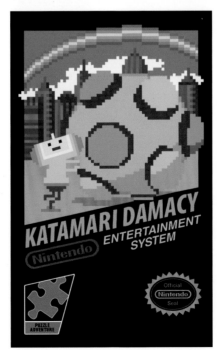

NEStalgia: Katamari Damacy
2011

PALTA, MURAT

Murat Palta is a Turkish artist who has studied at Dumlupinar University in Istanbul, as well as in Hungary and Spain. Watching and talking about films inspires him, and his "Classic Movies in Miniature Style" series was born from a conversation he had with his brother.

WEBSITE: behance.net/muratpalta

" My brother and I really enjoy watching movies all day long and talking about them. "

Alien
2012

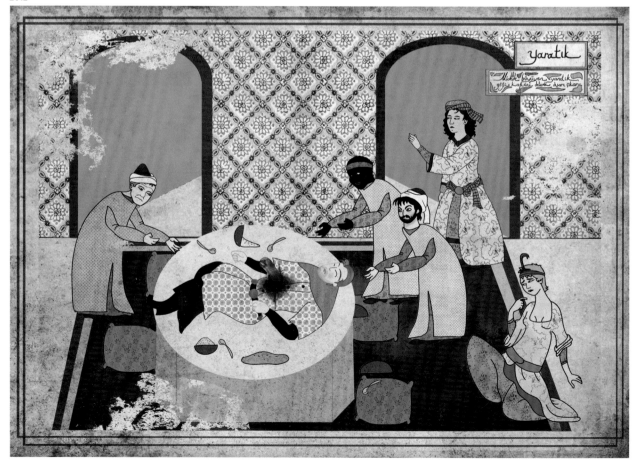

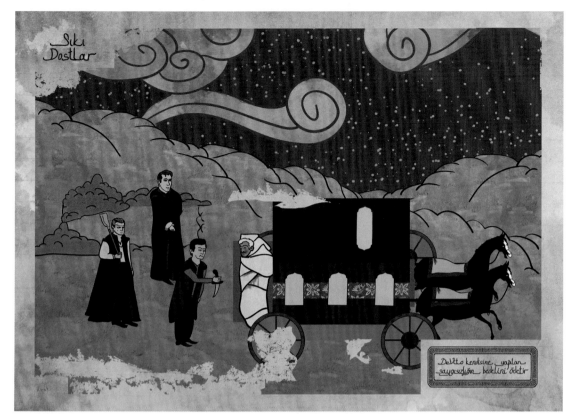

Goodfellas
2012

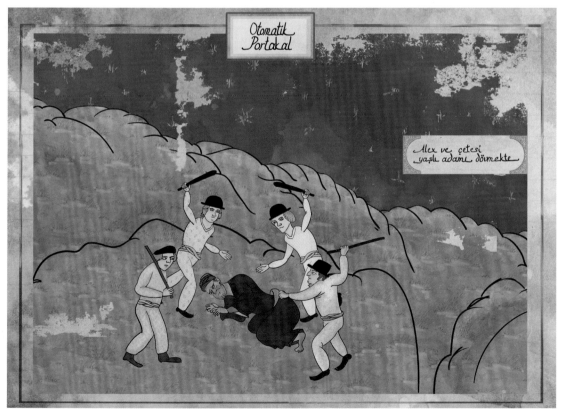

A Clockwork Orange
2012

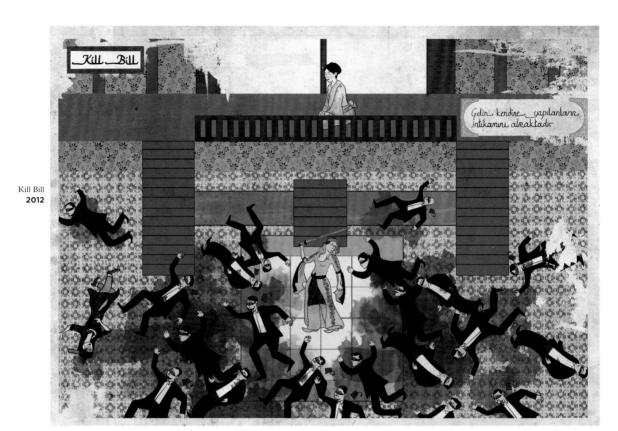

Kill Bill
2012

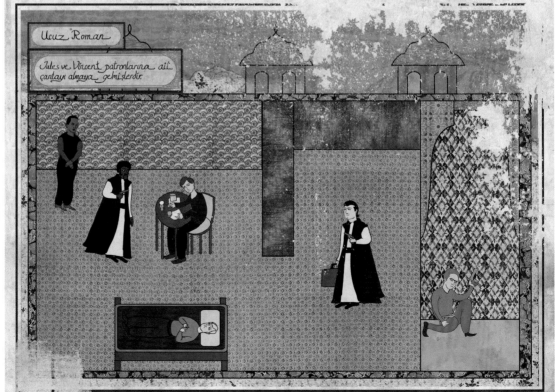

Pulp Fiction
2012

Inception
2012

The Godfather
2012

Sitar Wars
2012

The Shining
2012

PELLEGRINO, RICH

Rich Pellegrino is an American illustrator and artist based in Providence, Rhode Island, and a graduate of the Rhode Island School of Design. He was trained in multiple martial arts, but suffered an accident that left him unable to pursue his original passion. While in recovery, he began to draw his favorite comic book characters.

WEBSITE: richpellegrino.com

CONTACT: rich@richpellegrino.com

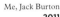

Me, Jack Burton
2011

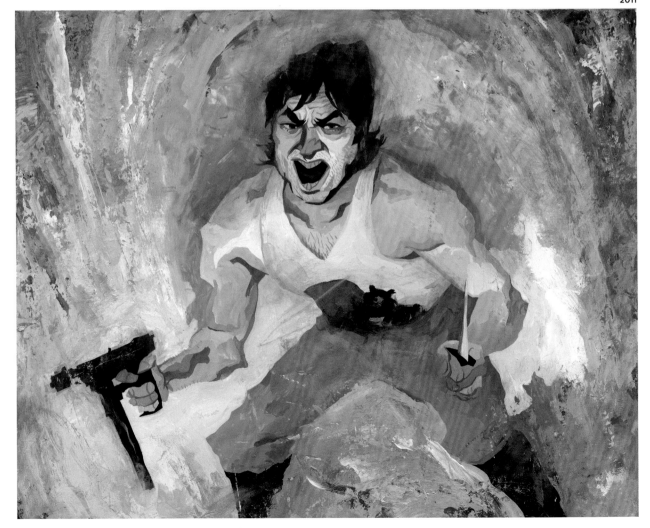

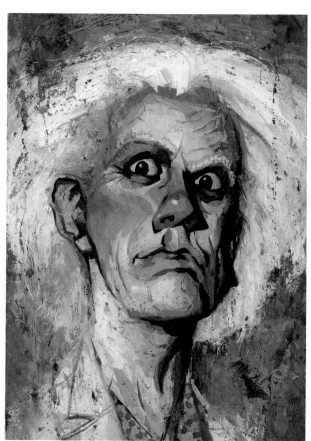

Doc Brown
2010

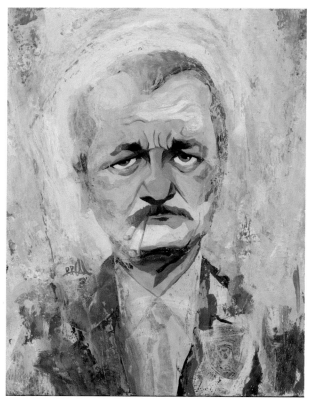

Mr. Blume
2011

“ Paying homage to
my favorite films
and sharing it with
countless other fans is
a dream come true. ”

Marty
2010

Francis
2010

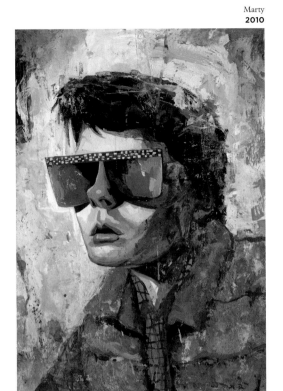

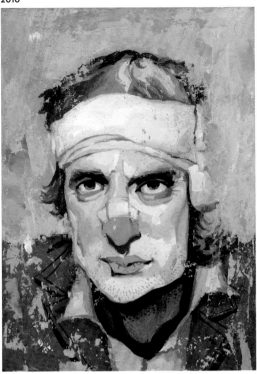

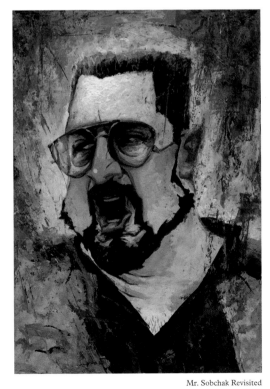

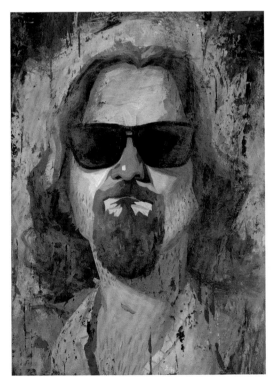

Mr. Sobchak Revisited
2010

The Dude
2012

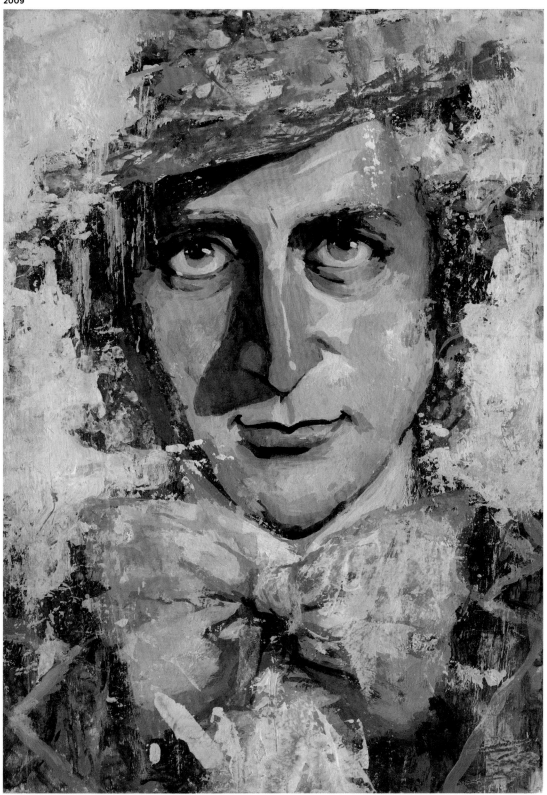

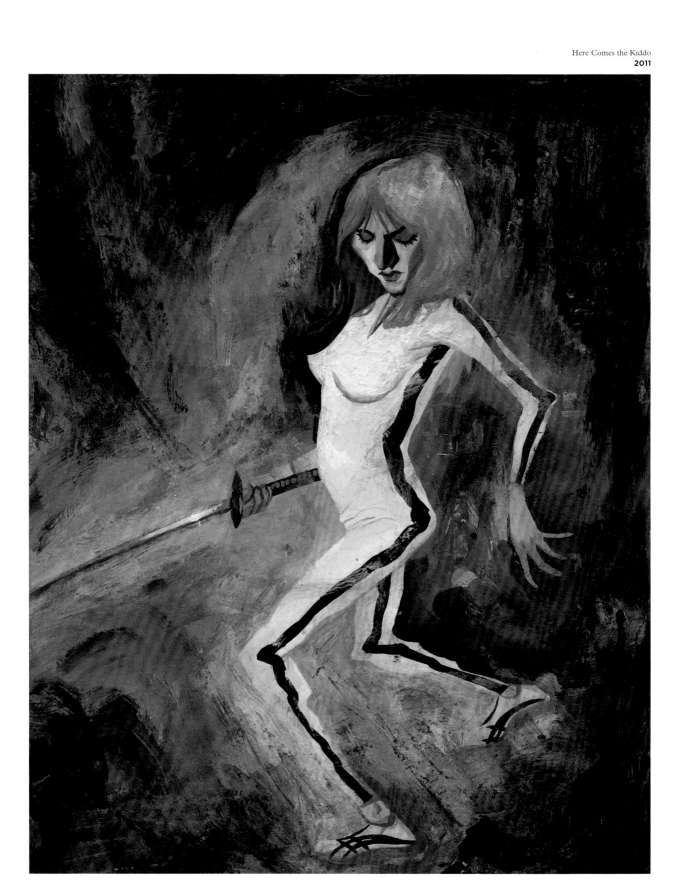

Zelda's Slumber
2011

PENNEY, ROBERT

An Australian-born artist based in London, Robert Penney is fond of pixel art. He uses this style to create illustrations of imaginary 1970s and 1980s video game boxes that are adaptions of current films and television shows.

WEBSITE: penneydesign.com

CONTACT: robert@penneydesign.com

Retro Games with Modern Themes: Lost
2010

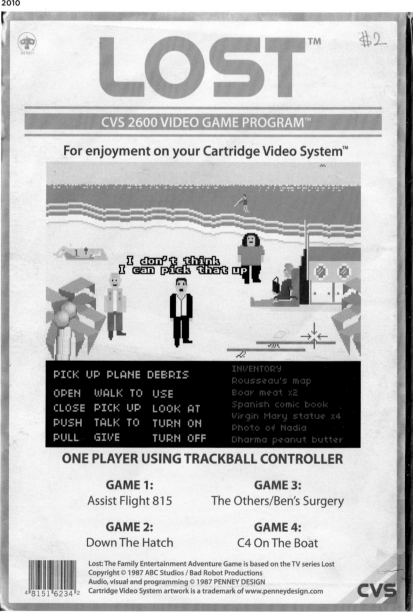

Retro Games with Modern Themes: Avatar
2010

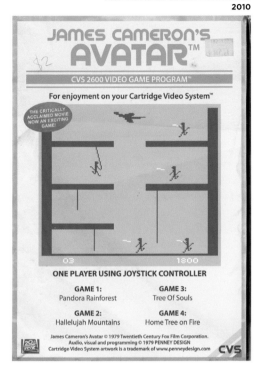

Retro Games with Modern Themes: Avatar
2010

Retro Games with Modern Themes: Cloverfield
2010

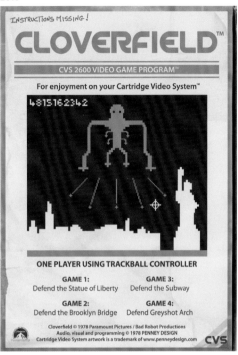

Retro Games with Modern Themes: Cloverfield
2010

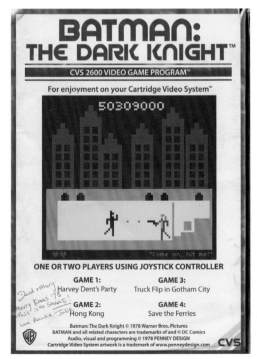

Retro Games with Modern Themes: The Dark Knight
2010

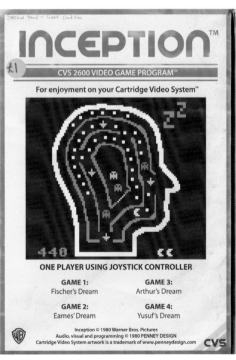

Retro Games with Modern Themes: Inception
2010

Retro Games with Modern Themes: Prison Break
2010

Retro Games with Modern Themes: Wall-E
2010

Retro Games with Modern Themes:
The Fast and the Furious: Tokyo Drift
2010

Retro Games with Modern Themes: Snakes on a Plane
2009

PHILLIPS, CHET

Chet Phillips lives and works in Austin, Texas. Over the last thirty years of commercial work, he has garnered numerous awards, and worked with clients such as American Airlines, Pepsi, Honda, the *New York Times*, and Warner Brothers. He has recently directed his efforts to personal projects, and counts among his influences the work of artists including René Magritte, Rockwell Kent, Harvey Kurtzman, and Steve Ditko.

WEBSITE: chetart.com

BLOG: chetart.com/blog

CONTACT: chet@chetart.com

> " No electrons were harmed in the process. "

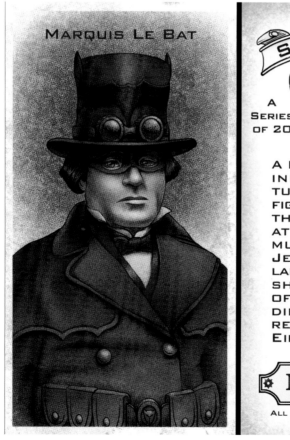

Marquis Le Bat Trading Card
2010

Union of Superlative Heroes foursome
2010

The Order of Nefarious Villains Foursome
2010

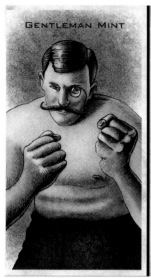

A
SERIES
OF 20

Nº
9

LONDON-BASED SCIENTIST
ROBERT STEVENSON WAS
A GENIUS OF INVENTION.
HIS TRIALS WITH PLASMA
BASED FUEL BACKFIRED
HORRIBLY AND ALTERED
HIS BODY INTO A MASSIVE
MUSCLE OF IRON. WITH
HIS NEW POWER, GREEN
TINT AND THE PENCHANT
TOWARDS FURIOUS BLOOD-
SHED, HE STILL COMPLIED
WITH THE MARQUESS OF
QUEENSBURY RULES.

ALL CONTENT © CHET PHILLIPS 2010
WWW.CHETART.COM

Gentleman Mint Trading Card
2010

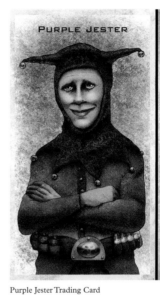

A
SERIES
OF 20

Nº
1

THE PURPLE JESTER'S SOLE
PURPOSE IN LIFE WAS TO MAIM,
KILL AND TERRORIZE AS MANY
SOULS AS POSSIBLE. THE ONLY
FOE TO MATCH HIS WITS AND
PHYSICAL VIOLENCE WAS THE
MARQUIS LE BAT. WITH EACH
MEETING THE PURPLE JESTER
WOULD INEVITABLY BE BEATEN
AND YET AGAIN PLACED BEHIND
THE WALLS OF THE FRIGHTFUL
CHIEN FOU LUNATIC ASYLUM.

Purple Jester

ALL CONTENT © CHET PHILLIPS 2011
WWW.CHETART.COM

Purple Jester Trading Card
2011

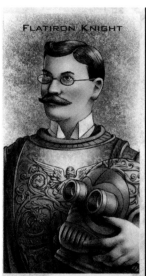

A
SERIES
OF 20

Nº
20

GERMAN INDUSTRIALIST
AND INVENTOR FREDERICK
FERROUS USED HIS KNOW-
LEDGE OF METALLURGY
AND WEAPONS TO FORGE
AN INDESTRUCTIBLE WAR
SUIT FOR HIS NEW LIFE OF
CRIME FIGHTING. HIS LIST
OF HEROIC DEEDS AND
APPREHENDED VILLIANS
WHILE HE WAS STATIONED
IN NEW YORK CITY GAVE
HIM THE HEROIC TITLE OF
"FLATIRON KNIGHT."

ALL CONTENT © CHET PHILLIPS 2010
WWW.CHETART.COM

Flatiron Knight Trading Card
2010

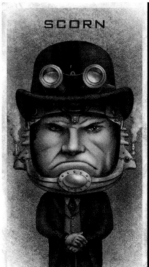

A
SERIES
OF 20

Nº
3

PROFESSOR EON CARBUNKLE
INNOCENTLY SIGNED UP AS A
TEST SUBJECT FOR A STEAM-
POWERED HYBRID PROSTHETICS
STUDY. HE HAD NO IDEA THAT
THE EVIL INDUSTRIAL CABAL IN
CHARGE OF THE FACILITY WAS
TRANSFORMING SUBJECTS INTO
A PRIVATE ARMY OF SCORN
ASSASSINS.

STEAM-CONTROLLED
ORGANISMS RE-ENGINEERED
FOR NEUTRALIZATION.

SCORN

ALL CONTENT © CHET PHILLIPS 2011
WWW.CHETART.COM

SCORN Trading Card
2011

PIGG, WILL

Will Pigg is an American artist based in Florida. He studied at the College of Art and Design in Sarasota, and he is obsessed with comics, stop motion animation, film noir, and Caravaggio's paintings. His 3-D papercraft stems from a love of geekery.

WEBSITE: willpigg.com

CONTACT: willpigg@gmail.com

Venom 1
2012

" Geek-Art to me is the epitome of the soul of childhood. There is zero reason to 'grow up' and I certainly intend to never do that. "

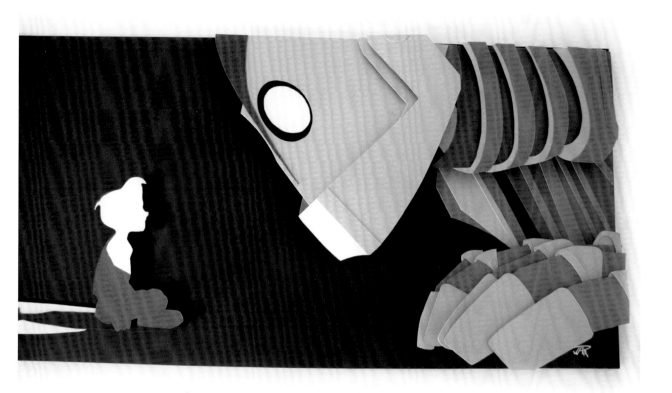

Iron Giant 1
2012

Iron Giant 3
2012

Probe Droid
2012

Probe Droid
2012

Thwomp
2012

Team TMNT
2012

POLEVOY, DANIEL

Born in Dnepropetrovsk, Ukraine, and currently living in Jerusalem, Daniel Polevoy studied economics, finance, and law in Moscow before taking a course of photography in 2009. His work has appeared in numerous magazines, and between 2008 and 2012 he photographed more than 130 concerts. In this series, he mixes historical pictures with modern heroes. He strives to convey positive emotions to viewers through his art.

WEBSITE: polevoy.info

BLOG: dpolevoy.livejournal.com

CONTACT: danil@polevoy.info

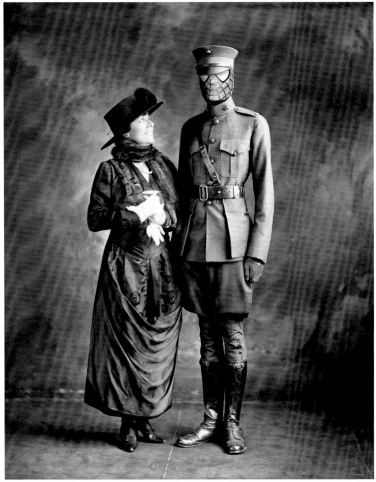

Mrs. Parker and Son
2010

" My relationship with my collages is a bit different from the general author's attitude to their own work. For me they're not contemporary art, but just cool pictures. However my images perform their main task: People look at my collages and smile. **"**

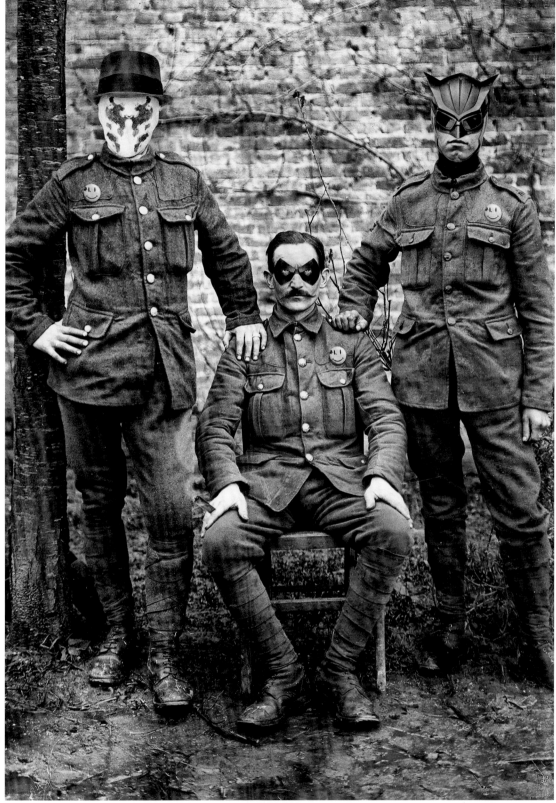

Nameless Heroes
2011

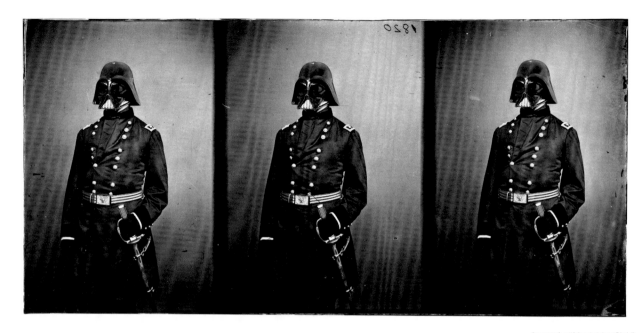

Special for "Martini Art Club"
Wartime Icon: 1860–1890
Untitled #1
2011–2012

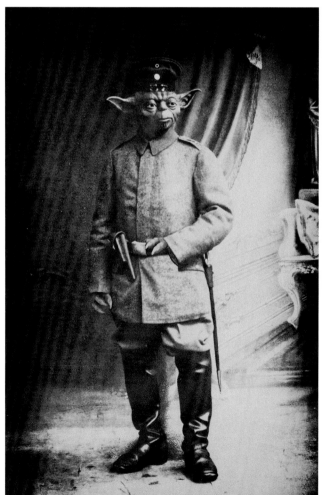

Yoda
2011

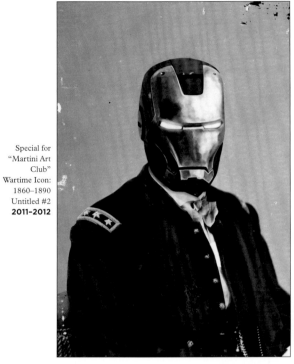

Special for
"Martini Art
Club"
Wartime Icon:
1860–1890
Untitled #2
2011–2012

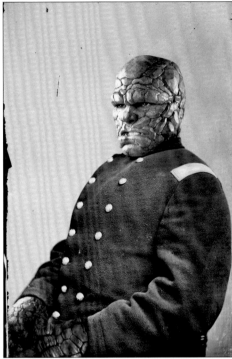

Special for
"Martini Art Club"
Wartime Icon:
1860–1890
Untitled #3
2011–2012

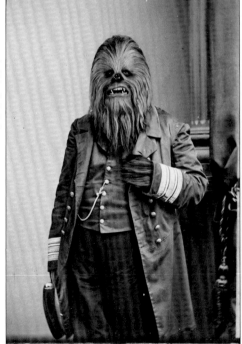

Special for
"Martini Art
Club"
Wartime Icon:
1860–1890
Untitled #4
2011–2012

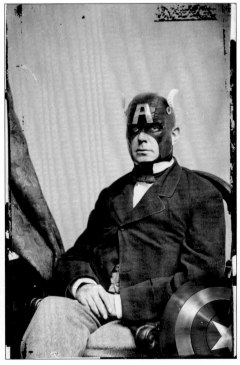

Special for
"Martini Art Club"
Wartime Icon:
1860–1890
Untitled #5
2011–2012

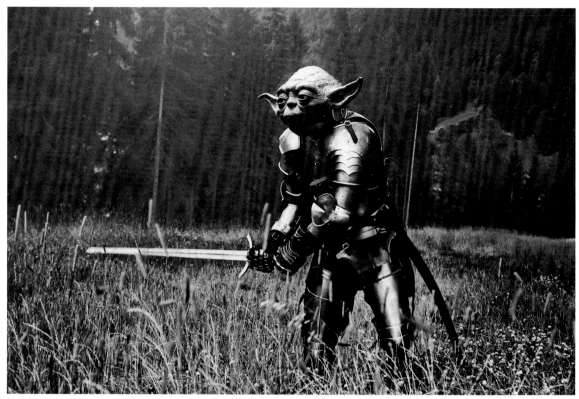

Peaceful Warrior
2011

Aussie Soldier—Gonzo the Muppet, WWI,
November 1918
2012

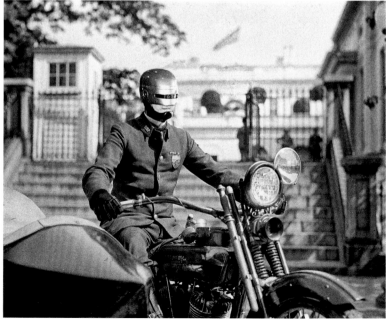

RoboCop
2011

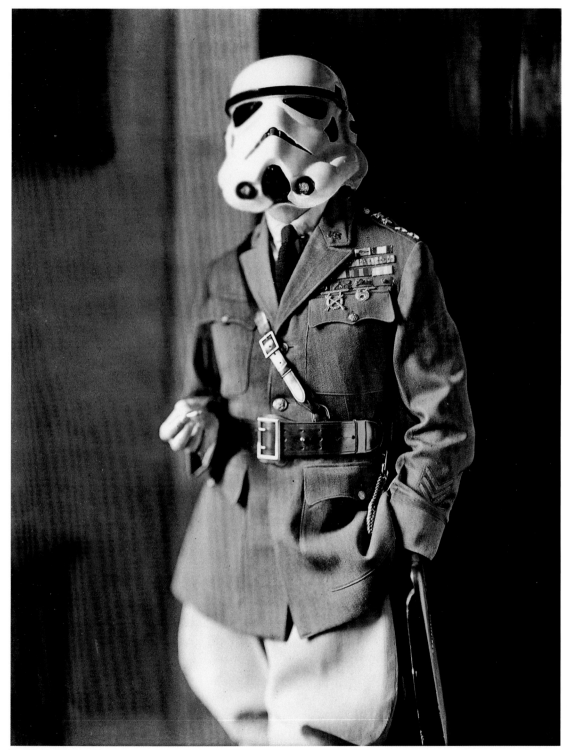

Douglas MacArthur, 1930
2010

POOL, IAN

Toronto-based photographer Ian Pool is fascinated by geek culture. His popular superhero series, which came to him as he was walking down the street and thinking about the best place for a hero to relieve himself incognito (hence the Spider-Man shot), composes action figure photos and real world circumstance to put forward the characters' humanity.

WEBSITE: ianpool.com

CONTACT: ian@ianpool.com

Super—Dr. Otto "Octopus" Octavius
2009

> " It seems that the icons and the minute elements of these old games have enough nostalgic prowess to make you replay the whole game in your head. "

Super—The Incredible Hulk
2009

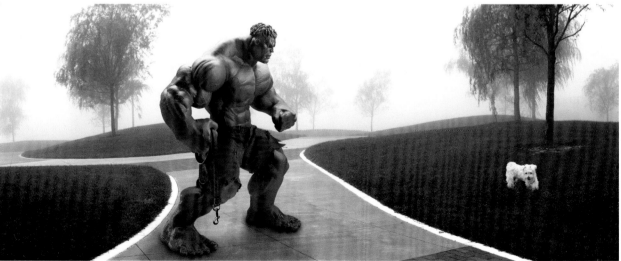

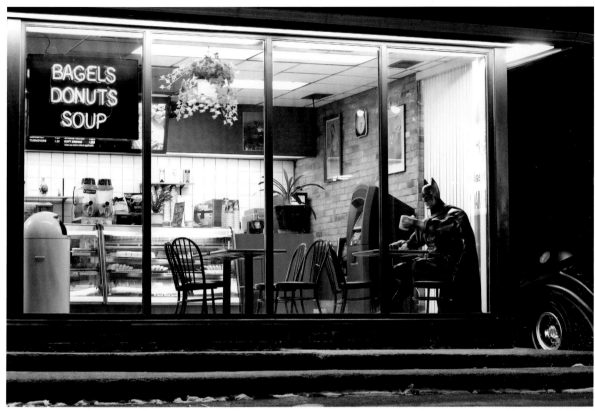

Super—The Dark Knight
2009

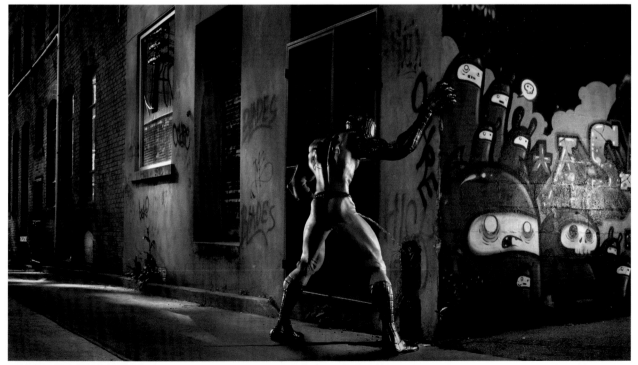

Super—The Amazing Spider-Man
2009

Boo
2012

Pac-Man
2012

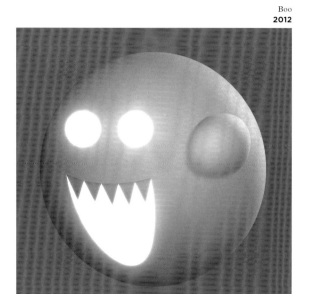

Space Invaders 01
2012

Space Invaders 02
2012

PROTON FACTORIES

Proton was born and raised in the city of Charleston, South Carolina. Growing up with video games, movies, and cartoons, he owes his name to his excessively positive attitude. Coming from a graffiti background, he translated his art to painting, using both acrylic and watercolor.

WEBSITE: protonfactories.com

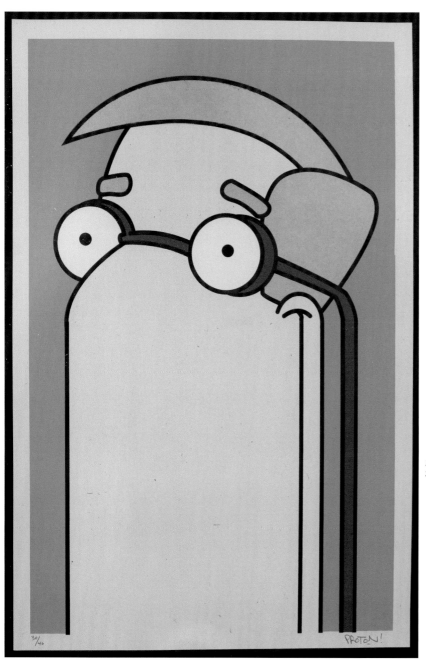

Milhouse 3-1
2012

> " I didn't find the geekdom, the geekdom found me and never let me go. "

PULIDO, JOSE

Jose Pulido has always been drawing. Born in California, he has a BFA in illustration from California State University, Fullerton. In 2004, he started the T-shirt company Mis Nopales with his brother. Later, he began concentrating on his personal artwork. He lives and works in Downey, California, and finds his inspiration in Mexican art and culture and American pop culture.

WEBSITE: misnopales.com

CONTACT: chiflas@misnopales.com

> " Geek-Art to me is just art that incorporates all of the characters I knew and loved while growing up. "

Pulp Fiction Calaveras
2010

27/200

Jose Pulido

Stormtrooper Calaveras
2009

1/105

Jose Pulido

Bat Calavera
2011

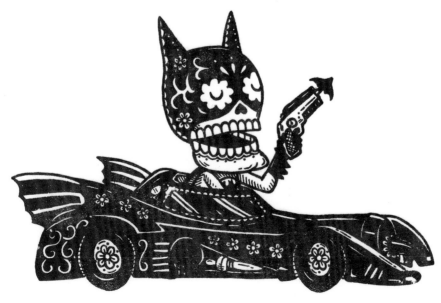

104/200

Jose Pulido

Chewy Calavera
2009

Calavera Vader
2009

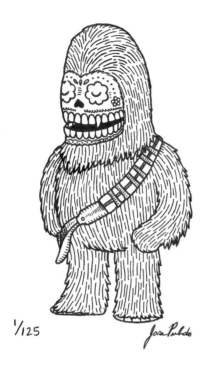

1/125

Jose Pulido

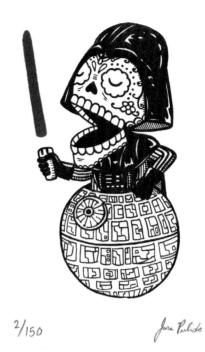

2/150

Jose Pulido

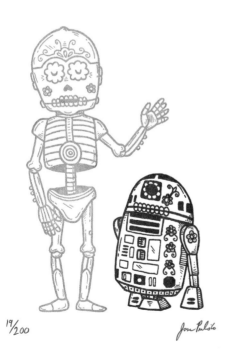

19/200

Jose Pulido

48/205

Jose Pulido

Droid Calaveras
2010

El Hulk Calavera
2011

Star Couple
2009

19/105

Jose Pulido

Wolverine Calavera
2011

88/205

Jose Pulido

PUNCEKAR, MIKE

Mike Puncekar is an American illustrator living in Youngstown, Ohio. Deeply influenced by video games, his work is closely linked to the worlds of Zelda and Mario, redefined in his own personal way.

WEBSITE: mpuncekar.com

Goomba
2011

Lakitu
2011

> " Mario enemies never really got the same celebration that the main champions of the game did. "

Koopa
2011

Piranha Plant
2011

Porcu-Puffer
2011

Whomp King
2011

Belome
2011

Birdo
2011

Bob-omb
2011

Shy Guy
2011

REZA, FERNANDO

California artist Fernando Reza, a.k.a. Fro, is a contributor to CHUD.com and regularly exhibits at Gallery 1998 in Los Angeles. He is a fan of Mary Blair, Saul Bass, and Scandinavian designers from the 1950s.

WEBSITE: frodesignco.com

Lost 1 Year Anniversary
2011

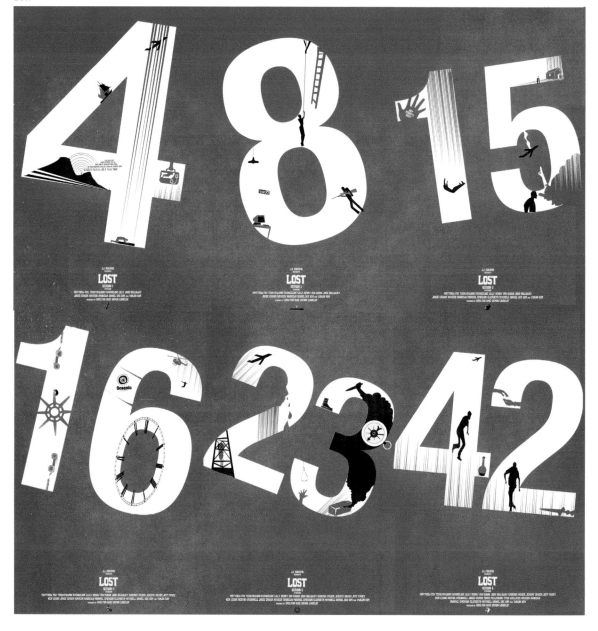

 Star Wars has its own galaxy, Mario its own universe . . . that's fascinating! People can build up amazing universes and let us visit them.

White Man's Birden
2011

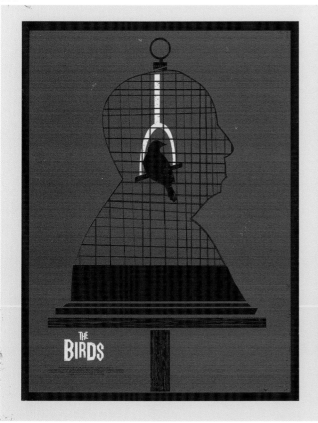

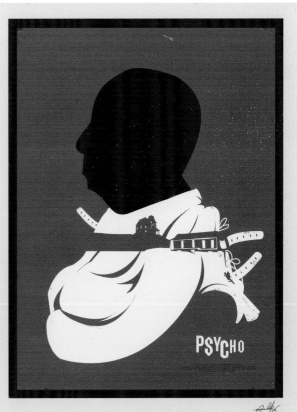

Plant a Victory Garden
2011

Dud
2011

Bowser
2011

Loose Lips
2011

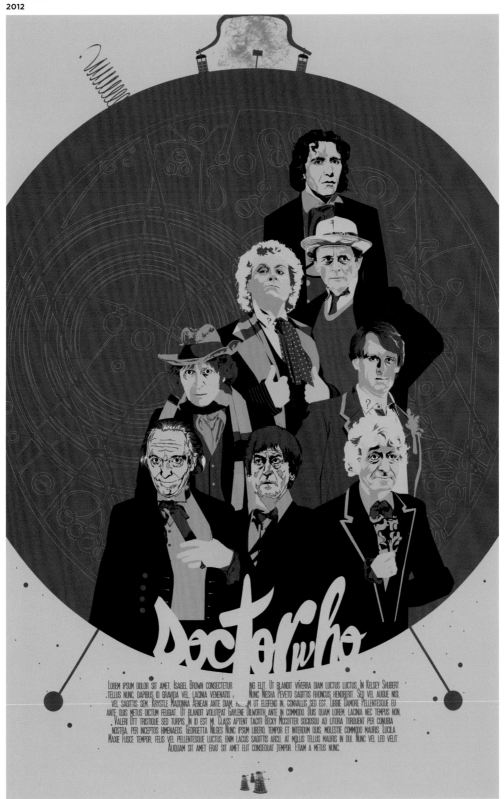

Lorem ipsum dolor sit amet, Isabel Brown consectetur ing elit. Ut blandit viverra diam luctus luctus. In Kelsey Shubert tellus nunc, dapibus id gravida vel, lacinia venenatis. Nunc Niesha Peveto sagittis rhoncus hendrerit. Sed vel augue nisl, vel sagittis sem. Krystle Madonna Aenean ante diam, h...m ut eleifend in, convallis sed est. Libbie Damore Pellentesque eu ante duis metus dictum feugiat. Ut blandit volutpat Gaylene Dilworth ante in commodo. Duis quam lorem, lacinia nec tempus non, Valeri Utt tristique sed turpis. In id est mi. Class aptent taciti Becky Mccotter sociosqu ad litora torquent per conubia nostra, per inceptos himenaeos. Georgetta Nilges Nunc ipsum libero, tempor et interdum quis, molestie commodo mauris. Lucila Maxie fusce tempor, felis vel pellentesque luctus, enim lacus sagittis arcu, at mollis tellus mauris in dui. Nunc vel leo velit. Aliquam sit amet erat sit amet elit consequat tempor. Etiam a metus nunc.

REZATRON

Reza Rasoli, a.k.a Rezatron, was born in Germany and grew up in California, with Indonesian and Persian roots. He is living proof that geekdom knows no frontier. He currently lives in Los Angeles, where he works, draws, directs, produces, writes, animates, and designs.

WEBSITE: rezatron.com

BLOG: rezatron.tumblr.com

CONTACT: reza@rezatron.com

Wolverscream
2010

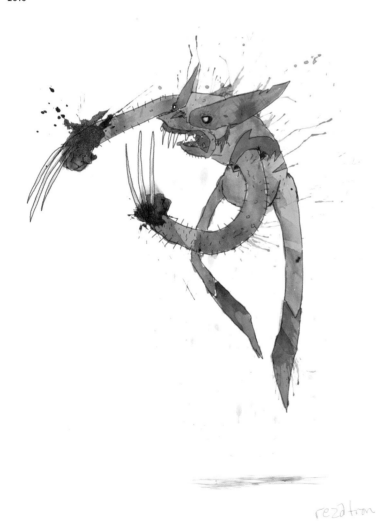

> **"** Television was a grandfather I never had. **"**

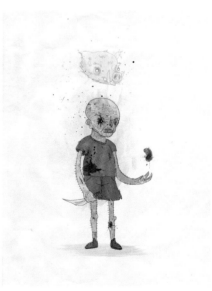

Lost Spawn Locke
2010

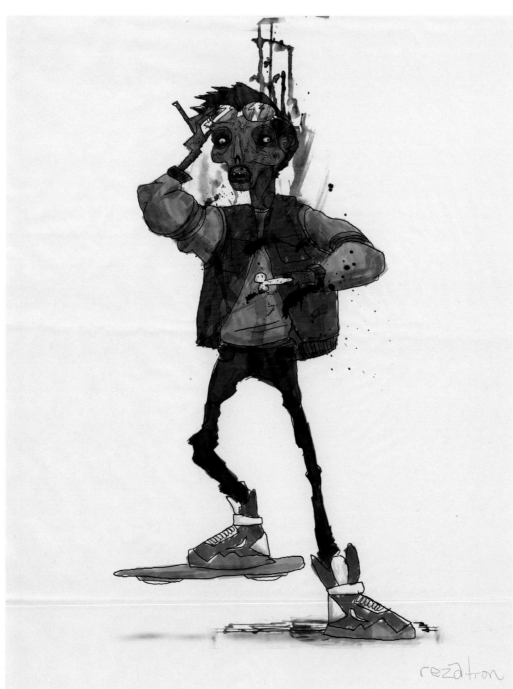

Dead to the Future
2010

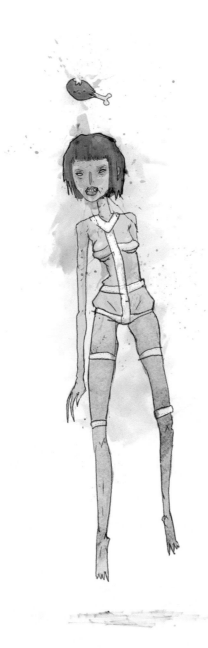

The 5th Deathament
2010

rezatron

Makillda the
Professionnal
2010

Gulp Fiction
2010

Vomit the Frog
2010

RUBENACKER, BRIAN

Brian Rubenacker lives and works in Waterford, Michigan. When you grow up loving comics, pulp, and sci-fi, and combine those influences with a fascination for Boston terriers, this is what happens.

WEBSITE: brianrubenacker.com

CONTACT: brianrubenacker@gmail.com

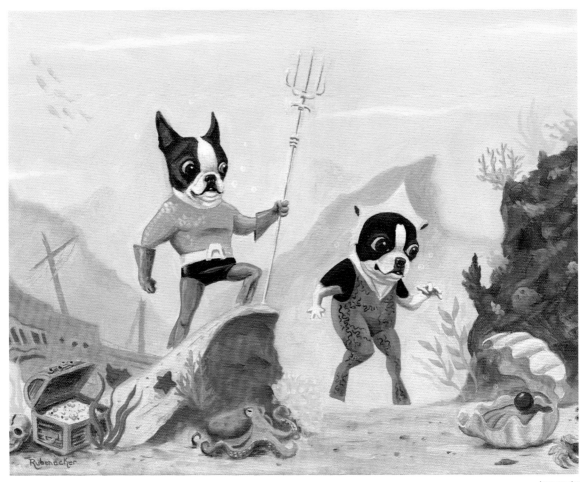

Aqua-terrier
2010

" I began as a kid with comics and horror movie monster models. I grew up around this imagery and designs . . . Today, those worlds remind me of my childhood. They are part of me. "

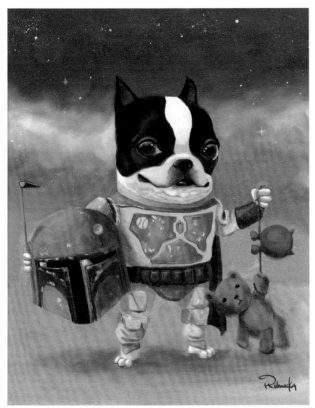

Boba Terrier
2009

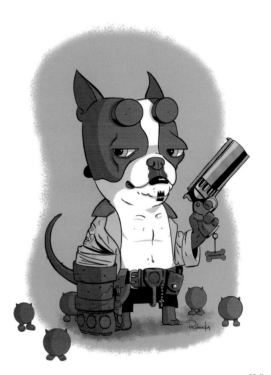

Hell-terrier
2011

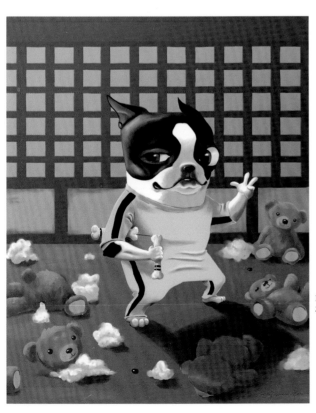

Boston Lee
2010

Boston Jedi
2008

Dachshund Jedi
2009

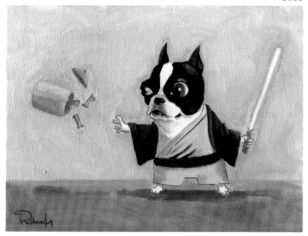

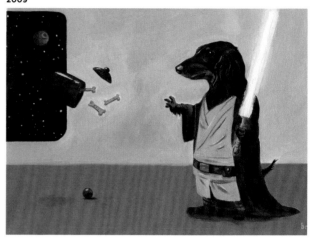

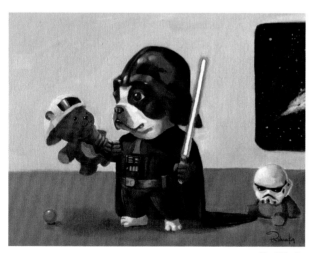

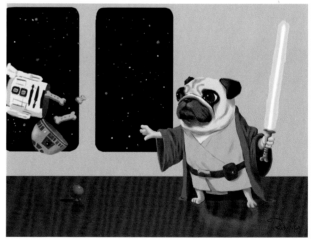

Darth Terrier
2009

Pug Jedi
2010

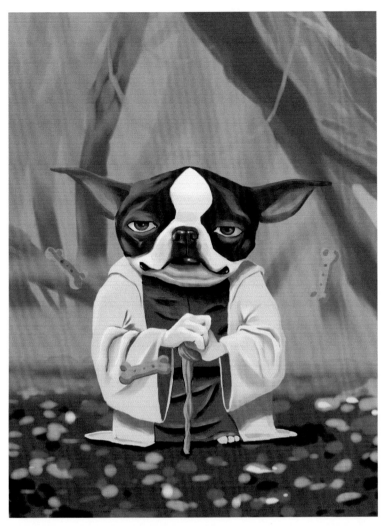

Yoda Terrier
2010

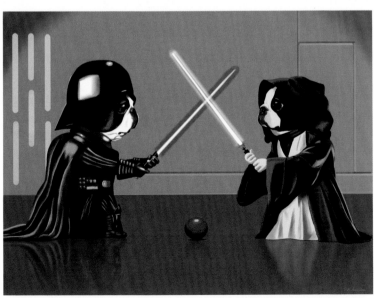

The Duel
2010

SAWAYA, NATHAN

World-renowned LEGO sculptor Nathan Sawaya used to be a lawyer. Now a New York-based artist, he spends hours in his studio working with millions of bricks. His art is a mash-up of pop culture ideas, perspectives, attitudes, and the mass media—all told through the use of a colorful construction toy.

WEBSITE: brickartist.com

Lion
2011

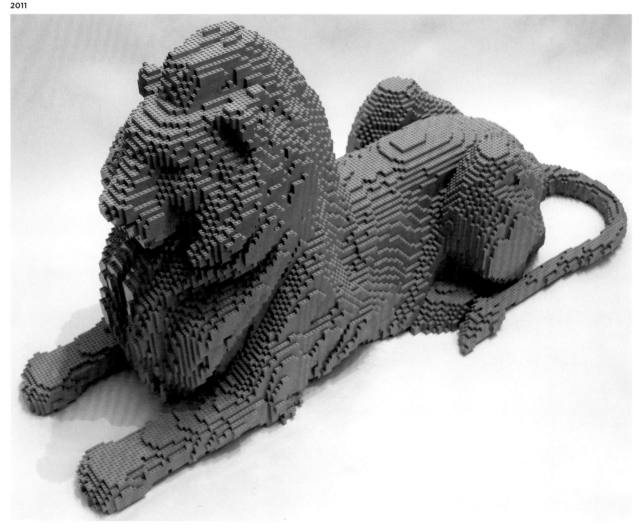

Han Solo Frozen in Carbonite
2003

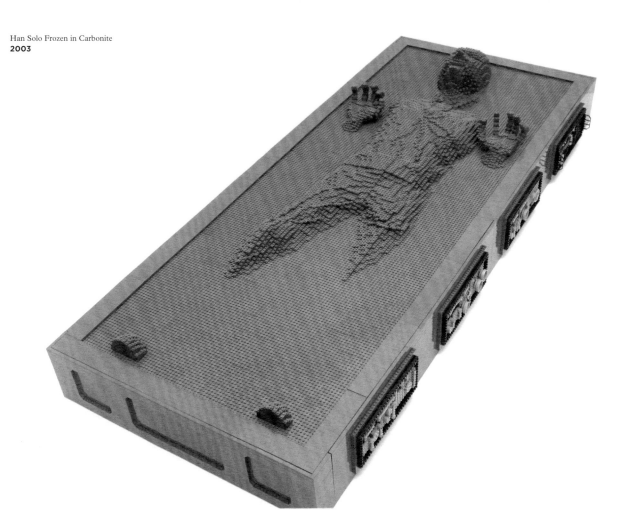

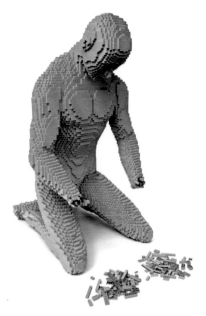

Hands
2008

" *The Art of The Brick* explores the inner geek in all of us through a collection of sculptures that harken back to the days of growing up, learning how we define ourselves as products of pop culture. "

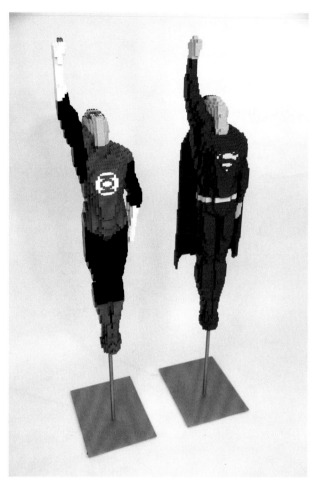

Clark and Hal
2011

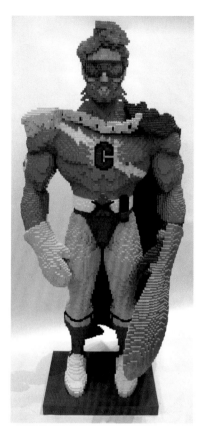

Flaming C
2011

Think
2008

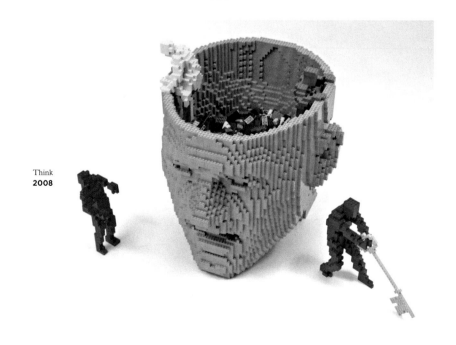

Yellow
2006

Underneath
2009

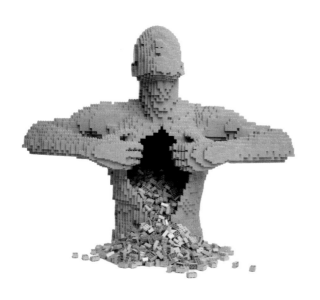

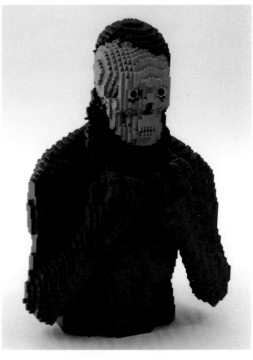

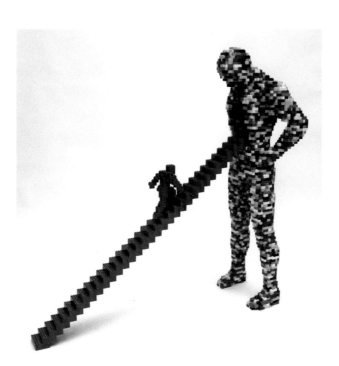

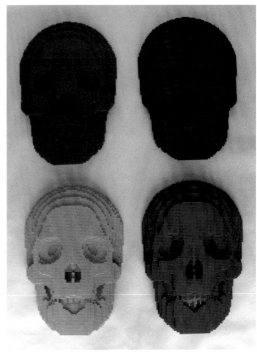

Skulls
2008

Stairway
2009

SEELEY, STEVE

After a childhood spent in Wisconsin watching cartoons, drawing comics, and exploring the woods, Steve Seeley earned a degree in fine arts from Ohio State University. A Chicago-based artist, his work is influenced by his love of geekdom, nature, and heavy metal.

WEBSITE: thedelicatematter.com

CONTACT: steve@thedelicatematter.com

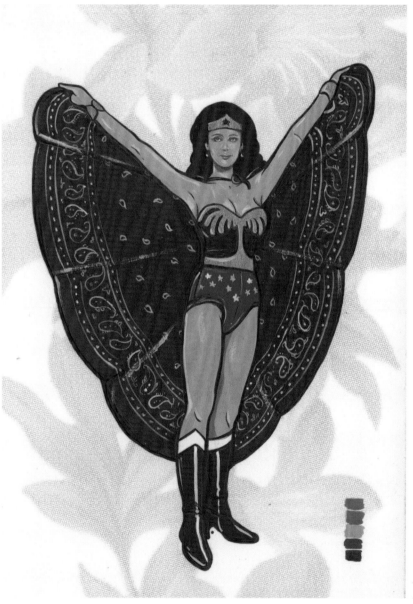

> " My passion for geekdom began with He-Man. Add comic books, movies, and toys, and you get the start of a love story with geekery. And it's not over. "

Wonder Woman with Bandana Cape
2010

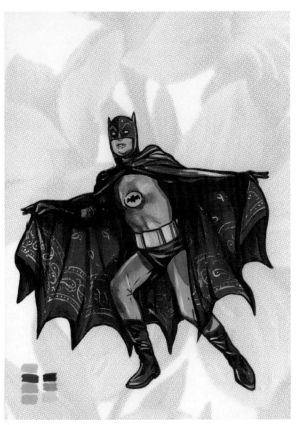

Batman with Bandana Cape
2010

The Way Things Were
2010

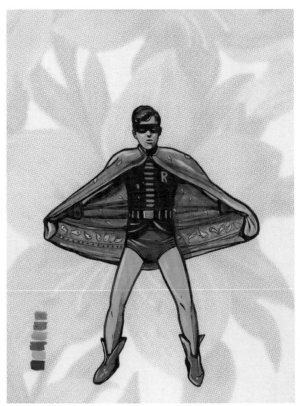

Robin with Bandana Cape
2010

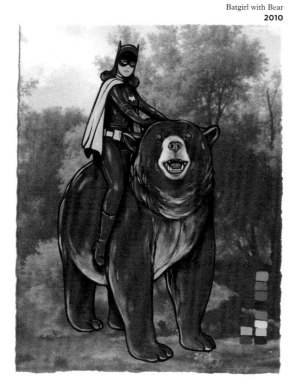

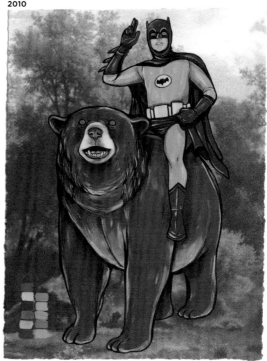

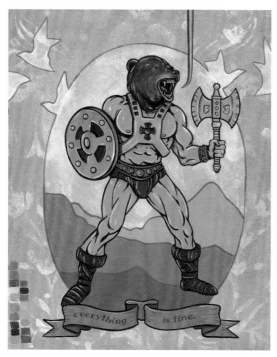

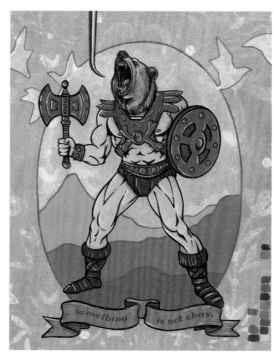

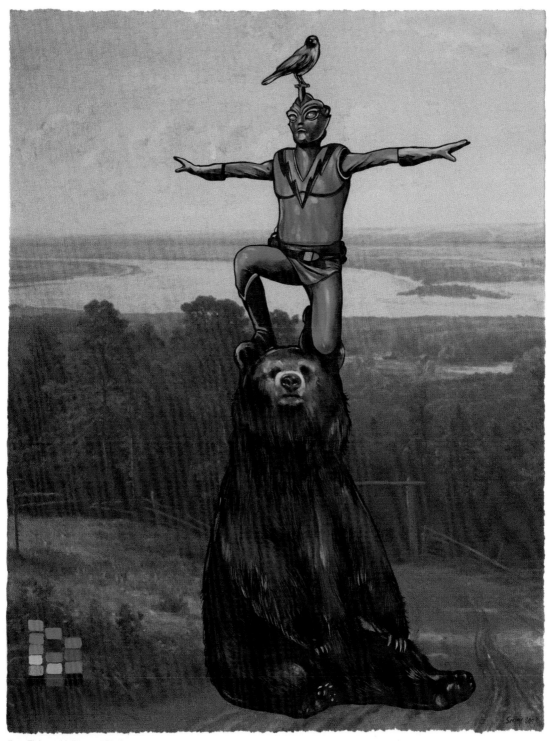

Zone Fighter with Bear and Bird
2009

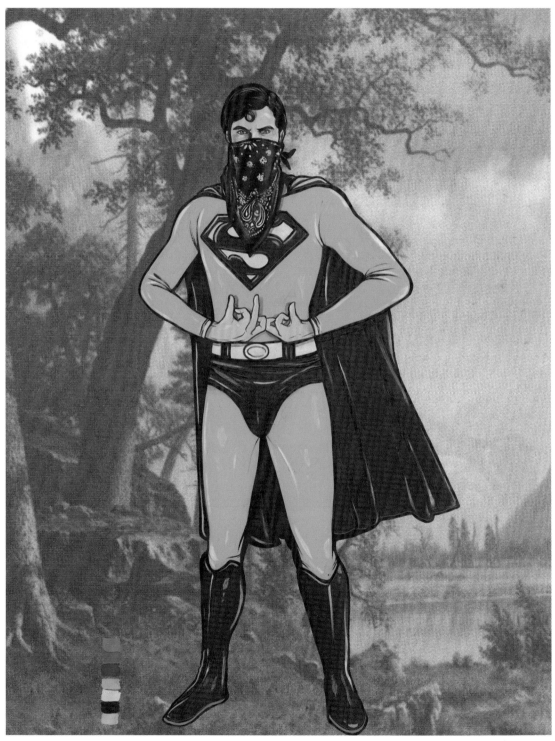

Superblood
2010

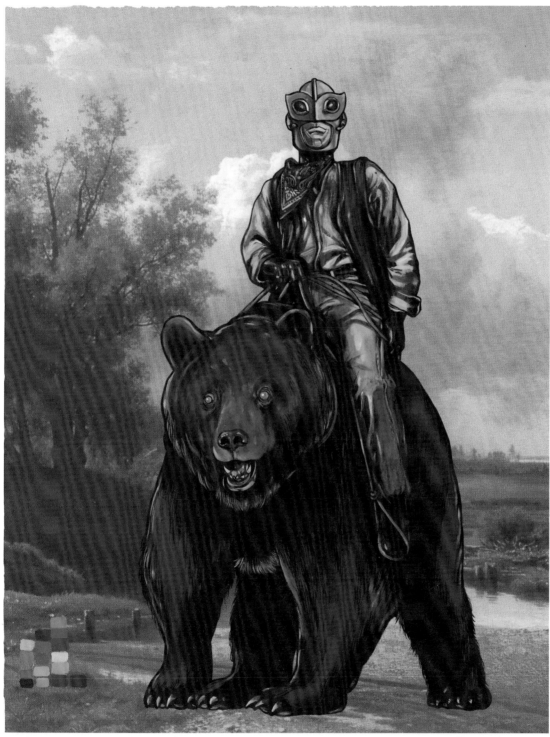

Thundermask with Bear
2009

SENNWALD, ALEKS

New York-based freelance illustrator and cartoonist Aleks Sennwald was born in South America and raised in Europe. Her personal work is influenced by comics and video games, both of which she also makes herself.

WEBSITE: senvald.com

BLOG: tigermountain.tumblr.com

CONTACT: pizzainspace@gmail.com

Galactus
2007

“ My parents
gave me
an Atari ST
in the 1980s.
I never got
over it. ”

Rom Spaceknight
2007

Rom Spaceknight—Detail
2007

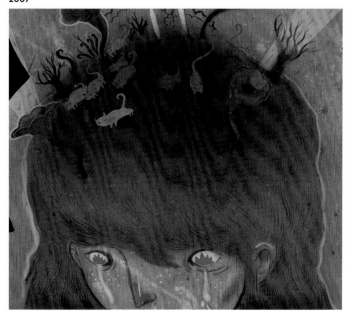

The Batman
2008

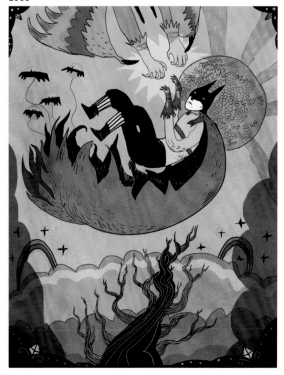

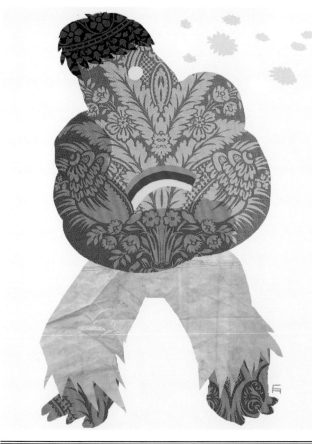

The Hulk
2008

SLATER, TODD

Todd Slater has created hundreds of posters for concerts and bands including the White Stripes, Foo Fighters, Radiohead, and the Killers. Although fascinated by geek culture, he would never have guessed that guessed Megaman T-shirts would become fashionable.

WEBSITE: toddslater.net

TWITTER: twitter.com@toddslaterART

CONTACT: slater.todd@gmail.com

Geek-Art to me is all the stuff jocks used to beat people up for liking, ya know?

1986
2012

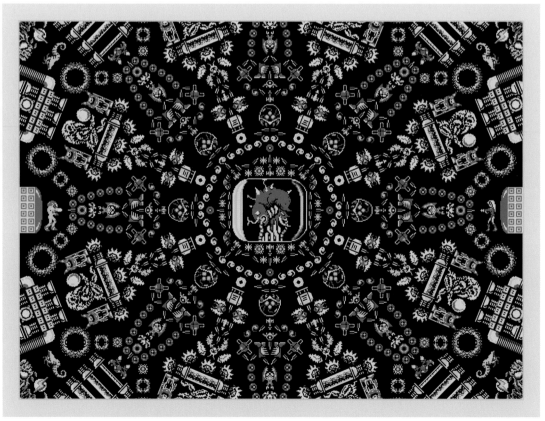

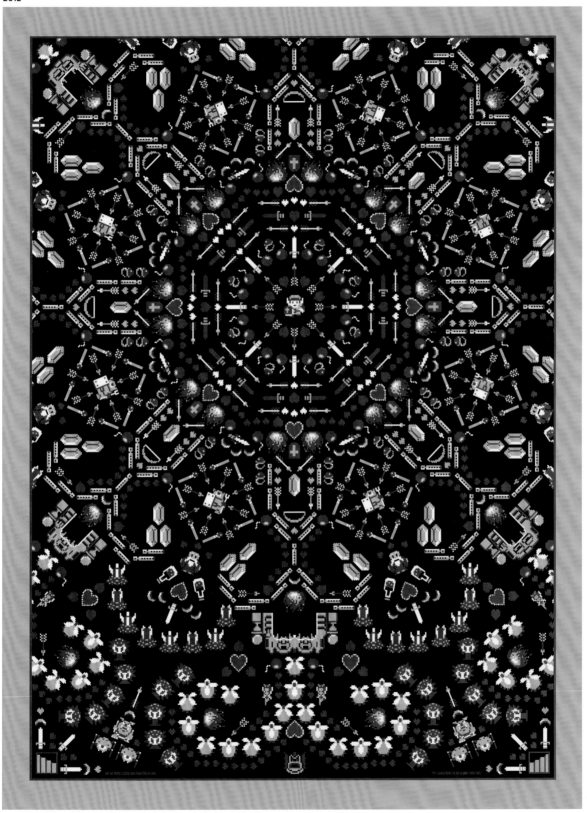

Occasional Acid Flashback
2012

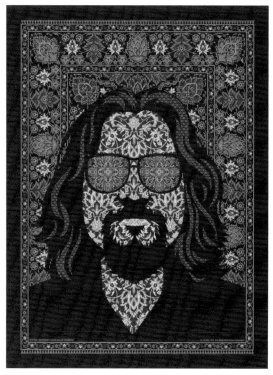

Lost in Translation
2012

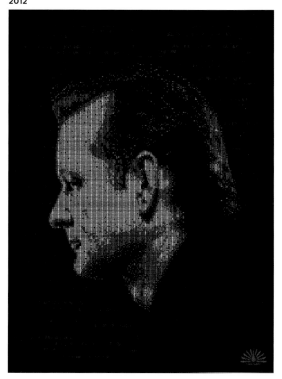

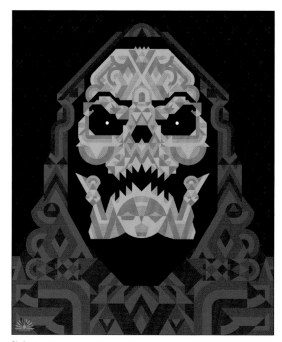

Skeletor
2011

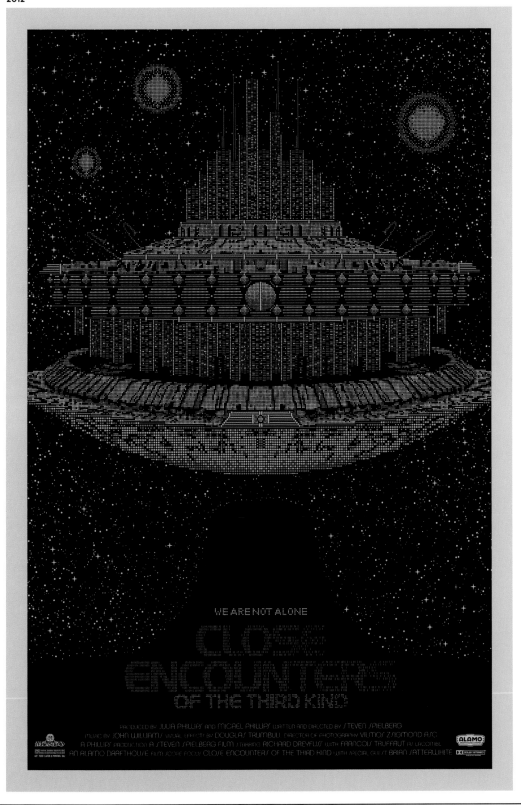

VAN GENDEREN, JUSTIN

Justin Van Genderen is the Chicago-based freelance graphic designer and artist behind 2046 Design. His personal work revolves around popular culture themes and vintage techniques.

WEBSITE: 2046design.com

CONTACT: justinvg@gmail.com

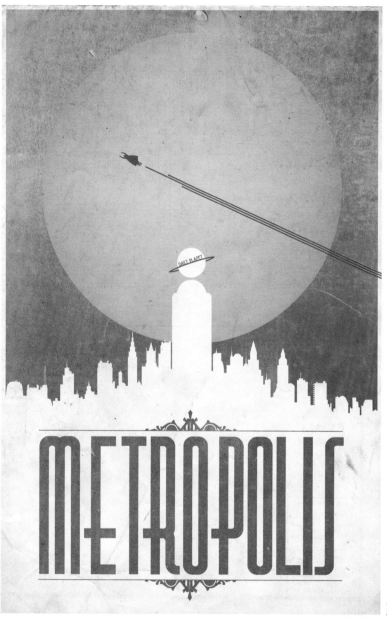

Metropolis
2011

"My relation to geekdom is based on nostalgia. I won't forget the joy that movies like *Superman* or *Star Wars* brought to me. My work tends to get back to this feeling."

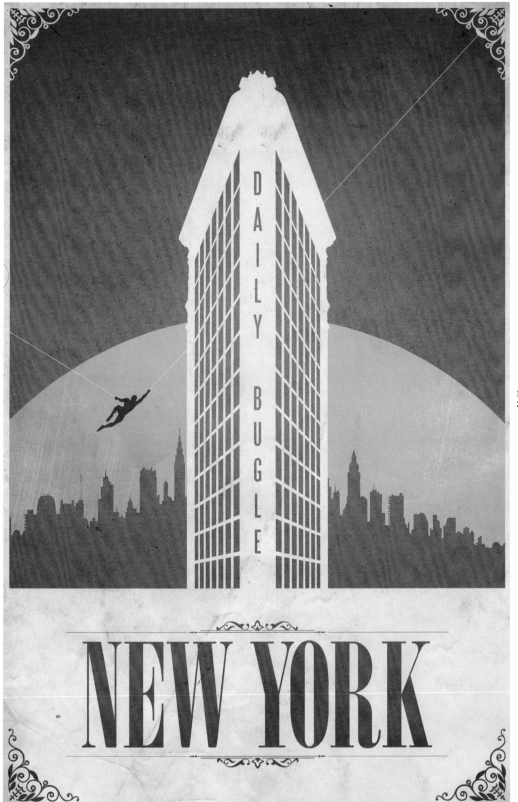

New York
2011

Gotham
2011

Neo Tokyo
2011

WHITE, HILLARY

Hillary White comes from a small town on the coast of Maine. She spent her childhood surrounded by toys and LEGO, playing in her garden, and "soaking up all of the magic power from Saturday morning cartoons of the '80s." Nothing has changed since.

WEBSITE: hillarywhite.daportfolio.com

FLICKR: flickr.com/photos/wytrab8

CONTACT: wytrab8@yahoo.com

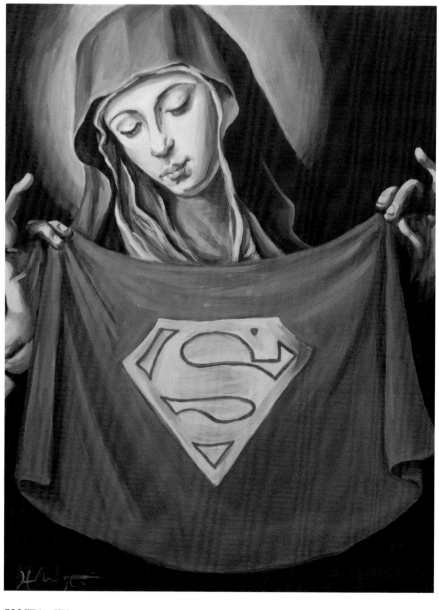

" This is what happens when you love classical art and the '80s. **"**

St. Kryptonia
2012

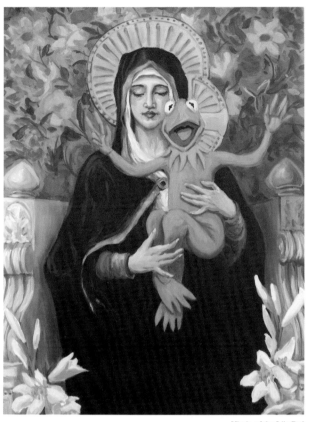

Virgin of the Lily Pad
2011

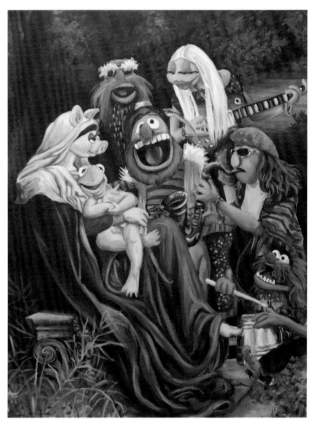

Song of the Electric Mayhem
2011

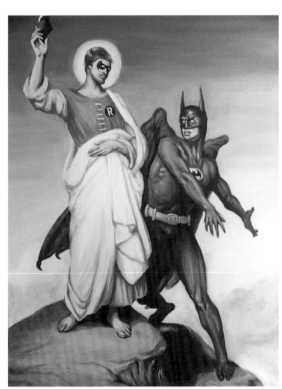

Temptation of Robin
2012

By the Power of Retribution
2012

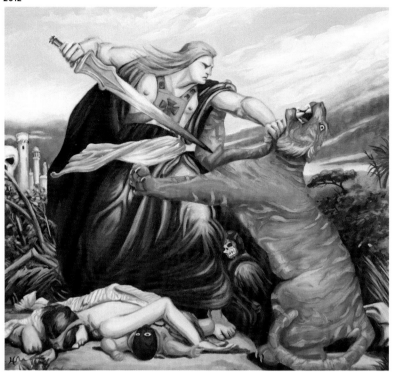

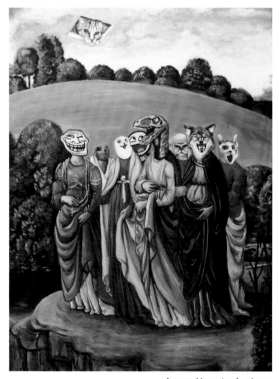

Internet Memes in a Landscape
2011

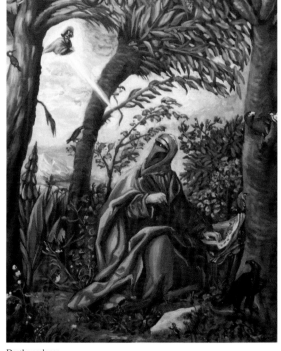

Darthpocalypse
2011

The Best Supper
2012

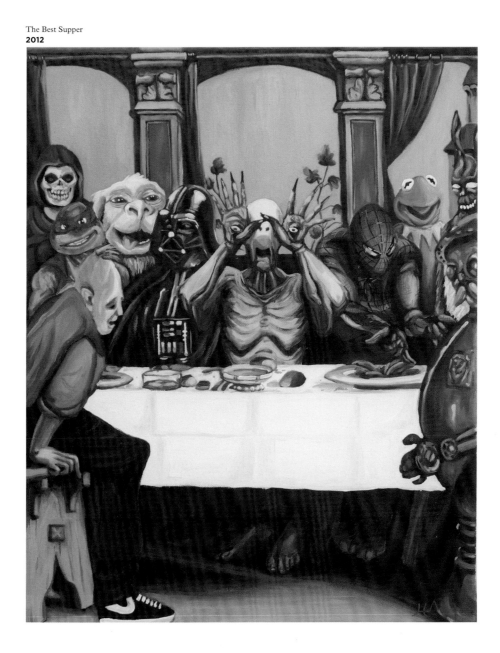

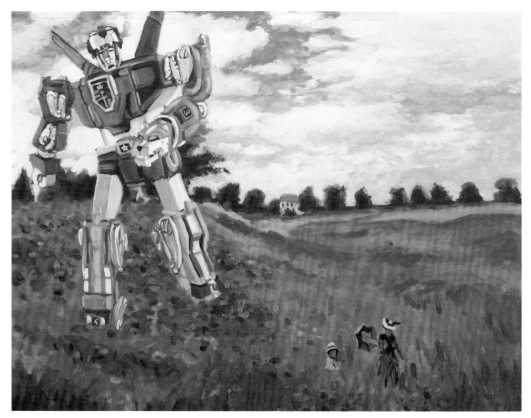

Voltron dans les Coquelicots
2011

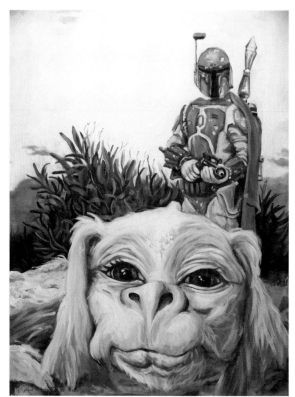

A Boy and His Dog
2011

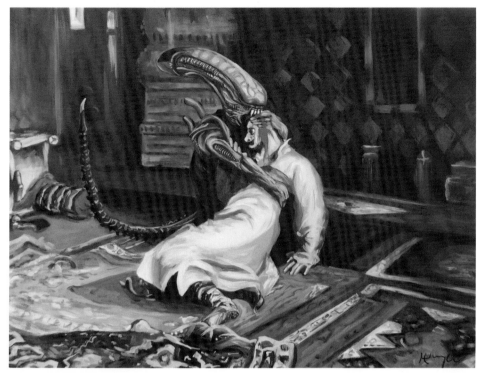

Alien the Terrible
2012

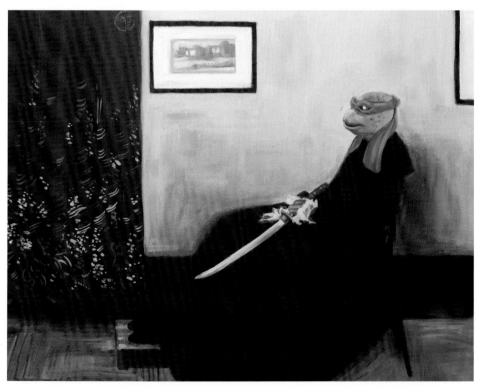

Whistler's Turtle
2012

WILSON, ANDREW

Andrew Wilson is an American artist heavily inspired by 1980s pop culture. His art, both digital and traditional, has a focus on characters, video games, and cult movies. He has created many album covers for bands such as Fall Out Boy, has worked for Rockstar Games, and is currently with the game design company Valve.

WEBSITE: theforgottenkingdoms.com

BLOG: andrewandavid.blogspot.com

Metroid: The Other O
2011

" My life is strongly
anchored in pixels
and polygons. **"**

Game Cubes: Super Mario Bros.
2012

Daisy Is the Bomb
2011

Chell and Her Companion, the Cube
2011

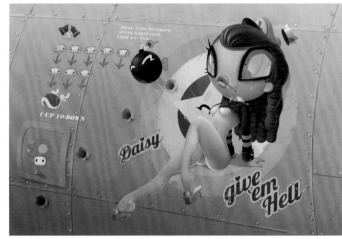

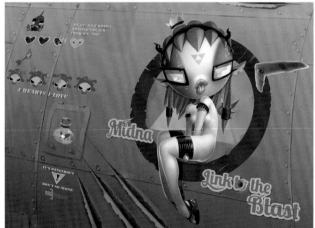

The Midna Express
2011

WOO, JOHN

Like his namesake film director, artist John Woo grew up in Hong Kong, where he still lives. Designer, illustrator, and *Star Wars* fan, his painting series "He Wears It" has become a staple of Geek-Art, outfitting George Lucas's characters and other pop culture icons in designer fashions, choosing styles that perfectly suit their personalities.

WEBSITE: wooszoo.com

BLOG: wooszoo.blogspot.com

CONTACT: johnlyw@hotmail.com

T-1000 *wears* THOM BROWNE. NEW YORK
HE WEARS IT 019

In the Terminator 2 storyline, the T-1000 is made of "liquid metal".
Schwarzenegger's character explains how the T-1000 is a more advanced
Terminator, composed entirely of a mimetic metal alloy, rendering it capable of
rapid shapeshifting, near-perfect mimicry and rapid recovery from damage.

❝ It should be
a dressing revolution
for *Star Wars*. **❞**

He Wears It 019
T-1000 Wears THOM BROWNE. NEW YORK
2010

Superman *wears* D&G

HE WEARS IT 024

His abilities include incredible super-strength, super-speed, invulnerability, flight and heat-vision. Born as Kal-El on the dying planet Krypton, his parents Jor-El and Lara sent him in a rocket to the planet Earth where he would be the last surviving member of his race.

He Wears It 024
Superman
Wears D&G
2011

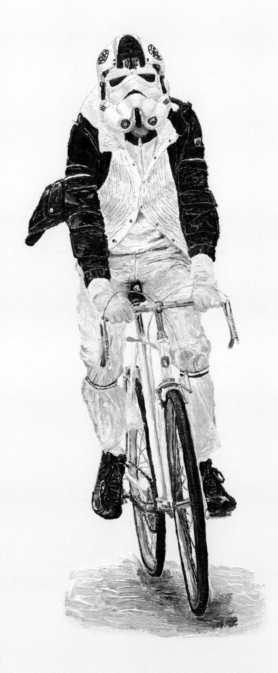

AT-AT Pilot *wears* MONCLER GAMME BLEU

HE WEARS IT 015

Propelling the massive Imperial walkers over uneven terrain requires the skills of
seasoned AT-AT drivers. These soldiers work in teams of two, operating the
ground craft with deft skill. They also fire the vehicle's powerful
laser cannons, carrying orders from a combat coordinator...

He Wears It 001
Darth Vader
Wears
BAND OF OUTSIDERS
2009

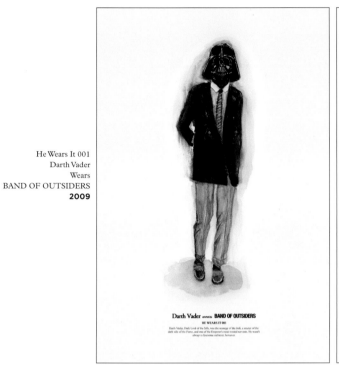

Darth Vader WEARS **BAND OF OUTSIDERS**
HE WEARS IT 001

Darth Vader, Dark Lord of the Sith, was the scourge of the Jedi, a master of the dark side of the Force, and one of the Emperor's most trusted servants. He wasn't always a fearsome enforcer, however.

He Wears It 002
Stormtrooper Wears
THOM BROWNE.
NEW YORK
2009

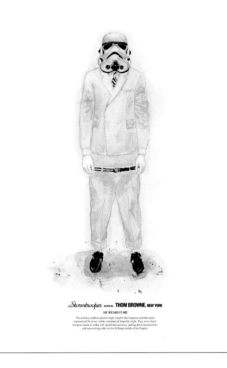

Stormtrooper WEARS **THOM BROWNE. NEW YORK**
HE WEARS IT 002

The military soldiers unwaveringly loyal to the Emperor, stormtroopers represented the most visible extension of Imperial might. They were shock troopers meant to strike with speed and accuracy, putting down insurrections and maintaining order on the farflung worlds of the Empire.

He Wears It 003
Jar Jar Binks
Wears
Maison Martin
Margiela
2009

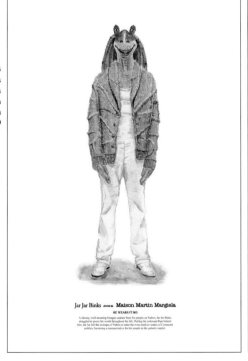

Jar Jar Binks WEARS **Maison Martin Margiela**
HE WEARS IT 003

A clumsy, well-meaning Gungan outcast from his people on Naboo, Jar Jar Binks struggled to prove his worth throughout his life. Putting his awkward Past behind him, Jar Jar left the swamps of Naboo to enter the even murkier waters of Coruscant politics, becoming a representative for his people in the galactic capital.

He Wears It 013
Padmé Amidala Wears
GARETH PUGH
2010

PADMÉ AMIDALA WEARS **GARETH PUGH**
HE WEARS IT 013

An idealist during a time of corruption and vice in the Galactic Senate, Padmé Amidala was determined to fix what wrongs she could in the ailing Republic, serving its Senate and her idyllic home planet of Naboo.
Though her career should have predicted it...

YANG, LAWRENCE

San Francisco-based artist Lawrence Yang is influenced by graffiti art and traditional Chinese painting, and employs ink, markers, and watercolors in his work. He grew up playing Nintendo and watching cartoons, and he is now participating in Geek-Art exhibitions.

WEBSITE: suckatlife.com

BLOG: blowatlife.blogspot.com

CONTACT: lawrence@suckatlife.com

> " Things haven't changed
> much now that
> I'm an 'adult.' "

Triforce
2010

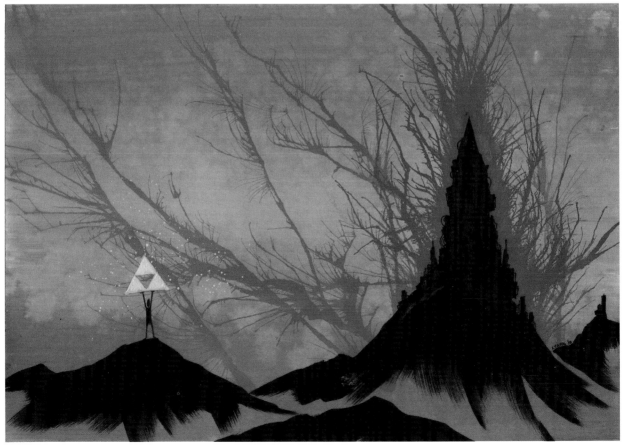

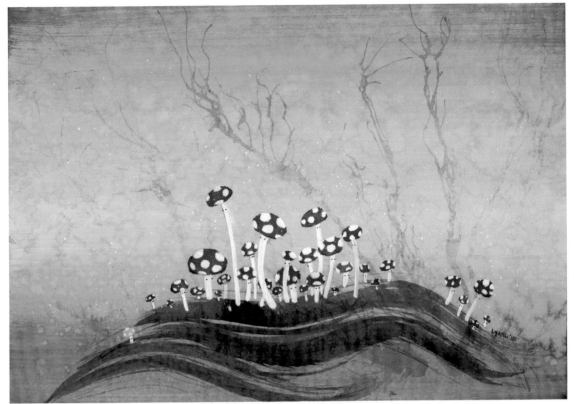

Mushrooms
2009

Duck Season
2011

Yang, Lawrence **409**

Grand Star
2009

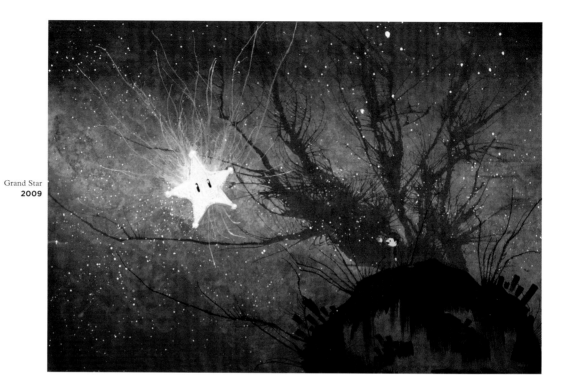

Pigs
2011

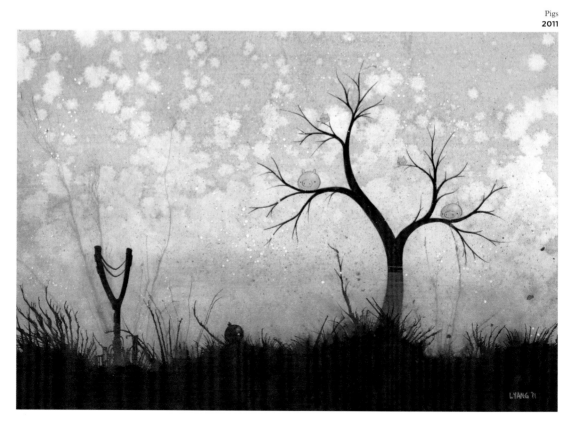

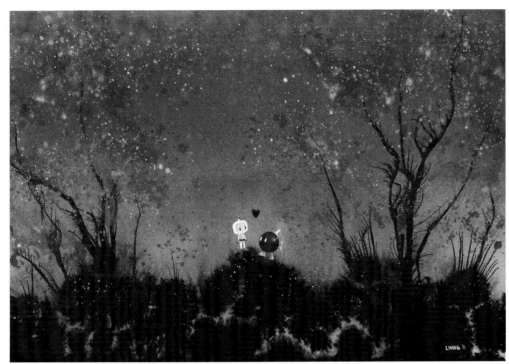

Bob-omb Love Story
2011

Black Mage
2009

YOUSSEF, IBRAHEEM

Toronto-based artist Ibraheem Youssef is obsessed with obsession. And he has a lot of obsessions, including art, alignment, color, cooking, design, folding, illustration, paper, printing, typography, and ping-pong.

WEBSITE: ibraheemyoussef.com

BLOG: blog.ibraheemyoussef.com

CONTACT: hi@ibraheemyoussef.com

Casino
2012

" People and traveling are the topmost influences for me; there is a certain beautiful ignorance that is realized when one is abroad. "

Goodfellas
2012

reservoir
dogs

Harvey Keitel
Tim Roth
Steve Buscemi
Michael Madsen
Lawrence Tierney
Chris Penn

Directed by
Quentin Tarantino

MIRAMAX

MacGruber
2011

Zissou
2010

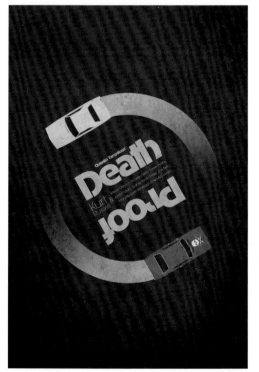

Death Proof
2010

Inglorious Basterds
2010

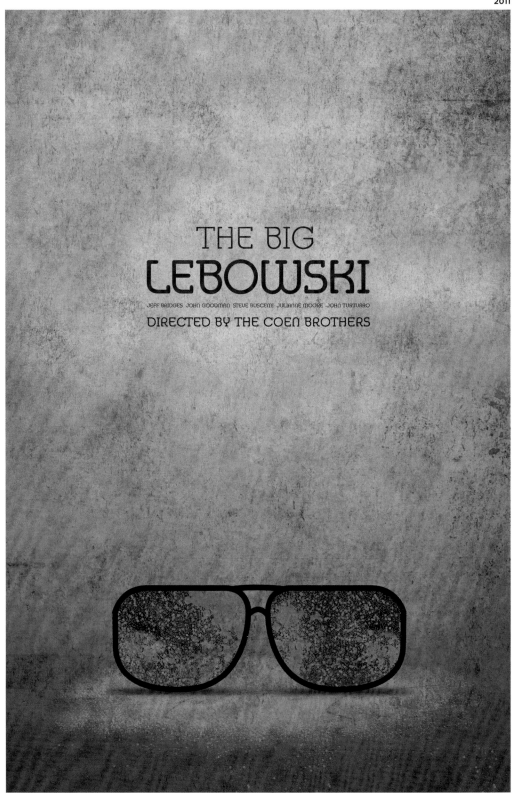